The Beauty *of the* Real

The Beauty *of the* Real

What Hollywood Can Learn from Contemporary French Actresses

Mick LaSalle

STANFORD GENERAL BOOKS

An Imprint of Stanford University Press
Stanford, California

Stanford University Press
Stanford, California

Printed in the United States of America on acid-free, archival-quality paper

Library of Congress Cataloging-in-Publication Data

LaSalle, Mick, author.
 The beauty of the real : what Hollywood can learn from contemporary French actresses / Mick LaSalle.
 pages cm
 Includes bibliographical references and index.
 ISBN 978-0-8047-6854-2 (cloth : alk. paper)
 1. Motion picture actors and actresses--France. 2. Actresses--France. 3. Women in motion pictures. 4. Motion pictures, French--United States. I. Title.
 PN1998.2.L376 2012
 791.43'65220944--dc23
 2011049156

Designed by Bruce Lundquist
Typeset at Stanford University Press in 10.5/15 Bell MT

For my mother, *for* Joanne, *for* Amy *and for* Leba Hertz.
Great women.

Contents

The Beauty *of the* Real

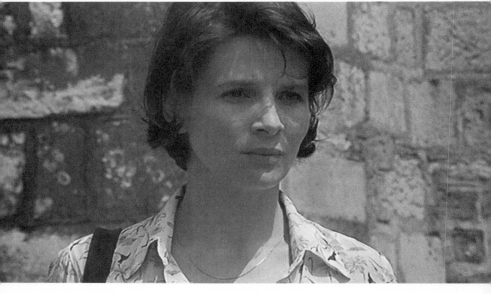

Juliette Binoche in *Alice et Martin* (Vertigo Films), 1998.

Introduction

Two Myths

W<small>E BEGIN WITH A STORY,</small> really half a story. You supply the ending.

It takes place in Paris, in the present day, where a nice young woman lives with her handsome boyfriend. But alas, she is not happy, because her boyfriend has become interested in another woman. What's more, instead of suppressing this longing, which would have been virtuous, or cheating and keeping the fact to himself, which might have been convenient, he has moved the Other Woman into their apartment. Now three people sleep in the same bed.

At first, the nice young woman is willing to give this a try. She hopes this is just a phase. But as time goes on, she realizes that her passivity is perpetuating this state of affairs, that her boyfriend is quite happy to have two lovers and unwilling to give up this ideal situation. So she despairs. She confides in her mother. She spends time by herself, thinking and brooding. Inevitably, there are arguments, including one particularly fierce one as the three walk down a street heading toward a nightclub. But soon enough, they calm down and proceed to the club as planned. It's crowded. Loud music plays. And then. . . .

Let's leave our story there. Imagine you're the screenwriter. Where would you take the story next? How would you develop it? How would you end it?

Let this percolate in the back of your mind for a bit, and we'll get back to it soon.

THIS IS A BOOK ABOUT FRENCH CINEMA, specifically the women of today's French cinema—a subject as vital as life and as irresistible as movies. Yet many Americans, unfamiliar with French film, will hear "women of today's French cinema" and immediately imagine something forbidding or austere. Other more refined cineastes may know and appreciate the French movies that play at art houses and arrive on DVD in this country, but they can't know the full story. They are not in a position to know that what they are seeing is just a hint of something vast and extraordinary.

The full story is that for the last two decades France has been in the midst of an explosion of female talent. What is happening in France today is a blossoming of female brilliance and originality of a kind that has never happened anywhere or at any period of film history, with but one glorious exception—in the Hollywood of the 1930s. Indeed, today's Hepburns, Davises, Crawfords, Garbos, and Stanwycks are not American. They're French. They are working constantly, appearing up to three or four times each year in films geared to their star personalities and moral meaning. These films, often intelligent, personal, and insightful investigations into what it means to be human in the twenty-first century, are the kinds of films that many Americans want to see. And they wonder why no one is making them. But people *are* making them, just not in the United States.

Moreover, women are not only working in front of the camera in France but behind it, too. Important actresses are writing and directing films, and many of the country's biggest and most acclaimed directors are women. Truly, this is a halcyon period, happening as we speak, and to miss this moment would be like living in 1920 and never seeing a silent comedy, or like living in 1950 and never seeing a film noir. It would be to miss one of the most enriching cinematic movements of your time. Yet most Americans, virtually all Americans, have been missing it.

AMERICAN FILMGOERS operate according to two myths when it comes to foreign film. Like most myths, they are comforting. Unlike a lot of myths, these are not even slightly true.

Myth Number One is that we in the U.S.—especially those of us who live in cities and have access to film festivals and art houses—get the very best of foreign cinema. We may not get everything, the idea goes, but why import what we already have? We don't need a routine cop thriller from Denmark. The important thing is that we get the best.

We don't.

The truth about foreign distribution in the United States is that what we get in theaters (and on DVD) is random—a small, haphazard sampling of average to above-average product. True, we usually don't get the worst films, but beyond that there's no pattern. Great movies are often ignored, while pretty good movies somehow slip in. And the vast, vast majority of good and great product we never see at all. We never hear about it. Unless we go out of our way to find out about it, we never know it exists.

Myth Number Two is even worse, because it's pernicious, difficult to dislodge and is believed by many people, including sophisticated folks who care about movies. This is the notion that the dearth of foreign cinema in America doesn't really matter, because American independent films can serve the same function. According to this line of thinking, American independents can even be a kind of improvement, a lively, no-subtitles alternative.

In reality, American independent cinema is very much a product of the same culture that produces Hollywood films. The aesthetic values may be different, but the cultural values and assumptions are identical, because the films are, in the end, products of the same country, the same people and the same period of history. Some independent films may show us new ways of looking at movies, but they won't show us new ways of looking at life. Moreover, they tend to be guy-movies just as often as the films out of Hollywood. Hollywood guy-movies may be more violent or boorish, and independent guy-movies may be more thoughtful and sensitive. Hollywood leading men may be handsome, while independent leading men may be more scruffy or homely and look exactly like the director. But it's still mostly guys, all the time.

Only foreign films can show us entirely new ways of being and of seeing life . . . which brings us back to the story that introduced this book,

about the nice young woman forced into a three-way relationship by her randy live-in boyfriend. I asked you to come up with the rest of the story. Think about it for a minute, then read on.

HOW WE FINISH THE STORY highlights how we see the world. Present this scenario to a group of Americans, and inevitably you will hear the same three endings, all of them mere variations on a theme:

Scenario One: The nice young woman leaves the boyfriend and resumes her life, meets someone else . . . and just as she's recovering from her sadness, but while she's still vulnerable, the boyfriend comes back, begging her to return. She does return, but then realizes she has the strength and the desire to get rid of him, and so she does. He's miserable. She's happy. The End.

Scenario Two: The nice young woman leaves the boyfriend and resumes her life. She gets over him, and then one day he returns. He begs. He crawls through mud. He walks on broken glass. She's inclined to reject him as a bad bet, and then some crisis takes place, and he gets to prove that he really, really has changed. She accepts him back. He's contrite but redeemed. She's happy. The End.

Scenario Three: The nice young woman remains in the uncomfortable situation but starts bonding with the other woman. They share a growing frustration, amusement and disdain for the boyfriend. Then one night, when the boyfriend is away and they're sitting around drinking wine . . . something happens. They look at each other. They start kissing. They realize that what they like best in the relationship is each other, and what they like least is the guy. This feeling solidifies over the course of time, and eventually the gals throw the bum out. He's embarrassed and shattered. The women are happy. The End.

You'll notice that these three scenarios, while different, have one big thing in common. In all three, the nice young woman—suffering and put-upon at the start of our story—ends up triumphant. And the boyfriend, who has been heedless of her feelings, ends up sorry. In the first scenario, he's rejected. In the second, he's humbled. And in the third, he's sexually humiliated.

These scenarios bespeak our American way of seeing reality. Young and old, urban and rural, liberal and conservative, Americans have an ingrained cultural tendency to see life in moral terms. This is so much a part of us that we don't even notice it, but even our love stories are about finding Mr. Right and rejecting Mr. Wrong. Even our romances are about discerning the eternal moral pattern in the clutter of our specific circumstances. Thus, when Americans hear half a story, they complete it by restoring the moral order.

The French are not like this. They may care about right and wrong as much as we do, but they're much less interested in exploring moral gradations in their stories. Their movies are more interested in human behavior, in the stuff people do. They are far more content to live with the unknowable and accept the unexplainable than to settle for a glib answer. To them, putting a neat button on things is cheap, not a way of identifying and establishing value but of minimizing and limiting a story's scope and resonance.

In the case of the young woman and her boyfriend, the scenario I gave you is from an actual movie, Christophe Honoré's *Les chansons d'amour* (*Love Songs*), from 2007. Ludivine Sagnier starred as Julie, upset that Ismaël (Louis Garrel) has brought Alice (Clotilde Hesme) into their bedroom. But alas, the true fate of young Julie is far different from anything imagined in our Three Scenarios.

In the actual film, Julie and Ismaël argue all the way to a nightclub, then calm down and go inside. And then, within minutes, Julie begins to feel ill. Needing air, she walks outside the club . . . and drops dead. Of a cardiac arrest. Because you know how it is: Seemingly healthy twenty-nine-year-old women are dropping dead of cardiac arrest all the time.

And what of Ismaël and Alice? They break up soon after, and Ismaël experiences a dark night of the soul that goes on for several months, until one day Ismaël realizes that he's gay. He gets an apartment with a nice young man and discovers love once more. That is the happy ending.

Now in terms of Hollywood storytelling, *Les chansons d'amour* would be considered utterly insane, and I admit that it's an extreme example.

Most French movies do not have scenarios quite so ludicrous. But while Americans might reject the story as far-fetched in terms of character and pointless in terms of meaning, a French viewer might see the movie as simply depicting an interesting situation—a situation so different and unexpected as to be worthy of dramatization.

It should go without saying that there is no single right way of seeing the world or of telling stories. The French fascination with life as it is lived has given us the human comedy of Jacques Tati, epic achievements such as Jean Eustache's *The Mother and the Whore*, and just about every film of the French New Wave. At the same time, in lesser hands, the same French tendency has given us narratively flaccid, self-serious films that are basically just a succession of pointless incidents pretending to indicate the randomness and absurdity of human existence. It has given the French too much of a tendency toward easy, thoughtless nihilism—or silliness such as *Chansons d'amour*.

Likewise our American preoccupation with morality, in the right cinematic hands, has give us films like *Casablanca, Brokeback Mountain* and *No Country for Old Men*. America's best movies, such as *The Godfather, Schindler's List, Bonnie and Clyde* and *Million Dollar Baby*, are almost invariably grand moral documents that explore the nature of good and evil and that challenge moral complacency. Yet on the downside, this same American preoccupation with morals has given us preachy movies, idiotic romantic comedies and every mindless action movie known to man. It has given our movies too much of a tendency toward easy, thoughtless formula. And it has also made our love stories predictable and our romantic scenes the least sexy and most ridiculous in the world.

This last point can best be illustrated by the rather absurd fact that in American films first-time lovers almost never actually *decide* to have sex. Instead, we routinely find one of two clichés. In comedies, two people become so hot for each other that they fall through the front door and proceed to demolish the apartment. Dishes break, tables are overturned, they tear off each other's clothes—careful to leave on the leading lady's bra, because her contract doesn't include a nude scene.

American dramas, meanwhile, cart out a parallel cliché—the standing-up sex scene. People are so hot for each other that they don't take the time to lie down. No matter that in real life, having sex standing up requires precision akin to linking the lunar module to the mothership. Never mind that in real life women tend to wear stockings or at least underwear that would have to be taken off—in American movies, women apparently wear bras but no underwear. These ridiculous clichés, comic and dramatic, are so pervasive we barely notice them anymore, but the real question is *why are they there?*

They are there because the American preoccupation with right and wrong makes filmmakers squeamish about presenting characters mor-ally culpable for their sexual behavior. So they make their characters too lust-ridden to think. Walking into a bedroom, or even taking the extra second or two to lie down, would imply a certain cognition. It would mean deciding. It would mean taking responsibility.

It would also mean dealing in human emotion, in the realities of interpersonal relationships, in thoughts and motives. But over the last fifty years, as women have joined the workforce and as the weekday matinees that once sustained women's pictures have faded into history, American films have increasingly concentrated on action, on grand conflicts, on the world of external struggle and violence. Actresses have become marginalized. Male box-office dominance has become a permanent condition.

By now, America has not only lost many potentially distinguished women's careers. It is in the process of losing what might be called the Female Principle. In the most pervasive and influential of art forms, we have lost feelings, inner life, reflection, introspection, the soul, the spirit. In its place, Hollywood is offering a titillating, neurotic vision of life out of balance, in which half the equation is missing.

To see the films coming out of France is to break into a vast treasure and become liberated from these and other varieties of domestic neuro-sis. And, ironically, through this foreign cinema, it is to come into con-tact with what's missing and intensely desired within the American soul.

SOME OF THE WOMEN YOU WILL MEET on these pages, you will already know. Some you'll know by name, and others, including some of the very best, you may never have heard of. Frankly, some of these women have careers that deserve a book-length treatment all their own. I'm thinking, in particular, of Nathalie Baye, Sandrine Bonnaire, Isabelle Huppert, Agnès Jaoui, Sandrine Kiberlain, Valeria Bruni Tedeschi and Karin Viard. In any case, over the course of this book, you will come to know their best work and that of their colleagues. It is a striking thing, the sheer vastness of the working talent, a roster that includes but is hardly limited to names such as Isabelle Adjani, Fanny Ardant, Josiane Balasko, Emmanuelle Béart, Leïla Bekhti, Monica Bellucci, Juliette Binoche, Élodie Bouchez, Isabelle Carré, Amira Casar, Marion Cotillard, Marie-Josée Croze, Emmanuelle Devos, Marina Foïs, Sara Forestier, Cécile de France, Catherine Frot, Charlotte Gainsbourg, Julie Gayet, Marie Gillain, Marina Hands, Mélanie Laurent, Virginie Ledoyen, Valérie Lemercier, Sophie Marceau, Chiara Mastroianni, Anna Mouglalis, Géraldine Pailhas, Charlotte Rampling, Natacha Régnier, Brigitte Roüan, Ludivine Sagnier, Emmanuelle Seigner, Mathilde Seigner, Audrey Tautou, Sylvie Testud, Kristin Scott Thomas and Elsa Zylberstein.

Some of these women are renowned for their beauty (Béart, Bellucci, Binoche, Marceau). But many others are beautiful in ways that elude analysis. They are warm or electric or magnetic or so idiosyncratic that your eyes immediately go to them. They are beautiful like the actresses of an earlier Hollywood generation, like Barbara Stanwyck, Claudette Colbert or Olivia de Havilland. In the 1930s, Busby Berkeley's chorus lines were filled with women who were prettier, and yet these ladies became objects of cinematic fantasy. Obviously, they had some requisite base level of good looks, but what pushed them into the realm of beauty was something else, something inside *them*, something to do with their essential being. And yet . . . what happens if a culture or an industry isn't interested in a woman's essential being? Stanwyck and her exalted colleagues would have been nothing in such an environment, just as many American actresses today are going through entire careers without ever showing what's inside of them.

In 2003, Meryl Streep won a career achievement César Award, the French equivalent of an Oscar. Streep's words (my translation) acknowledged the enduring interest of French audiences in women's lives and women's stories:

I have always wanted to present stories of women who are rather difficult. Difficult to love, difficult to understand, difficult to look at sometimes. I am very cognizant that the French public is receptive to these complex and contradictory women. As an actress I have understood for a long time that lies are simple, seductive and often easy to pass off. But the truth—the truth is always very very very complicated, often unpleasant, nuanced or difficult to accept.

In France, an actress can work steadily from her teens through old age—she can start out in stories of youthful rebellion and end up, fifty years later, a screen matriarch. And in the process, her career will end up telling the story of a life—her own life, in a sense, with the films serving, as Valeria Bruni Tedeschi puts it, as a *"journal intime,"* or diary, of one woman's emotions and growth. No wonder so many French actresses are beautiful. They're radiant with living in a cinematic culture that values them, and values them as women. And they are radiant with living in a culture—albeit one with flaws of its own—in which women are half of who decides what gets valued in the first place.

Their films transcend national and language barriers and are the best vehicles for conveying the depth and range of women's experience in our era. The gift they give us, so absent in our own movies, is a vision of life that values emotional truth, personal freedom and dignity above all and that favors complexity over simplicity, the human over the machine, maturity over callowness, true mysteries over false explanations and an awareness of mortality over a life lived in denial.

In the luminous humanity of their faces and in the illuminated humanity of their characters, we discover in these actresses something much more inspiring than the blank perfection and perfect blankness of the Hollywood starlet. We discover the beauty of the real.

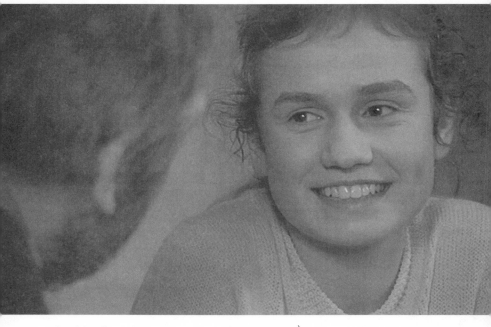

Sandrine Bonnaire reacting to Maurice Pialat in *À nos amours* (Gaumont), 1983.

1 Teen Rebellion

EVERY YEAR IN MARCH, the Film Society of Lincoln Center hosts the "Rendezvous with French Cinema" festival, a sampling some of the best French movies produced within the previous year. Some of the films go on to get U.S. distribution, but most go into oblivion, and so, if you want to see French movies, this is something to build your plans around.

In 2008, Sandrine Bonnaire came to the festival to promote her latest film. At the time she was forty years old and had made dozens of movies, many of them classics with some of the best French directors of the previous quarter century: Pialat, Varda, Leconte, Sautet, Rivette, Chabrol. But this new film was particularly special to her in that she had made it herself and the topic was personal. It was a documentary about her sister, Sabine, just one year her junior, who had suffered from a form of autism all her life and was institutionalized. *Her Name Is Sabine* had become an unexpected hit in France. At Cannes it won the International Federation of Film Critics prize ("the most beautiful film that Cannes has given us this year") and millions watched it when it aired on French television. Bonnaire was given an audience with President Nicolas Sarkozy to discuss the plight of autistic people. But in America, of course, the expectation and the reality were much more humble. Following the New York screening, Bonnaire was interviewed on stage before an audience of approximately 150—the only people in a city of some eight million wanting to avail themselves of a chance to meet one of the best actresses in the world.

Bonnaire is no disappointment in person. She is warm, smiling, funny, and has no entourage, just one assistant who is actually rather pleasant. (A typical Hollywood trick is for the assistant to be monstrous, thus allowing the star to seem almost human by contrast.) Very few actors look the same in real life. Bonnaire is smaller than her big presence on screen would suggest, slim and at most 5′3″, despite websites listing her as taller. On this day, she wore black and her light brown hair was pinned up in that consciously unselfconscious way that French women have made famous.

To talk with Sandrine Bonnaire is to get the sense of someone with a great and native sensitivity whose attention is directed outward. Without her trying to communicate it, she conveys the impression that she knows what other people are feeling. There is a gentleness about her and an emotional honesty. She seems entirely at home with herself, sure of who she is and content in that her career is where she wants it to be and that her work is satisfying. The one thing that's not clear is whether she knows quite how good an actress she is. I would think that she would have to, but that if she does, she does not confuse talent with moral license or some other form of superiority outside that sphere. She was born working class, and in her demeanor maintains the best of her origins. Nothing about her is lofty or distancing. Talking to her, it's very easy to forget she is, for all practical purposes, screen immortality incarnate—though when she smiles, there certainly is no forgetting that this is, indeed, Sandrine Bonnaire, and that you've just been treated to your own exclusive close-up.

As an actress, Bonnaire's great gift is her emotional accessibility, her empathic understanding of the characters she plays and her ability to show us their emotions—sometimes towering, staggering emotions—with no filter and without the added alloy of discernible technique. She was discovered at age fifteen by the director Maurice Pialat, who wanted to make a movie about a pair of teenaged girls. Movie history is full of cases of filmmakers discovering actresses, yet there are aspects about Bonnaire's discovery that are unique. In almost every case of a directorial discovery going on to supreme artistic distinction, some preselection took place before the director ever got to see the person. For example, Swedish director

Mauritz Stiller found Greta Garbo for his film *The Saga of Gosta Berling* by calling the Royal Dramatic Theatre in Stockholm and asking them to send over their two best actresses. In that case, the preselection had been done by Garbo's deciding to become an actress, Garbo's managing to get herself into her country's premier drama school, and Garbo's distinguishing herself from her classmates. Cases of true, out-of-nowhere discovery usually produce humbler results.

But Bonnaire really was discovered out of nowhere. In 1982, two of her sisters answered Pialat's advertisement in a Paris newspaper looking for teenaged girls. Sandrine just went along for fun, but Pialat spotted her, auditioned her, cast her and got so excited about his new discovery that he settled on the idea of making his movie about one girl, not two. This became *À nos amours*, about a fifteen-year-old coming into her adult sexuality and about her relationship with her family, including her mostly absent father (played by Pialat himself).

"He was asking me to do special things," Bonnaire recalled in an interview for this book. "But for me it was easy, because I was an unconscious innocent. It's what I say all the time now, when you do this work for twenty, twenty-five years, you have to unlearn this work, because I think we are better when we're not in control. If you always think of what you are doing all the time, you are in a kind of performance—you are out of character."

Indeed, in talking about Bonnaire in *À nos amours* it is difficult to persist in the idea that she is playing a character at all. Certainly, she is playing the character's circumstances. But everything about the film is designed to break down the barrier between her and the role. The justly praised father-daughter scene, in which Suzanne (Bonnaire) comes home from having sex with her boyfriend and has an unexpectedly candid late-night conversation with her father, was filmed with two cameras and unscripted. Bonnaire did not know what Pialat was going to throw at her next, and you can see her looking at him with amused attentiveness. Is this Suzanne appreciating her father or Bonnaire appreciating her professional father? You'd have to say it's both. The scene depicts a rare communion

between the characters and a wonderful symbiosis between mature and blossoming talent. It's also the scene that lets you see what it was about Bonnaire that had Pialat so excited—her warmth, her sense of fun, her quality of listening and the way thoughts and emotions light up her eyes like electric currents.

THE REBELLIOUS YOUNG WOMAN—the young woman just coming into adulthood with her own ideas about her world and how she wants to live her life—is a common protagonist in French cinema. Director Benoît Jacquot, for example, has made a number of films built around teenage actresses (Virginie Ledoyen, Judith Godrèche, Isild Le Besco), all of whom have gone on to significant careers. In the case of Bonnaire, the image of youthful rebellion stuck for a number of years. Against her agent's advice, she followed *À nos amours* with a horrible crime thriller, *Tir à vue*, playing a vacuous teenager who goes on a crime spree with her boyfriend and ends up dead. (We meet her in a photo booth, with her shirt open, taking pictures of her own breasts. That's the level we're dealing with here.) Hardly better was her small role in the next Pialat film, *Police*, playing a prostitute. It's another vapid, clueless, overly sexualized teenager, and she is filmed fully naked and in an unflattering light. Years later, Bonnaire told a reporter that she had recovered from *Police* "in spite of myself." It was at this point that Agnès Varda rescued Bonnaire from what in retrospect begins to look like exploitation and cast her in *Sans toit ni loi*, known to the English-speaking world by the title *Vagabond*.

Vagabond (1985), an enigmatic and distinctly French creation, is, in its broad outlines, very much like Sean Penn's *Into the Wild* (made two decades later). Both movies present characters that leave home at a young age, confront the elements and end up freezing to death. Both movies are told from the point of view of witnesses after the event, remembering their encounters with the person, and the life choice of each protagonist is treated as a philosophical statement. The difference is that the American film presents a charming character everyone loves on sight while the French film presents a withdrawn, selfish, stinking, lazy nuisance.

The American film looks at the life as posing a moral question—did this young man do right or wrong? Was he a hero or an idiot? The Varda film is more interested in the mystery of human behavior: What did she do? What else did she do? Why did she do it?

Bonnaire's light brown hair was dark brown in *Vagabond*, but not from hair dye. "I stopped washing my hair for twelve weeks," she said. "I was crazy." Not by nature a closed, withholding presence, Bonnaire found in *Vagabond* a chance to play someone guarded and defensive who is determined to go through life completely free of any kind of inhibiting, defining social contact. She is common and damaged, and yet has the dignity of someone trying hard to do something impossible. The film debuted in September 1985 at the Venice Film Festival, and the following year Bonnaire won the César Award for Best Actress. It was her second César—she had won the Best Newcomer César two years before for *À nos amours*—and she was still only eighteen years old.

It's not uncommon for distinguished French actresses to make their first films while still in their teens. Isabelle Adjani, Isabelle Carré, Charlotte Gainsbourg, Marie Gillain, Sophie Marceau, and Ludivine Sagnier—you'll hear more about them later—all made an impression before their twentieth birthday. That teenage actresses can regularly, naturally and seamlessly move into adult roles is illustrative of French cinema's way of seeing a woman's life as all of a piece, as one smooth flow from childhood to youth to maturity to old age. That's how American cinema sees men's lives. We see the boy in the old man and find that engaging, and we recognize precociousness in pubescent boys, including sexual precociousness, as something to be expected. But with girls and women in American cinema, the situation is different.

A woman's life on the American screen is more compartmentalized, defined by age, and with specific rules with regard to sexual behavior. Phase One is childhood, which ends at sixteen or seventeen, in which sex is simply not allowed and must either be trivialized, romanticized or criminalized. Phase Two is prime womanhood, which extends from roughly seventeen up to some vaguely delineated endpoint somewhere between forty-five

to fifty-five (corresponding roughly to the onset of menopause). These are the sexual years. And finally, there is Phase Three, cronehood, lasting from approximately fifty until death, in which sexual feelings either mercifully do not exist or are presented as either grotesque or as subjects fit only for hopeless, nostalgic or wistful contemplation.

French cinema, lacking such ironclad divisions, allows teenagers to be more sexual and allows actresses of a certain age to make movies highlighting their emotional, personal and sexual lives. I suspect that most Americans, at least in theory, would applaud the latter. And indeed, as the baby boomers age, you're seeing Hollywood's cronehood line being pushed northward, in films featuring actresses such as Meryl Streep and Annette Bening. But France's relaxed portrayal of a teenaged girl's sexuality would be a little more challenging to the American sensibility.

In *À nos amours*, Bonnaire was filmed nude and cuddling with a boyfriend when she was barely sixteen. Sophie Marceau was not yet fourteen in *La Boum*, in which the story turned on the possibility of her losing her virginity. And Marie Gillain was on the cusp of sixteen when she played a fourteen-year-old discovering her sexual feelings (and her own newfound allure) in *Mon père, ce héros*. In all three films (the latter two are comedies), the girl's sexual impulses are presented as neither ludicrous nor terrifying, just normal, and the loss of virginity is treated as an inevitability, one best delayed, but no catastrophe in any event. This tradition continues in recent times with films such as Céline Sciamma's *Naissance des pieuvres* (*Water Lilies*), about a fifteen-year-old lesbian's sexual awakening.

Americans may see the French treatment of teen sexuality as shocking or cavalier or simply very French. Yet our own treatment of teen sexuality is hardly more virtuous, just more twisted, a bizarre combination of denial and prurience. For a bitter taste of both, take a look at the American version of *Mon père, ce héros*, remade three years later as *My Father, the Hero* with the same star, Gérard Depardieu, in the title role. In both films, the daughter—embarrassed to be vacationing with her father—tells everyone at a seaside resort that Depardieu is her lover. In the American version, the girl's age is changed from fourteen to sixteen, young enough,

but still the age of consent in many states. Also in the American version, the father and daughter don't stay together in the same cabin (a charming, true-to-life detail in the original) but rather in a big hotel suite with a separate section for each of them. Yet at the same time, the daughter in the American version (Katherine Heigl) walks around in a thong bathing suit that's considerably more revealing and disconcerting than anything worn by Marie Gillain in the original.

Overreaction and titillation—that's the American way—and the result is that a movie that was touching and funny in the French incarnation, the story of a father recognizing his daughter is no longer a child, becomes tin-eared, ugly and salacious in the American version. (It doesn't help that the remake portrays the girl as a spoiled brat who despises her father. How could anybody hate Gérard Depardieu?) Libertines need puritans to rebel against. Puritans need libertines to define themselves as virtuous. Thus we have in America an obsessively sexualized, pornographic culture that, at the same time, is always in a state of outrage. Alas, the results of Puritanism and libertinism are inevitably the same: to make the normal ugly.

The French, here and elsewhere, give us a vision more guiltless and more natural. Yet even agreeing with this, one may allow oneself a distinct sense of cultural dislocation watching Sophie Marceau frolicking in bed with Depardieu in *Fort Saganne* (1984). In a period piece that plays out over the course of many years, she begins as a teenager in love with him. Eventually she becomes his wife, then the mother of his children, then his widow—but Marceau acted in this film when she was at most seventeen and looked no older than sixteen. To see her nude from the waist up with Depardieu, who hardly looks like a starter boyfriend, can make you listen for the distant whine of police sirens over the sound track, or at least to wonder where Sophie's parents were.

THE NATURE OF FRENCH STARDOM (beginning early, staying late) makes it possible for a woman to grow up on screen. Marceau has been in films now for over thirty years. Catherine Deneuve's career is past the mid-century mark. Danielle Darrieux has the ultimate record to reach for—she

started at age fourteen and made films into her nineties. Theirs become lives recorded in all their stages, and it's fascinating to notice the changes. As a child, for example, Sandrine Bonnaire almost seems like a different person—impish and mischievous, rather than focused and warm. The same could be said for Marie Gillain, whose affecting doubt and frailty in later films, such as *Les femmes de l'ombre* (*Female Agents*) and the beautiful *All Our Desires* (2011), are nowhere to be found in the invincible vixens of her youth. Sophie Marceau's first films, by contrast, give a hint of the wry, amused distance that would be so much a part of her appeal as an adult. And Charlotte Gainsbourg is already recognizable in the teenager of aching, naked sensitivity in *L'effrontée*. Such early performances give a kind of pre-echo of the later work, like the electronic whisper of a vinyl record just before the song begins in earnest.

Isabelle Huppert's first important showcase, however, gives us a lot more than a whisper of things to come. It gives us the whole song, playing at full blast, music and lyrics included. Indeed, to go back and see Huppert's first notable screen appearance—in Bertrand Blier's *Going Places* (*Les valseuses*)—is to feel almost as if this is Huppert at fifty, ingeniously disguised as a kid.

Over the years, Huppert would be acknowledged throughout the world as one of France's greatest actresses, best known for her studies in perversity, for playing women of monumental strangeness, coldness or selfishness. But all this was ahead of her when she was cast in *Going Places*. She played a teenager having a dreary seaside lunch with her parents and little brother. Suddenly the movie's heroes, two young louts played by Depardieu and Patrick Dewaere, appear on the scene. They intimidate the parents, steal their food, physically jostle them—and when the camera turns to Huppert, we see that she is utterly delighted by this. She takes off with them on the back of a motorcycle and has sex with them both.

Those shots of the young Huppert delighted at her parents' fear and humiliation introduce more than a new personality to the screen—one almost wants to call it a new moral consciousness. The expression on her face is one of total amusement and stimulation with no moral qualms. In

fact—and this is the actress's contribution—there is no hint that the char-
acter had moral qualms and overcame them. Rather, the idea of consider-
ing her parents' feelings, of considering the rightness and wrongness of
what she's seeing and how she's reacting, has not even entered her men-
tal calculus. It does not seem to cross her mind that anyone would react
differently. Usually this kind of self-absorption is associated with mental
cretinism, but the face in that close-up is anything but stupid. That's an
alert face and a winning intelligence—a dangerous intelligence, too, when
coupled with courage and not limited by moral restraint.

Huppert's appearance in *Going Places* is the first in her gallery of ego-
centric, courageous and possibly disturbed women, a role not identical
to but very much in line with the roles she would go on to play in *Story
of Women*, *La Cérémonie*, *The Piano Teacher*, *Ma Mère*, *La vie promise*, and
many, many others. These later films were made with Huppert's star im-
age in mind. But *Going Places* was made when Huppert was still a nobody,
and yet the peculiar distance and moral strangeness are already there,
and not by some lucky accident of an actress's meeting a role. Rather
they are there because of what specifically this actress brought to bear on
what easily might have only been a gag—a girl runs off with two louts.

Recalling that scene in our 2010 interview, Huppert said, "Usually di-
rectors, especially good directors, tell you much less than you would think.
I don't think [Blier] ever told me anything special." It was Huppert who
brought in elements of emotional cruelty and a skewed consciousness. It
was Huppert who decided that this was an opportunity to present some-
thing more than funny or absurdist, something with a tinge of pathology.

Going Places was not a portal to stardom. That portal would not reveal
itself for another three years. Huppert would find it in Claude Goretta's
La dentellière (*The Lacemaker*, 1977), playing a shy working-class girl—
a shampooist in a beauty parlor—who gets her heart broken. The first
thing we see in that film is her hands: She is washing a woman's hair, and
something in the precise nature of her gestures that lets you know this
is Huppert before you even see her. "One often talks of a major encoun-
ter between you and a role," Huppert said in 2010. "That was a major

encounter, a witness role to what I was. That kind of opportunity rarely occurs in an actor's life."

It was a role that easily might have been sentimental, but Huppert holds back. Playing a girl who gets exploited by a rich young man while on vacation, Huppert makes no plea for audience sympathy but maintains a dignified reserve that ends up suggesting deeper emotion than surface longing. Moreover the performance is filled with enigmatic little moments that defy analysis. For example, there is one moment in a car when the young man asks if she is a virgin. She says, "*Oui,*" and you want to rewind the moment immediately, because she answers so quickly, with no coyness or embarrassment, but rather with a complexity that I can't completely sort out. Something about her response indicates a surprising amusement and relaxation, which is unexpected. Certainly almost any other actress, playing a shy person, would have chosen to seem most shy in answering this most personal of questions. But Huppert's answer hints at a private world within this character that we are never quite going to get at, while offering just the slightest, most delicate suggestion that she's looking forward to losing this virginity at the first opportunity.

"With the film, you feel some little hints of a potential personality, which is ready to open, little hints of humor, of irony, sometimes of joy," Huppert said. "The reason why the movie was so emotional was that all of that was just put under the cupboard and didn't have time to come to the surface."

Pay close attention to *The Lacemaker* and you see the fullness of Huppert's understanding, as well as the ways in which she lends that fullness of understanding, when appropriate, to the character. When this rich young man (Yves Beneyton) looks at her, it's with a fantastic coldness, as though he hopes to see that she is something less than himself, so as to maintain his class snobbery—which is his entire grounding in the world. When *we* look at her, we see that *she* sees this, that she knows how he sees her, but she won't let on. At the same time, Huppert knows when to show us her character's limits, things the character herself can't possibly be aware of—how she expects so little of life, has no ambition and craves

only contentment. Decades later, Huppert—with her strangely expressive introversion—is the reason to revisit *The Lacemaker*.

In interviews for the film at the time of its release, some writers, distracted by the young Huppert's reserve and her blank, unadorned prettiness, mistook her for the character she played. But one interviewer came close to the truth, noting the "discretion, calm, restraint, simplicity and naturalness" of Huppert, but also her "attention, distance, irony, balance, clarity and [the] very clear frankness of someone who knows and holds the reins." She was in her early twenties, and fully formed.

That Huppert had a career ahead of her playing reserved, watchful people was something that her first critics were quick to realize. What they did not and could not know was the meaning of Huppert's reserve, which would soon reveal itself as having less to do with shyness and more to do with assertion and challenge—with blankness as a form of aggression.

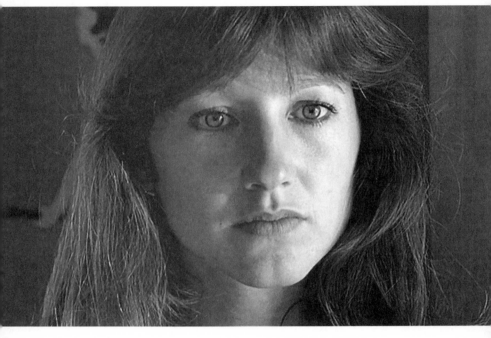

Nathalie Baye in Jean–Luc Godard's *Every Man for Himself* (MK2), 1980.

2 The Young Woman Alone
Isabelle Huppert, Isabelle Adjani, and Nathalie Baye

FRENCH CINEMA'S PORTRAITS of the young woman on her own constitute a strong and enriching strain in recent decades. Some of these films are romances, but just as many aren't. Even when they are, romance and men are just conveyances for the movies' real points of focus. These are movies all about exploring a young woman's essence, character and soul, and many actresses begin their great careers by putting their own stamp on specifically these kinds of films.

As we've seen, it was in precisely such a film (*The Lacemaker*) that Isabelle Huppert came to prominence, though in retrospect that delicate, gentle film seems almost like an intentional feint in the wrong direction. Huppert's destiny was to play a different sort of solitary figure. Within a year of *The Lacemaker*, she would begin exhibiting her true calling as the Emily Dickinson of world cinema—the little lady who seems harmless, until you look into her eyes; the little lady who could blow up the world just by thinking about it. Over time, Huppert would give us some of the most exuberant portrayals of malevolence by a major actress ever, enacting the fall and destruction of half-mad postal workers, World War II abortionists and frustrated piano teachers.

To interview Huppert after seeing forty or fifty of her films is not to expect someone twisted and evil, but it is to expect a series of uncomfortable moments squirming under a basilisk stare. After all, no one but Huppert has used stillness and silence to such unsettling effect. But the off-screen Huppert is hardly silent. She is extroverted and good-humored, jumps on questions before they're barely uttered and talks fast

and lucidly on all aspects of film. She is well read and analytical in her appreciation of movies, but her approach to her own work is instinctive. "It's pure intuition. I never prepare anything. Movies work on immediate feeling, something you can never expect. I like to be late when I arrive in the morning. I like to be quick. I sometimes rewrite my dialogue when it's no good—I do this in two minutes. I don't want to think too much. I'm very, very fast."

Her instinct is for the unusual. She is attracted to the evil, the epic and the tragic. This is the general pattern of Huppert's career, though in pointing it out I have no desire to limit or define her under a single category. From the beginning, this actress's ambition has been ravenous, her interests wide-ranging, and her energies inexhaustible. She makes two, three and sometimes four films a year, and in between she appears on stage. It is difficult to keep up with her, frankly. To live in America is to be always two or three movies behind. She has played everything, including that incarnation of very un-Huppert-like fragility, Blanche DuBois in a 2010 avant-garde French stage adaptation of *A Streetcar Named Desire*. Her tragic and wicked roles represent the most conspicuous and unique strain in her filmography, but she has had considerable success in the other direction—lovely as a shy wife and mother in *Coup de foudre* (*Entre Nous*) (1983) and kittenish as the young cheating wife in *Coup de torchon* (1981). Yet even in her relatively normal roles, she is not afraid of confusing or alienating an audience. For example, the film *Loulou* (1980) begins with her dancing with a big lug (Gérard Depardieu, of course) and laughing in her husband's face—laughing like she would like to contain herself but can't. It's a laugh that tells you that marriage is over.

A life of crime needs an accomplice. And so it came to pass that in 1978 Huppert found her best collaborator in director Claude Chabrol, who cast her as the title character in *Violette* (*Violette Nozière*), the true story of a young woman in the 1930s who poisoned her parents. Huppert described her connection with Chabrol as "immediate." Being in his films, Huppert "had the sense, like a home movie, where you're a family member. So you don't draw any barriers, you are totally free. He filmed me as if I were

his daughter. Instead of choosing a specific angle, he turned the camera around me 360 degrees. He was interested in my whole persona, not trying to favor one angle over the other. Basically that's the ideal, when people—they just love you, they love the way you are, they love the way you speak, they love the way you laugh, they love everything. So they just put the camera on you and say, 'Action.'"

Chabrol felt the connection, too. He appreciated the way Huppert's acting fit into his design and liked the way she was able to let go of the role at the end of a workday. (As Huppert put it in 2010, "If you express something, you get rid of it.") Chabrol was, in his public presentation, a boisterous epicure, and the Huppert persona has always been cautious and watchful. But beyond the surface, they had much in common. Both were borderline workaholics, fascinated by evil and buoyed by a cheerful work ethic. Chabrol's extroversion sometimes made him seem like a prankster, just as Huppert's stillness can make her seem austere, but neither stereotype was true. They were clinicians—intellectually energized pathologists carving up corpses.

For *Violette*, Huppert wore flat shoes and no makeup for the home scenes, then transformed at night as she pursued a life of promiscuity and prostitution. Violette is a curious creature from the beginning, a moral dilemma to be investigated, and that's even before she poisons Mom and Dad. Only later do we realize the motive for Violette's crime, that her father had raped her throughout her childhood. And with this realization, we look back on the action and come to understand both Violette's story and the subtleties of Huppert's performance. The information defines the nature of not only Violette's emotional reserve, but Huppert's. Just as the characters know from hard experience that pleading and showing weakness does no good, Huppert knows these shortcuts to audience sympathy cannot illuminate the fullness of a character.

This was perhaps the most crucial connection between the actress and the director, and it would resonate throughout Huppert's career: "Claude Chabrol really took for granted, and I took for granted as well—because this was his view of characters—never to idealize them, never to make

them bigger or smaller than they are, or heroes. If you take the character in its—I wouldn't even say humanity, in its *normality*—you just approach a little bit of the mystery of a human being."

IF YOU WERE TO ASK MOVIEGOERS in the late 1970s who among the then-current young French actresses would be recognized as undoubtedly great in the twenty-first century, you might find an intelligent few to answer, "Isabelle Huppert." Or perhaps a perceptive clairvoyant to guess "Nathalie Baye." But surely the vast majority would have mentioned, with complete assurance and no hesitation, "Isabelle Adjani."

Adjani was an international phenomenon in the late 1970s, who rose to acclaim on both sides of the Atlantic while still in her early twenties. Groomed for the stage from childhood, she switched to film and had her first hit with *La gifle* (*The Slap*), a comedy with Lino Ventura, when she was nineteen. The following year, she established herself as an actress to be reckoned with in François Truffaut's *The Story of Adele H.*, about a young woman's romantic obsession for an officer. A period piece, based on the real-life story of Victor Hugo's daughter, it gained Adjani a César nomination for Best Actress. More impressively, considering how rarely it happens, Adjani captured attention in the United States as well. She received an Oscar nomination for Best Actress and won a number of American critics' prizes, including one from the New York Film Critics.

Indeed, the role of Adèle H. may represent the best performance of Adjani's career. It can be instructive to see an actress's work before everybody tells her how great she is. From the movie's first minutes, Adèle utters nothing but lies, and Adjani beautifully scores her performance so that she seems genuinely and increasingly to believe the deluded things she is saying. By the end, when Adèle has lost her mind to romantic fixation, we have been prepared for this and believe Adjani utterly.

Following *Adele H.*, Adjani was regarded as an actress particularly gifted at playing emotional extremity. She was the volatile young woman, crazy because she was so beautiful or beautiful because she was so crazy, but definitely beautiful and definitely crazy. She had the fun role in *Les*

soeurs Brontë (*The Bronte Sisters*, 1979) as the most talented and tormented of the sisters, Emily, who refused to acknowledge her tuberculosis and just carried on until she dropped. (It could not have pleased the other Isabelle, Huppert, to find herself in the comparatively thankless role of Anne, the quietest and least talented of the three.) Adjani won her first César for her performance as a demonically tormented woman in the English-language horror film *Possession* (1981), and two years later picked up another for *L'été meurtrier*, as a small-town vixen who drives men to extremes. In *Mortelle randonnée*, she played a serial killer opposite Michel Serrault and was amusing in a variety of modes and moods, trying on various wigs and attitudes, though it was more posing than acting.

In America, Adjani remains best known for *Camille Claudel* (1988), for which she earned a second Oscar nomination and César #3. Yet seeing her in the film today, as a talented sculptor who eventually goes mad, it's difficult to believe that the Camille of Adjani's performance is truly driven to create or that she is capable of sculpting anything. Her aura is one of knowing or frustrated irritation, a familiar note in most of Adjani's troubled women performances. Indeed, over and over, from role to role, we see the same self-conscious panic and unconscious vanity; neither is it hard to ignore a certain narcissistic blankness in her work in *Queen Margot* (César #4). Adjani can be entertaining and intermittently convincing. But even in her prime, when she was undoubtedly lovely to look at, she was the least complex and least interesting of France's major actresses. Perhaps—here is an awful thought—that vacuity was part of her popularity in America.

Over the years, Adjani has chosen to make fewer films than any actress of comparable stature. Nathalie Baye, for example, has more than twice as many credits as Adjani, and Huppert has almost three times as many. In 2009, Adjani would return to the screen after six years to star in the hostage melodrama *La journée de la jupe* (*Skirt Day*), in which she played a literature teacher in a tough, ethnically mixed school. The film was ridiculous—at one point she holds a gun on her students and makes them recite Molière—and Adjani's performance consisted mainly of uninhabited fretting. Yet again, incomprehensibly, she was nominated

for a César that year, against a strong field: Dominique Blanc (*L'autre*), Sandrine Kiberlain (*Mademoiselle Chambon*), Audrey Tautou (*Coco Before Chanel*), and Kristin Scott Thomas (*Partir*). Yet more confoundingly and astoundingly, Adjani won.

Vincent Lindon, who was nominated for best actor the same night, said, in an interview with me a few weeks later, "I'm really really really really happy not to get the prize this year, because I wouldn't like to get the prize from the same people who gave it to Isabelle Adjani this year. [It was] a joke, a joke, a fucking joke." But apparently, others must disagree. Despite a small filmography, Adjani's fretting, troubled, tormented women—who always seem to be looking at themselves fretting as much as they are actually engaged in sincere, spontaneous fretting—have made her one of the most honored and lauded actresses in the world.

NO DOUBT, THEN, when the generations look back and the histories are written, the dysfunction of Adjani's panicked, solitary women will still hold some fascination. Her work has been too popular not to have lingering appeal. Yet I suspect that the rueful functionality of Nathalie Baye's women will be much more prized, for the particulars of Baye's performances and for the ways in which they reveal and define the life of her time.

Nathalie Baye has been an institution in France for over three decades and is notable for her combination of popularity—she is still a major box-office draw—and artistic distinction. Her résumé's mix of art films and popular entries is no accident, but "a choice," Baye said in 2010. "If you do a popular movie, it gives you the strength to help a more fragile film."

Yet it took a while for her to establish her hold on the public's imagination. She first gained attention for her role as the script girl, Joelle, in Truffaut's *Day for Night* (1973), about life on a film set. Despite comparatively little screen time, and the distractions of a superb ensemble, Baye's script girl becomes the character we look for, a portrait of competence, youthful enthusiasm, and almost comical single-mindedness. Baye was twenty-four—she had originally intended to become a dancer—and this breakthrough performance all but guaranteed her some kind of career.

Still, it would be another six or seven years before she would emerge as a major star.

We might well ask how, in a country and an industry that can recognize genius inside barely formed teenagers, did it take so long for Baye to take her place at the summit? Perhaps she didn't command immediate attention because, unlike Adjani, there was nothing exotic in her look and, unlike Huppert, nothing dangerous in her aura. Also, Baye tends to be subtle in her effects. To be sure, she has a capacity for fun and flashiness—she can go big and broad and comic with abandon and apparent relish—and yet even then, nothing she does ever seems to be directing our attention to herself or her own invention. She operates at all times within the imperative of illuminating the character and not with the purpose of making you say, "Nathalie Baye is a great actress."

Her looks are unique and paradoxical—striking yet unobtrusive, a natural vision of preternatural beauty. With her strong nose and warm brown eyes, she looks something like an ordinary, pretty woman but more like a Platonic ideal of ordinary prettiness. Her allure is almost beyond reason. It seems to derive, at least in part, from an unshakable sureness of self. Baye has a singularity of style that is not teachable and that Americans think of as distinctly French. She started dance training at age fourteen and moves like the dancer she once was. Her pensiveness is backed by first-rate intelligence. Her smile suggests precise but sympathetic perceptions.

In the end what made it hard to define Baye became her best asset. Her user-friendly looks have enabled her to be cast in every possible way, from hometown girl to businesswoman to police lieutenant. Yet even from the start, we can see her edging in the direction where so much of her career would ultimately reside. Baye is, more often than not, the woman alone, wearing her fatigue well and embodying the whole question and phenomenon of women in the modern world, juggling femininity with the demands of capitalism, and dealing with the wounds of men. She is distinctly contemporary. Her body of work documents the story of women in modern times better than that of any actress working in any country.

Baye often tells us stories of loneliness and disappointment, of a woman being thrown back on her own resources, sorting her way through some kind of maze. We can say this of a lot of actresses, but what sets Baye apart from her colleagues—and makes her portraits of young women on their own distinct from those of Huppert and Adjani—is that Baye's problems are almost always external, not internal or self-created. In *The Green Room* (1978), again playing opposite and being directed by Truffaut, she was a woman striving unsuccessfully to rescue a man from grief. In *La mémoire courte* (1979), she looks into the death of a writer and finds herself digging deeper and deeper into a conspiracy. Today, however, that film is best appreciated for the time it lavishes on solo scenes of Baye, in her hotel room, studying over the case. In style and manner, she is the quintessence of young womanhood, circa 1979, just as the film is a forerunner of many others that will showcase Baye as the professional woman, struggling with doubt or sadness.

Stardom came the following year, with *Une semaine de vacances* (*A Week's Vacation*), directed by Bertrand Tavernier. In it, she played a high school French teacher who needs a break. Something has gone wrong in her life. With another actress, something would have gone wrong in her head, but this is Nathalie Baye, who is never a madwoman, who always has good reasons. At thirty-one, she is stressed and on the verge of professional burnout. Her boyfriend (Gérard Lanvin) is defensive and brutish, not a bad guy, but not a keeper, and the biological clock is ticking louder. Her mother is getting old. Her father is infirm. A psychiatrist prescribes a week off, and aside from a one-day visit to her parents, she stays mostly in the neighborhood, thinking.

The film is a study of a period of life in which life's limits are first perceived and the daily, grinding realities of responsibility are realized. At one point, the teacher tells a friend that she never wanted to be anything, except a "pirate." In her early films, Baye usually seems surprised by the disappointments of life. (In her later films, as you'll see, she'll be just as heartsick, but not exactly surprised.) What further distinguishes *A Week's Vacation* is that it's very much about the particular dilemma of a professional person. Should she want something else, or should she remain a

teacher? From what little we see, she seems to be very good at what she does. There is a scene in which she has a private counseling session with a student, and the focus and warmth with which she listens to the girl is something rare. The scene calls to mind Baye's performance in *Les bureaux de Dieu* (*God's Offices*), some twenty-eight years later, in which she played a family planning counselor who hears an unwed teenager talk about her pregnancy. The quality of her concentration is attractive in itself and had to be a comfort to her younger costars.

There is an odd moment in *A Week's Vacation*, in which she lies in bed with her boyfriend and over the TV we hear an eerie operatic voice (possibly a countertenor) singing the words (in English), "My solitude / My sweetest jewel." The moment is both a subtle suggestion (never realized within the film) that the boyfriend will eventually go, as well as an unwitting prediction of the fate of most of Baye's heroines. At the end of the film, in a cheerful yet reflective vein, she tells a friend about her decision to keep teaching, and then talks about aging—how people sometimes just decide to get old. This leads her to thoughts about an old lady who lived across the courtyard, whose name she never knew. No one ever visited her. *A Week's Vacation* has a qualified happy ending, one in which a woman embraces her calling even as she resigns herself to life's finitude and the possibility, perhaps even the inevitability, of loneliness. Moreover the ending defines and refines what will essentially become the message of Baye's career, which is all about courage and realism and is, ultimately, though often in the grimmest possible way . . . optimistic.

In 1980, Baye went from being a supporting player with a middling career to an actress with a distinct identity. She was nominated for two Césars that year—for *A Week's Vacation* and a supporting nod for *Every Man for Himself*, a Godard film that is noteworthy only for the intelligence and appreciation with which Godard turns his attention on Baye. The film itself is so opaque it's hard to evaluate Baye's work here as a performance, but perhaps César voters, who accorded her the prize (Baye's first), saw something else: Essence. Her quality of somber reflection made the film a kind of avant-garde bookend to *A Week's Vacation*.

IN A LONG AND VARIED CAREER, Nathalie Baye has played a wide range of personalities—quiet women, boisterous women, difficult women, flighty girlfriends, adulterous women and wronged wives, writers and tough bosses. She has played both a prostitute and a frequent client of male prostitutes. Yet within that range, it's striking how consistent is the perception of her within each story. Too intelligent and stoic for us ever to see her as a victim, Baye is often found, nonetheless, directly struggling with the consequences of male weakness or perfidy. This combined with her innate quality of exalted averageness—Jennifer Aniston has some of the same quality in the United States, albeit in a less accomplished or cerebral way—enables Baye to be perceived as both her own distinct self and as a stand-in for modern women in general.

Perhaps for this reason, Baye rarely makes period films, and when she does, they tend to deal with modern concerns—for example, *The Return of Martin Guerre*. Set in medieval times, that film told the story of a young couple who become separated by war. Years later, Martin Guerre, long presumed dead, returns in the big, blustery form of Gérard Depardieu, and he takes his place in the community and in the bed of his wife. But he is not really Martin Guerre. He is an imposter, and the wife has to know it. But the wife never particularly liked the original husband. This new man is more fun, more kind and—it's actually stated—a better lover. "She had the possibility of choosing the man she's going to love," Baye said. "Of *course* she knows."

In placing the inescapably contemporary Nathalie Baye in the role of the wife, the movie becomes a rumination on how awful and constraining it would be to be a modern woman stuck in a dark age—to want all the things that all women want and yet be completely powerless. Once again we find Baye in emotional distress, not because of some internal disturbance, but because her society is unworthy of her aspirations and because men, not only the one she married but all the many men in power, are selfish or flawed.

"Bertrande [in *Martin Guerre*], gave me a lot—she was so strong," Baye said. "I was young at that time, and she gave me a little part of her

courage. I try to build characters and play characters, but they give me a lot, too."

In *I Married a Dead Man* (1983), one of Baye's best vehicles from this early period of stardom, she was a pregnant woman literally dumped on the sidewalk by a vicious, criminal boyfriend. Her luck changes, sort of, when she is in a train wreck and wakes from a coma to find herself misidentified as the pregnant widow of a winemaking heir. (In fact, the winemaker and his pregnant wife were killed in the crash.) Embraced by the dead man's family, she is welcomed into a world of ease and support. In effect, she lies to everybody, and when her old lover shows up in the third act, ready to blackmail her, she stabs him. Without words, Baye shows us emotional agony—that she is torn up with guilt over lying to these people, concerned over what might happen to her newborn were she cast out, and unsure what truly is the right thing to do, as everyone seems to take such comfort in her lie. Our loyalty toward Baye never comes into question because she is so good at making those unspoken emotions profoundly clear; because the man who rejected her is utterly repellent; and because something about Baye as a screen entity seems so worthwhile and fundamentally decent that any man who would treat her badly must automatically be disqualified from the considerations of general humanity.

Not for one second do we think, for example, what kind of lowlife would get involved with this guy in the first place? With Nathalie Baye, such thoughts never enter the mind. She is always a woman of quality—as she was even in *La balance*, in which she played a streetwalker. That film, a popular hit, contrasted Baye and her pimp (Philippe Léotard) with the police who are harassing them. The cops are revealed to be, not villains, which would be too easy, but limited, unimaginative, careless and rather uninteresting people. Meanwhile, the prostitute and pimp are presented as a man and woman in a healthy, however unconventional, loving relationship, and they are smarter, braver and have more integrity than all the police put together.

"I make thirty thousand [francs] a month, and I'm happy," she tells the cops when brought in for questioning. It's a strong moment, the kind

people remember. But even better are the scenes of private anguish, in which she and her lover are alone, two people being squeezed by the government for senseless reasons. The film is a statement about corruption in which the infectious mediocrity of the police (in the form of Richard Berry) comes between a man and woman, intruding on their idyllic private world. This is a very French formulation—to find purity and humanity in unexpected places—and creates what is ultimately a familiar Nathalie Baye situation, in which an intelligent woman with much to give finds herself on her own.

Isabelle Huppert and Isabelle Adjani have always played women whose loneliness is more or less predetermined by nature. In their distinctly different ways (and with their distinctly different abilities), they give us women who are always going to be a little isolated from normal society, even if they happen to be in a marriage or a relationship. They give us stories of the unusual, of the exceptional, and their portrayals have value—Huppert's more than Adjani's—in showing us what we would not otherwise see and in demonstrating the humanity of the uncommon.

Baye's work does the opposite. She shows us women with an obvious capacity for connection, whose loneliness is not preordained, but is the result of modern circumstance. She makes us see the familiar and feel the preciousness of the normal. Arriving when she did, with the distinct qualities she possessed, Baye would go on to play in modern stories about the exhilaration and pain of freedom. The journey would be a lonely one.

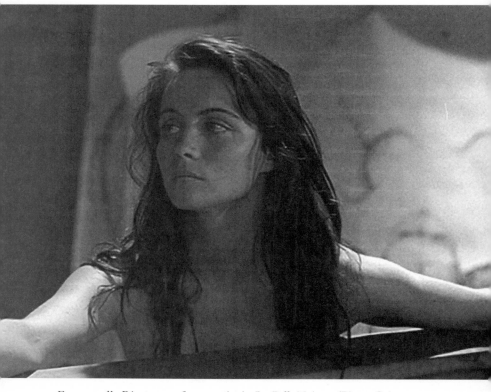

Emmanuelle Béart poses for an artist in *La Belle Noiseuse* (Pierre Grise Productions), 1991.

3 Juliette Binoche, Emmanuelle Béart, and the Temptations of Vanity

JUST AS JAMES STEWART usually played men who never stopped talking and yet is remembered as quiet and withholding in our emotional memory, we tend to think of Juliette Binoche, not in action, but in moments of reflection, when she looks as coolly inquisitive as a Roman matron in a first-century sculpture: Serene, secure in her essential value and gazing at us as if wondering stoically about her ultimate fate. Yet the women she plays are usually turbulent, troubled and extroverted. This is the essential contradiction of her screen image.

Especially when she was young, Binoche's face could sometimes look blank, almost masklike. Then at the slightest change of expression, she would become a different person. Her beauty is elusive. For one thing, it's eluding time. She is more beautiful in her forties than she was in her twenties. Does Binoche's beauty reside in the porcelain skin, the symmetry of features, in those ever-watchful eyes? Or are we talking about a spiritual condition that we intuit when we see her face?

Binoche came to prominence in the mid-1980s, at a time when almost every year saw a young actress emerge who would go on to do great work for decades. Nathalie Baye became a star in 1980. So did the teenage Sophie Marceau. Fanny Ardant made her first film for Truffaut in 1981, and Sandrine Bonnaire arrived in 1983. When Binoche achieved prominence in 1985, in André Téchiné's *Rendez-vous*, she looked no older than her age—twenty-one—but she had the uncanny maturity characteristic of French actresses of her generation. A dark, contemporary sex drama,

it placed Binoche in a role requiring so much nudity that it seemed to announce an actress with few physical boundaries—not necessarily what you'd expect as the opening note of Binoche's career. Yet for all its sensuality, the role did demand a quality of existential suffering, which would become a Binoche hallmark. She played a burgeoning actress who lands the lead role in a French stage production of *Romeo and Juliet* but finds herself tormented by visions of a dead lover. There was grief and confusion, and the question hovering over the film was whether this woman would be able to hold it together long enough to forge a career. That is, will she be able to transition from a preoccupation with sex and love to its sublimation in artistic excellence? It would be the first of many agonized journeys for this most deep revolving of actresses.

Rendez-vous launched Binoche in France, and then a few years later the world opened up for her with *The Unbearable Lightness of Being* (1988), directed by the American Philip Kaufman and shot in English. Since then, Binoche has been something of a hybrid star—French, to be sure, but a European star in general and a Hollywood actress as well. Most years she makes only a single film, and sometimes she skips a year. Her English-language roles have been selective and mostly of quality. Instead of going Hollywood after *The Unbearable Lightness of Being,* she returned to France to make *The Lovers on the Bridge* (*Les amants du pont-neuf,* 1991), then went to England for two films back to back: *Wuthering Heights* (1992), which she made with Ralph Fiennes, is the best adaptation of the Emily Bronte novel committed to film. (It played only on television in the United States.) Then came *Damage,* from director Louis Malle, which upended Binoche's purely ethereal image among English-speaking audiences, with its portrayal of reckless, obsessive sexual attraction and its consequences. She played a woman who takes up with her fiancé's father (Jeremy Irons).

Binoche was still only in her mid- to late twenties when she was playing these complex roles. More even than most of her colleagues, she seems to have been born thirty and to have graduated very quickly to thirty-five, where she would remain physically for the next twenty years. To look at these early performances is to find no immaturity of technique, no youth-

ful vanity, not even the exaggerated gravitas of the young—just focus, intelligence, commitment, and presence.

Yet I don't feel as though we see the complete Binoche until we get to Krzysztof Kieslowski's *Three Colors: Blue* in 1993. She begins the film institutionalized following the death of her husband and child in a car accident. As a way of not having to commit suicide, the grieving woman decides to leave the world mentally by withdrawing from any form of engagement with her past life. The film, about how she is brought back having walled herself away, is as intimate spiritually as *Rendez-vous* was physically, with Binoche opening herself completely to Kieslowski's all-knowing and ever-searching camera.

EMMANUELLE BÉART emerged a year after Binoche, as the shepherdess in the 1986 film *Manon des sources* (*Manon of the Spring*). From an artistic family—as is Binoche—Béart expressed from an early age an intention to act. She was twenty-three when *Manon* was released, but she had been working toward an acting career since childhood. From the age of nine, she had appeared in bit parts on screen. Then in her teens, she went to Canada to work as an au pair and learn English. The first film of her majority was *Premiers désirs* (1984), by the English photographer David Hamilton, a nearly unwatchable romp about girls cavorting on a beach. The only memorable thing is the appearance of the young and surprisingly sylph-like Béart.

To discuss the career of Emmanuelle Béart is to confront very early the delicate issue of cosmetic surgery. To a degree far beyond most of her colleagues—to a degree that is, frankly, a subject of scorn and perplexity among some of them—Béart has chosen to change her appearance through cosmetic intervention, making noticeable augmentations of her breasts and such dramatic changes to her lips that, by the first years of the millennium, when she was still a young woman, her face ceased to look quite like a real face. To introduce this subject is difficult for a male author, for reasons that are perhaps obvious and yet not so obvious as to go entirely without saying: (1) The looming surgical knife is a tyranny

all screen actresses live under, a tyranny that actors also know, but not nearly so universally, nor to the same extent. So one hesitates to speak of someone else's reaction or overreaction to a pressure that one could never know. (2) The whole question of cosmetic surgery takes us very near the realm of moral judgment—or at least threatens to introduce a tone of judgment, best avoided. (3) Even worse, the issue forces us into the uncomfortable area of aesthetic judgment, in which we end up becoming complicit in the very thing we're criticizing.

To illustrate this last point with regard to Béart, it has been common for people who are interested in this actress to look back on her appearance in the films of her early stardom—the period from *Manon* through Jacques Rivette's *La Belle Noiseuse*—and shake their heads in disapproval: Why couldn't she age naturally? Why didn't she leave herself alone? Yet confronting the boyishly built pre-stardom Béart of *Premiers désirs* presents aesthetes and moralizers with a dilemma that threatens to unhinge their aesthetics from their morals. Which is to say, if the Béart you find in her first years of fame was also augmented, do you really disapprove of plastic surgery, or do you simply disapprove of the plastic surgery that you do not like—that which does not fool you? If the latter, then you are the very person that Béart was trying to please all along—and pleasing in precisely the way you disapprove of. This also means that you were never really on her side, after all. You were just a problem that she needed to solve—and did.

Taking into account these considerations, we cease to regard Béart as simply misguided, as the woman who dared tamper with perfection, and instead give her credit for manufacturing some of that perfection in the first place. And we come to see her physical transformation as illustrative of a very modern story about the hazards and rewards of ambition, a story very much tied up with Béart's intense desire to become an extraordinary actress and work with the best directors. That ambition was largely realized: For at least two decades, Béart sought out and was sought by France's most distinguished directors and steered her career with taste and purpose.

Qualities of anger and judgment form the undertone of much of Béart's work. What can't be identified as anger, strictly, could be called impatience and an unwillingness to sit still for nonsense. All this is present in her *Manon*, who, despite the shepherdess clothes and blond tresses, is an aggrieved young woman, intent on uncovering and avenging a crime committed against her father. In her youthful films, Béart's judgmental anger, a consistent feature of her work, was especially arresting, because we don't generally expect a young person to have such force. Certainty, yes. Force, no. In her interviews from this time, she was forthcoming and unreserved; yet that quality of judgment was present. In 1987, in an early interview for *Manon of the Spring*, she matter-of-factly told a journalist that she didn't think Manon "could fall in love with this man"; that is, Bernard (Hippolyte Girardot), to whom she is married at the end of the film. "He's not strong enough."

Béart's command of English made it possible for her to make an American film—*Date with an Angel*—in the immediate aftermath of *Manon*. But it was dreadful and revealed the extent to which the filmmakers had no sense of whom they were hiring. It's as if Béart were chosen on the basis of the *poster* for *Manon*, not her performance in it. Who in France would ever think of casting Emmanuelle Béart as a real-life angel who falls out of the sky and lands in a knucklehead's swimming pool? *Date with an Angel* is a textbook case of how European actresses are misunderstood in Hollywood and how casting on the basis of appearance, rather than essence, is always a mistake. Yet the fact that Béart made *Date with an Angel* tells us two things. The first is that, despite a brilliant debut in a mammoth international hit, Béart had no better American offers; otherwise she would have made something else. The second is that she must have really wanted to work in America, that Hollywood success was part of the plan.

Following *Date*, Béart went back to France and made a few films, none with nearly the cachet of *Manon*. But then in 1991, as a bona fide star, she made her second great film, Jacques Rivette's contemplation of the creative process, *La Belle Noiseuse*, starring as a turbulent young woman who inspires an aging painter (Michel Piccoli) to pick up the brushes for

one last masterpiece. A good deal of the four-hour running time consists of Béart posing and Piccoli painting. But the film is not really about the relationship between the artist and his model, but rather about the relationship of each to the emerging work of art. The model subordinates herself to the artist's whims out of some intuition that the art will lead to self-discovery. In time, the artist discovers that he is still a master. And the model, wrestling with serious demons, turns her gaze inward and finds a void.

By turning Béart's disdain inward, Rivette provides Béart with the ultimate showcase. Instead of being irked about prosaic things, Béart in *La Belle Noiseuse* is upset at the limits of her own soul, at the futility of aspiration. Béart makes us believe that she has seen truths she will never escape. When a friend remarks that she should stop smoking, she answers, "I enjoy blackening my lungs." The encounter with truth has confirmed her in a spiral of anger and slow-motion suicide. There can be no turning back—the Béart heroine is invariably too brave for denial. And this is confirmed by the film's last shot, in which her handsome boyfriend proposes a romantic detour to Spain, as Rivette brings the camera in on Béart's face. "No," she says. End of film. End of relationship. End of everything.

The romantic with a hard heart, the world-weary woman with an angle on the unremitting truth—this is Béart as we most often know her. And in the right directorial hands, this is an image with depth, resonance and significance. But it is also one that has become overplayed with the passing years, sometimes as a reflexive fallback by the actress herself, at other times as a standard go-to for directors unwilling to explore or ask more of her. Thus, we too often find Béart on screen greeting the world with disdain, being strong without giving, creating spectacle while standing aloof from it, acting wise without being wise, and eschewing flattery while inevitably giving in to a more insidious vanity—the insistence that one has qualities greater than those which others are enamored of.

Béart's realism and impatience have their attractive side, to be sure, as in Claude Sautet's *Un coeur en hiver*, in which she played a concert violinist in love with a withdrawn violinmaker (Daniel Auteuil). In that film, she

is dignified, as always, but unprotected. Her coolness of demeanor does not shut out the world and does not degenerate into cold self-absorption. Despite a slight aloofness—which is part of who she is as an actress, and there's no reason to change that—Béart appears completely engaged and alive to the troubles and feelings of others. Likewise in Sautet's *Nelly & Monsieur Arnaud* (1995), in which she played a woman hired to type and edit the memoirs of a successful businessman (Michel Serrault), Béart makes us believe, with a minimum of show, how much she values her friendship with this old man and how it broadens her world.

But too often Béart has seemed locked in, indeed sometimes by the roles themselves. *L'enfer* (1994), the first of two films Béart made with the same title, marks a signal moment. Claude Chabrol, usually a fine director of women—the French master of suspense was like a Hitchcock who could get a date—concentrated on the male side of the equation in this story of a hotelier (François Cluzet) who develops the paranoid delusion that his wife is cheating on him. With his usual impish sadism, Chabrol makes sure that Béart is ridiculously stunning and seductive—this film probably represents the height of Béart's beauty. But the role becomes an abstraction, just as the movie becomes a kind of grandiose elucidation of how awful it would be to be married to a woman who looks like Emmanuelle Béart.

Throughout her career, Béart has had a difficult relationship with her beauty. She has never worn it lightly, with the ironic detachment of, say, Sophie Marceau, but rather with a grimness that goes way beyond Isabelle Adjani. For Adjani, beauty is like an expression of some inner purity that makes her vulnerable to the outside world, but even she takes some wicked, girlish delight in trotting it out and showing it off now and then. With Béart, beauty seems more like a great big nuisance, one that makes her prey to idiots, that guarantees that she will be misunderstood, and that gives her unwanted insight into the inner, selfish motives of others. Over time, Béart's characters have become increasingly hidden within a closed-off world, not the closed-off world of an Huppert, who watches with understanding and tries to wall in her emotions from the

other characters, but the closed-off world of the narcissist, who is self-contained and feels no impulse to show anybody anything. You don't have to be a psychiatrist to see how this impulse might relate to cosmetic intervention and a desire to perfect the mask. Béart, on screen at least, does not believe that those who say they love her really love her for herself.

It's hard not to feel that Béart's direction was being decided in the mid-1990s, with *Une femme française* (*A French Woman*, 1995) marking yet another step in Béart's movement toward self-consciousness. Written and directed by Régis Wargnier, the film is a rather ridiculous, could-only-be-French product, about a woman (Béart) who marries a man (Daniel Auteuil) just as he is about to go to war, and then for the rest of the movie, whether he is away or at home, she has sex with just about everybody he knows. This could have been the subject either for farce or for an exploration of psychological pathology, but Wargnier instead offers his heroine as a sympathetic, almost noble figure. Clearly something in the behavior and its presentation doesn't add up—until you find out the film is based on Wargnier's real-life memories of his own mother.

Wargnier's kind treatment of Mom may be laudable, in human terms. But what appears on screen rings false: A woman of spiritual nobility and emotional depth who can barely keep her skirt on long enough to cross the street. That mother-love could erode the sense of an otherwise exceptional filmmaker (he made this one in between making *Indochine* and *East/West*) is a nice thought, but the promiscuous-yet-noble take undermines Béart by encouraging her worst tendencies. This is the film that gave Béart the template by which she could mistake sexual display for a manifestation of higher consciousness. It gave her a context for seeing her own allure in grandiose terms, as a kind of existential statement. It granted legitimacy to the impulse toward vanity and inwardness. To tilt matters into the absurd, the film further suggested that to be such a woman was to be archetypal, to be "a French woman." Wargnier did not do this talented actress any favors.

Thus it became possible for Béart to appear nine years later in Anne Fontaine's *Nathalie* (2003) as a sex club dancer and sometime prostitute,

hired by Fanny Ardant to seduce Fanny's husband for some suitably impenetrable Gallic reason. The twist of the film is that Béart, in recounting her trysts with the husband, is in fact just making up stories. But the seriousness and gravity with which Béart gives the sexual blow-by-blow is so outsized and bizarre that you'd think she was talking about some epic and portentous event in human history. And it makes one wonder if this is indeed how Béart sees herself, as a sexual event on that scale. Only the fact that she is beautiful enough that some might be inclined to agree keeps her performance from skidding into hilariousness.

Years later, she would joke at an Ungaro fashion show, "I have a profession where I have to get dressed. . . . Well, I say that, but in the same time I love being naked." It was a charming, self-effacing moment, but one wonders if it might not be literally true when we see her doing a nude shower scene in Téchiné's *The Witnesses* (2007), which seems to exist for no reason but to show that Béart's breasts have gotten yet bigger. But let's not harp on this further. Too often in recent years, complaining about plastic surgery has become a backdoor way for men to make fun of women, usually older women, under the cover of feminism. Nor should we even consider for one second writing off Béart, who has made too many good movies and given too many strong performances to be dismissed or cheaply categorized.

My real interest is in noting, though of course it's a cliché to state it so baldly, that being a film actor is an exceedingly difficult enterprise and that being a film actress is yet more difficult. Aside from the obvious things, that it depends so much on luck and upon the will of others—filmmakers, publicists, journalists, audiences—it's a life that requires constant giving. Beyond the exposure of a personal life led in the public eye, it demands, as well, an emotional life led within breathing distance of a camera—a camera that must always be fed with yet more truth and yet more emotion, at the other end of which sits the world in dull, uncomprehending judgment. Such pressures must inevitably lead, in even the most talented of performers, into occasional perversions. For example, if the public responds to a body, give it a body. It is so much easier than

handing over your soul. But then, over time, the body gets exaggerated and the soul goes into hiding, and something that started as a pure expression becomes distorted.

WHEN A FILM ACTRESS somehow manages to stay pure in that expression, to deepen over the course of time and to stay focused on lasting values—*especially* an actress, more than an actor, because of the extra scrutiny that women live under,—and *especially* an actress known from the beginning as a beauty, because of all the horrid pressures, terrors and temptations of vanity that attend beauty—that is something to note and celebrate. That Juliette Binoche has done precisely that over the course of more than a quarter century in no way reflects poorly on any other actress. But it does bespeak an unusual emotional strength and a clarity of purpose on her part, as well as an optimism about the value of acting and what it strives to represent—the human soul.

In 1999, Binoche would play George Sand in Diane Kurys's *The Children of the Century*. The Sand of Binoche is pale and dark, a politically engaged international artist and a careful observer of people, a person of considerable warmth and charm, but with an obvious reckless streak and a certain appreciation for younger, very pretty men—in other words, a Sand not unlike Binoche herself. The role brought together familiar Binoche elements, her moodiness and contemplation (*Blue*), her audaciousness (*Rendez-vous, Damage*), her vulnerability (*Alice et Martin*), her maternal kindness (*The English Patient*), and her timeless, historically friendly aura (*The Horseman on the Roof*).

One scene is particularly worth mentioning: Sand (Binoche) goes to a party, in her usual male attire, and reads aloud an incendiary tract about the crimes of men and the plight of women. It is a moment of strength, but of distinctly feminine strength. Binoche depicts the passion and commitment behind Sand's words, but also the cost of uttering them. Sand isn't a man, riding roughshod over his feelings and then denying them afterward. She is a woman and an artist, who won't deny her feelings, which are her ultimate strength, but who is at the same time focused on

something beyond herself. The scene strikes me as emblematic of Binoche and a metaphor for her mission as an actress.

But then, there are all kinds of acting missions, and most are equally valuable so long as they're equally true. For example, it is hard to imagine a more inner-directed artist, one more focused on the changing frequencies of her own private music, than the next great actress to emerge in France: Valeria Bruni Tedeschi.

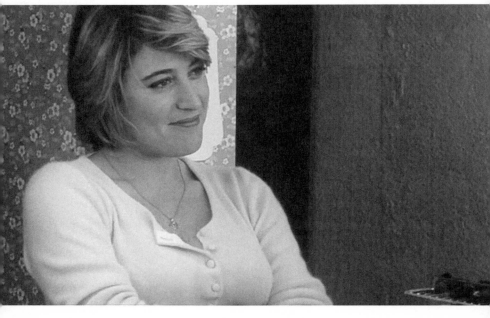

Valeria Bruni Tedeschi in the "God Only Knows" scene from *Nenette and Boni* (Canal Plus), 1996.

4 The Shame of Valeria Bruni Tedeschi

> She's got a wonderful persona—she's very complex as a
> person—troubled—and not shy—yes, she does have a shyness,
> but there's something eccentric about her that she doesn't
> control, and that I find quite amazing to watch.
>
> Charlotte Gainsbourg

1999. The restaurant scene in *Rien à faire*: Guarded for most of the film, a woman suddenly feels secure. She's glad to be with her lover, glad to be in a nice restaurant for the first time in her life, and she keeps telling the waiter that the food was "succulent." She is happy, but to the lover she suddenly seems common, vulgar and embarrassing, because, as played by this actress, she really does seem common, vulgar and embarrassing. And so he breaks it off, and the shame and the shock, as well as the confirmation of suppressed suspicions, are all there on her face.

You are seeing an uncovered soul. You are seeing eyes that catch and show everything and hide nothing. With Valeria Bruni Tedeschi, doubts, insecurities, longing, disdain, a woman's resignation and a woman's joys are there before us, shifting with the ebb and flow of hope and fear. In her futile attempt to deflect scrutiny, she might avert her gaze, look away, laugh awkwardly . . . but on screen Valeria Bruni Tedeschi lives the dream—that is, the emotional equivalent of the dream we have all had, where we look up and realize that we're the only person in the room who forgot to put on clothes.

From her first days on screen, at the start of the 1990s, Tedeschi's characters have radiated an extraordinary degree of humiliation. Tedeschi presents this with a certain comic self-awareness, but with no comic pushing and with little comic intent. She is not neurasthenic—she is strong and elemental, tall and broad-shouldered with an animal vitality and grace. She looks like she could chop down trees and plow fields, and she seems to have the constitution of a horse, but her emotional makeup, saturated with feeling, leads her to playing delicate sensibilities. She is eccentric, idiosyncratic, utterly singular and seems onscreen and even to an extent off screen, as well, to be guided by emotion. At the same time, she does seem in command of her own vulnerability, as well as her own sexuality—which she can turn on like a high beam.

If Tedeschi's body and spirit seem oddly matched, so does the voice—"her sweet voice" (*"sa voix douce"*), a rival says of her, with dripping sarcasm, in the 2008 film *Le grand alibi.* This voice—not weak, not unsupported, but definitely and distinctly high—in combination with her strong, earthy look—might have turned another actress into a comedienne, but Tedeschi has gone in the other direction. Mainly she has specialized in dramas and in characters in the midst of turmoil: professional hardship, guilt, conflicted impulses, romantic confusion, mental illness and, on more than one occasion, all those emotional maladies combined. In such films, she invariably finds some inspired and unexpected moment of humor, because there is something intrinsically funny about her. But hers is not necessarily the kind of comedy you laugh at. Tedeschi's comedy is the human comedy, and all these qualities combine to make her one of the most arresting and endearing of contemporary actresses.

Tedeschi's background is unusual for the cinema and surprising, if you know her only from her films. She was born in Turin, Italy, in November 1964, the daughter of a tire-manufacturing magnate and a concert pianist. Faced with threats by the anarchist terror group the Red Brigades, which was kidnapping the children of wealthy industrialists, the family moved to Paris in 1975, where they lived in splendor. Her father's wealth and business connections put them into ongoing contact with major movers

in government and politics, and her mother's artistic association meant that the children became personally familiar with some of the foremost artists and performers in Europe. One could not imagine a more advantaged childhood.

So Tedeschi has never for one moment known a hint of monetary anxiety. Moreover, she has never experienced what most people live with and helplessly regard as an inescapable condition, the knowledge that one is entirely on the outside of power and will never get that all-important big shot's phone number. The people who run the world, either in the arts or in politics, have never been a mystery to Tedeschi. She has lived in their world, not her audience's, and at the time we spoke—and still as of this writing—her sister, Carla Bruni, was the first lady of France. Yet, just as no one seems more at home in couture and sunglasses and surrounded by luxury than Sophie Marceau, whose father was a truck driver, something in Tedeschi just reads working class.

It's partly a matter of look. Tedeschi is heavy featured and doesn't have the classic appearance of an aristocrat. More importantly, she has a quality of internal struggle, which, when given external form in drama, turns into stories of struggling women. In any case, she has excelled in working-class roles and has been drawn to them. At first this affinity was unconscious, but in recent years she has recognized that these roles are for her a particular strength.

"One day I found out that the characters I did in theater and cinema, there were the working class and the bourgeoisie, like two different sides. And when it was the bourgeoisie—for movies like *La balia, Actresses,* a lot of movies—I feel neurotic and not very sexy. And a little bit, like, *angolosa,*" she said in a 2009 interview for this book. "And when I am in the more popular social class, I feel rounder, *rotunda,* more in contact with eroticism, my sexuality, and more free in my body, more joyful in my body. I found that it gives me freedom to go in a social class that's not mine, where I can feel more myself. It's strange, isn't it?

"The first character I ever did in my life, in a drama class when I was very young, was *Baby Doll.* And I felt the pleasure of being on the stage.

After that I did Nina in *The Seagull*, which was more bourgeoisie, and I felt more stuck in my shoulders. It was not the same feeling."

Perhaps such positive associations with economic struggle could only be held by an actress who was born wealthy. But it's not the whole story. "There is something in the fact of *not having*. To be without anything— that makes the characters in a sort of innocence or lust. For me, there is something, a connection, for a woman, between eroticism and the fact of being poor. For me, it's difficult to feel a rich woman erotic. A woman for me, in my imagination, to be in contact with her body, has to be poor, in a sense—symbolically. To be that she doesn't *have* something. If she is powerful, and she has money, it's as if she has a sex [a penis]. So I have to feel poor to feel like a woman."

In real life?

Laughing: "Of course, I do. In a way, yes."

Tedeschi's first significant role was in *La Baule-les-Pins* (1990), released in the United States under the title *C'est la vie*. It was a working-class role, in which Tedeschi says she felt "free, very free" playing a nanny cracking under the responsibility of watching two children over the course of a seaside holiday. The young Tedeschi, freckly and cute, appears in the film from the second shot on. She has lots of screen time and gets to play opposite the film's star, Nathalie Baye. But best of all, director Diane Kurys grants Tedeschi one moment that gives us a hint of this young actress's singularity.

The moment comes when Odette (Tedeschi) confides to the proprietor of the summer rental that she, in fact, has two children of her own and that they live with their grandparents. What's unexpected is the *way* Tedeschi says this, nodding and with a sly smile, as though this were some ace in the hole, some fabulous distinction that sets her apart. The moment provides a slightly comical and completely idiosyncratic illumination of the character's psychology. It's more than funny. It shows how Odette sees the world and sees herself.

As Tedeschi came into her own and could choose roles and have roles tailored to her, moments of humor or sweetness would often come with

a touch of pain. This sweetness and pain is the essential Tedeschi, which director Claire Denis highlights beautifully in a lovely set piece for the 1996 film *Nenette and Boni*. Tedeschi had a supporting part in that film as a baker's wife, a happy young mother. As the Beach Boys' "God Only Knows" plays over the soundtrack, the baker (Vincent Gallo) watches his wife tidying their shop, and he stops to savor the sight of her. Then the camera switches to Tedeschi, as the wife, as she goes about her business, realizes she is being watched, tries to ignore it, laughs, becomes self-conscious, and laughs again.

Denis captures Tedeschi's gentleness and lovely, awkward humanity in those moments, but something else is suggested, too, a sadness in the midst of happiness, the inability in life to hold on to a precious moment. "I was playing a happy woman—a completely happy woman," Tedeschi said. "And I asked myself what is interesting about happiness? Because usually I try to find the pain of the character, the loneliness of the character, the interior conflict of the character, and this was a happy woman. So I was a little bit embarrassed, because I didn't know how to work, because I need conflict. And then I realized what the problem is with happiness: *It's that we can lose it.* So this is the *fragility* of happiness. We are happy, but inside we are aware that we can lose it."

You can't be in Tedeschi's presence for more than five minutes without being conscious of her acute sensitivity. Though she is not the embarrassed person she often plays in her films—the confident woman she played in *Le grand alibi* rather calls to mind her off-screen manner—Tedeschi seems to have not only strong feelings but a sense of obligation toward those feelings. In an interview setting, this translates into an unwillingness to settle for easy, expected answers. In a quiet way, she is militantly focused on staying true to her perceptions, as though to do otherwise would constitute a betrayal of her wellspring. She is plugged into her own essential current of truth, and that truth, though sprinkled with aspects of comedy and absurdity, is invariably melancholic.

"Life is painful, because it speaks about death. I remember at sixteen years old, one day I saw myself, and I had the feeling I was young but that

I was getting old. I remember at seven years old I was for the first time aware that time goes, that times goes is the pain. Cinema tries to grab time, to stop time, to me it's something against death. But actually I don't like to see myself in cinema, because I see the time, and this I don't like.

"I don't watch [my films] more than once. Even if I am beautiful and young, I think, oh, and one day I will die, you know? It makes me think of death to see me. I don't like to see me, to hear my voice, to see pictures, it gives me a lot of fear. I can't stop myself. When we do a group picture— a picture of a group of people in a restaurant laughing—oh, I hate that! I think, OK, in ten years, who will be alive? It's terrible, it's horrible, I prefer not to have this thought, you know?"

Thus, if you mention that, in the few years since making her first film as a director (*It's Easier for a Camel...*), she has achieved all the things her alter ego longed for—in particular, a husband (Louis Garrel) and a child— Tedeschi says, "Achieve is a little too strong. I am very happy to have a child, but everything is very fragile. Love and work also are fragile. OK, as an actress, as a director, I do things, but it can stop. Nothing is solid."

IN 1993, Valeria Bruni Tedeschi made a film called *Les gens normaux n'ont rien d'exceptionnel* (*Normal People Are Nothing Exceptional*) that won her a César and established her as a major actress. It was a story of mental illness and, not surprisingly, a working-class role. At the start of the film, Martine (Tedeschi) is doing phone sales—smiling nervously, in the way Tedeschi often does when insecure or hostile—then yelling into the phone. The inevitable mental breakdown follows, and she soon finds herself in a sanitarium, where she thrives. Once the craziest normal person in the outside world, Martine is now the sanest person in the nuthouse, and she becomes confident and inspired. Playing mental disturbance, Tedeschi shows great volatility and freedom—by turns seductive, bored, angry, laughing—expressing a flood of emotions without a filter. And though the character uses her romantic wiles on men, and though much of the film turns on our heroine's romantic obsessions and relationships, Tedeschi is decidedly, uncompromisingly unglamor-

ous in this, her first great showcase. She dresses terribly, and her hair is unwashed half the time.

"For years and years, I fought against the glamour," Tedeschi said. "I don't know why. Maybe it was some opposition with my sister, but I think it was deeper than that. I felt I had to—it was not conscious—go into the emotions, the pain."

The pain that Tedeschi goes into is the pain of an open heart coming into contact with implacable reality, but it's less passive than that. It's the frustration of an obstinately sensitive person who feels in possession of some acute understanding the world has no time for. Tedeschi suggests the emotional estrangement of someone who feels more than others. In *Normal People*, when Martine lives with others in the same boat, she blossoms. But most often Tedeschi's heroines find themselves feeling on the outside of things and unable to get in, and the experience they have is one of discomfort, surprise and shame.

Tedeschi's gift for shame is unusual among leading ladies of the screen, but shame and shame's less permanent counterpart, embarrassment, form a running motif in her work. She is only a supporting player in *Mon homme* (*My Man*, 1996), a Bertrand Blier comedy about prostitution, but her big scene is the one to remember. She plays a woman who decides to dabble in prostitution, but having stripped down to her underwear, she can't go through with it. Once again, this very smart, very rich woman is playing someone broke, diffident and slow on the uptake, and she's quite moving—the heart of a film that's otherwise rather arch and coarse.

Embarrassment isn't limited to her poor characters. Guilt and embarrassment underlie, as well, the semiautobiographical role she wrote for herself in *Il est plus facile pour un chameau . . .* (*It's Easier for a Camel . . .*). She played a woman who was born into a wealthy Italian family. As in real life, the family moved to Paris to escape leftist terrorists. Federica (Tedeschi) goes through the film guilty about her wealth, embarrassed by it, and embarrassed, in a sense, by her life, because with wealth comes responsibility and opportunity. "It's about the sense of guilt, the sense of insecurity, the sense of shame," Tedeschi said.

Tedeschi came fully into her own in 1999, with three very different roles to which she gave her own distinct stamp: Claude Chabrol's *The Color of Lies*, Marco Bellocchio's *La balia*, and Marion Vernoux's *Rien à faire*.

For Chabrol, she played a police detective investigating the murder of a child. "In the beginning, I was skeptical. The character was really far from me," she said. "I had to invent a lot of life for her that was not in the movie. I invented a story, the loneliness and all that." Tedeschi created a detective who was observant and sly but at the same time painfully shy and embarrassed to ask questions. So in the film, every time she asks something particularly pointed, she laughs and looks away. And when someone gives her an answer she doesn't believe, she mutters underneath her breath. At first you watch and think this is just bizarre. Then you realize, no, she's Columbo. Behind the awkward style, an incisive mind is at work. This characterization was all Tedeschi's doing, a matter of her taking a standard character and slanting it in the direction of sadness and embarrassment. Perhaps that's what Chabrol had in mind when he cast her.

"I did it by myself," she said. "Chabrol says, 'You decide.' He doesn't say anything. But he's very strong and powerful and doesn't need to say anything. He directs by just being there."

For Bellocchio in *La balia*, she lent her intensity to a turn-of-the-century drama, playing a woman whose painful labor—rendered harrowing in Tedeschi's performance—makes her unable to feel any closeness to her baby. So she hires a nanny to care for the infant. "I love this character," she said. "I remember I had this corset, and I couldn't breathe, and I really tried to work with that. There was this pleasure of being in prison in my body."

Vernoux's *Rien à faire* (*Empty Days*), Tedeschi's first apotheosis, came at the end of the year. The film, which brings together much of what she means and contributes to the screen, concerned an upper-middle-class man (Patrick Dell'Isola) and a working-class woman (Tedeschi) who meet because they both happen to be unemployed. They see each other at the government employment agency and become close over the course of

these empty days. "I loved to do this movie, loved to do this character," said Tedeschi. "I did it with all my heart. It was something that I really wanted to say at this moment in my life."

Tedeschi offers a portrait of a working-class wife and mother who has nothing particularly going for her. The working-class cliché in Hollywood film is that the seemingly average Joe will invariably turn out to be a math genius, but when Tedeschi says in the film, "I've never been good at anything," you know it's true. Daily, she treks to the unemployment office in search of unskilled labor—sales work, housekeeping, a factory job. This woman is special in no way except in her capacity to feel and to give herself.

Rien à faire does a couple of things that the French do particularly well and that modern American cinema hardly does at all. First, it shows the process of two people getting to know each other. (In American films, that's usually handled in a montage.) Second, it deals openly with class differences. In the United States, we tend either to believe class differences don't exist, or that there's something vital and wonderful and true about being broke (so long as it's not us). We also try to tell ourselves that the only difference between wealth and poverty is money. But in *Rien à faire*, class represents a gulf that cuts across every aspect of life. Marie (Tedeschi) dresses poorly. She is uneducated. At one point, their grocery bags get mixed up, and Pierre (Dell'Isola) comes home with cheap food that his live-in girlfriend laughs at. Tedeschi lends Marie the diffidence—the shame—of someone who has traveled in very limited circles and doesn't know how to act. She does a brilliant take when he tells her how much money he made at his previous job: She's stupefied, amused, embarrassed, caught in one moment between imagining he must be joking and taking in that he is someone outside her league. The smile barely leaves her face, and yet you see her concern that she is falling in love with a man from another world.

Throughout, Tedeschi looks and carries herself like someone who has never had a dime and knows she never will. I saw the film long before I knew of Tedeschi's wealth and never would have guessed that this actress wasn't pulling from some personal memory of poverty. Perhaps someone

with greater perception than I might consider that Tedeschi is rather like a poet of the proletariat and that no one who has ever really been broke could find poetry in that. (Sandrine Bonnaire, for example, who is from a working-class background, is less romantic and more matter-of-fact when playing people financially up against it.) Still, I find Tedeschi flawless in this. Especially notable is that way she presents Marie as being less polished in her reactions, and therefore the first of the two to admit what is happening emotionally. There is no line in which she announces that she's in love and worried about it. We just see it, in her second-by-second reactions to him, and gradually in the change in her appearance, from drab to beautiful. There is no makeover. The clothes are still bad. Nothing has changed—except the light has been turned on.

"Life is also like that," Tedeschi said. "People push the button, and we feel the light is there. The glamour is in life. When a woman falls in love, she feels glamour, because she feels something start to move. The glamour is erotic fluid." Tedeschi combines the sexual charge of an Anna Magnani with the stubborn inwardness and reflection of a Monica Vitti.

Rien à faire opened to good, not great, reviews in France and didn't do much at the box office. France may make more serious movies about people and relationships, but the truth is that in France, as in the United States, lowbrow or at least upbeat entertainment is usually the safest bet for bringing in crowds. One of Tedeschi's biggest successes, for example, is a coarse sex comedy called *Ah! Si j'étais riche* (*If I Were a Rich Man*), about a woman who leaves her husband just as he hits the lottery. Actually, it's not all that bad, but Tedeschi says, "It's vulgar. I'm ashamed of this movie. And it's the only one I did [that's] this commercial. The problem is, because I don't do movies like this, I also don't do all the movies with others that I'd like to do. It stops me working with some directors with whom I would love to work."

Tedeschi is not averse to the idea of commercial movies. But throughout her career, she has mainly pursued an art film direction. Twenty years ago, she started taking Berlitz English classes, hoping to work with Woody Allen. "And now he asked my sister—so it's finished." (Carla Bruni had a

small role in Woody Allen's *Midnight in Paris*.) She works with the best auteurs, usually in France, but also in Italy—perhaps a fourth or fifth of her films are in Italian.

"I feel Italian, but I also feel French," she said. "Italy is deeper. France is strong, but it's after." Actually, one of the surprises about meeting Tedeschi is how Italian she seems. Though she has no trace of an Italian accent when speaking French—and says that, in Italian, she shows signs of having lived in France—she sounds Italian when speaking English. There is no suggestion of French at all.

Tedeschi does not seem like someone who could consciously phone it in or do a film that she thinks is bad and feel sanguine about it. She craves an authentic experience—something she discovered years ago, as a student of director Patrice Chéreau, who cast her as Sonia in *Hotel de France*, an adaptation of Chekhov's *Platonov*.

"It was the first time I experienced the joy of being in front of a camera. Something surprised me very much in the scene, where Sonia sees Platonov after years—and doesn't recognize him. She speaks of Platonov—'Oh, I knew a Platonov'—and everybody laughs, because he's there, he's looking at her. It's a very beautiful scene, and I started to laugh after saying something. And we continued the scene, and this laugh—the panic and trying to control myself. I think for me this was really the first—like you make love for the first time, or something very, very strong.

"It was amazing. The experience of this scene. Its heart is what I want to find in doing my work."

Sandrine Kiberlain in *Rien sur Robert* (France 2), 1999.

5 Sandrine Kiberlain

S ANDRINE KIBERLAIN—who made her first notable ap-
pearance at the side of Valeria Bruni Tedeschi in *Normal
People*—has been a major, award-winning French actress for the better
part of two decades. But many Americans didn't make her acquaintance
until the 2010 release of *Mademoiselle Chambon,* the story of an elementary
school teacher who falls in love with the father of one of her students.

To discover Sandrine Kiberlain is to encounter a singular talent, an
actress with the thin grace of one of Modigliani's women and a face that
can go from plain to delicately sensual with a look. Her conscious reserve
is matched by a startling animal acuity. We sense and witness the sharp-
ness, sometimes the harshness, of her judgments and perceptions. We also
experience her most delicate feelings, even as she seemingly refuses to
show them—even as she seems to be wanting to stay safe behind a barrier
of rationality so as to lessen their sting and stay in control.

Mademoiselle Chambon called upon Kiberlain to suggest a past of
heartbreak and disappointment but without any specifics, just hints, in
the script. Stéphane Brizé, who directed and cowrote the film, knew his
screenplay called for an actress who could rise to its very specific re-
quirements and make a virtue of them. "I thought of Sandrine first and
foremost because this is a role that has so little dialogue in it, and I really
wanted to find an actress to be able to explain who she is through the
silences," Brizé told me in a 2010 interview. "Only a great actress such
as Sandrine Kiberlain could really nourish from the interiors the silences
I had in the screenplay."

As we infer from Kiberlain, this woman, Mademoiselle Chambon—first name, Véronique—once had dreams of becoming a professional violinist, but now she will only play for someone with her back turned. She is intentionally rootless, working every year as a teacher in a different part of France. At the same time she is perfectly functional, kind and intelligent, and clearly a good teacher. Though a perceptive viewer will recognize the rueful undertone, there is also a quality of understanding in her bearing that suggests that everyone's life has disappointments, and so there's no point in making a fuss about her own. Here, as in virtually all of her dramatic parts, Kiberlain plays a woman who feels great emotion, who surrenders to great emotion, and yet who essentially distrusts it and does her best to hold it at a remove.

So what a wonderful accident that Kiberlain's first, tentative footstep into cinema history should have found her next to Tedeschi, her equal in talent but her opposite in temperament. In her bit role in Tedeschi's breakthrough, *Normal People*, she appeared in two scenes as the new girlfriend of the man who has recently dumped our heroine. As such, Kiberlain experiences Tedeschi's rage in her first scene, watching with an ironic distance that seems in no way studied. Much later in the film, in her second and final scene, Kiberlain sits on a park bench and watches—with a combination of put-upon patience and suppressed irony—as the unbalanced Martine (Tedeschi) harangues her on the meaning and splendor of love. Watching the scene today, it's impossible not to have in mind that both actresses were at a turning point in their lives, at the dawn of great careers, just months or short years away from high professional honors and public recognition. And there they were, playing exaggerations of their future selves: Tedeschi, whose emotion is her guide and glory; and Kiberlain, for whom emotion is something private and a challenge.

But even forgetting hindsight, even if this were 1993, I believe you would still notice the unknown Kiberlain and wonder about her. Her intelligence and self-possession, her specialness, are too much in evidence. To be that indelible, she would clearly have to be either a real actress or

no actress at all, perhaps a fascinating natural the director happened on. The one thing she could not be is generic.

In the years that followed, Sandrine Kiberlain would specialize in playing women of wit, composure and inner fire. The Kiberlain heroine is not mercurial, but cool; not visceral, but intellectual; not self-serious, but ironic. Yet she is almost invariably reckless, consciously and methodically so. She knows what she wants and fully understands the probable consequences of going after it. In some cases, she'll even observe her situation with sardonic detachment. But whether sardonic or anguished, the Kiberlain heroine will almost always do the daring, irrevocable thing. And she won't succumb to self-pity. This willingness to be unpleasant rather than to show weakness, to be smart, defiant and aware and to move forward in life, always forward, strikes me, for want of a better word, as distinctly modern.

Sandrine Kiberlain was born in 1968, a year of revolution in France. Her grandparents were Polish Jewish immigrants, which means that for some of her childhood, Polish was the language spoken around the family table. On her father's side, "my grandmother was the Sarah Bernhardt of Poland," she said in a 2009 interview for this book. "I think it's not true, but for her it was true. They were from Poland and when I started this job, they could have been shocked or opposed." Instead "for them, it was the realization of a dream."

Between 1989 and 1992, Kiberlain attended the Conservatoire National Supérieur d'Art Dramatique, whose alumni included heavyweights such as Nathalie Baye, Isabelle Huppert and Juliette Binoche. "I felt the need to go to the biggest, most important acting school to be credible in the eyes of my family. And for me, school was good. Being in the scholarly structure, I could let out my wild side. I never attended all the classes, but I went to the scene classes, to discover what I like to play. Towards the end, I got chosen for *Les patriotes*."

Les patriotes (1993) was for Kiberlain what *Normal People* was for Tedeschi—the beginning of everything—yet for those familiar with the rest of Kiberlain's career, her debut may come as a surprise. It is, indeed,

a role that might have shocked anyone's grandparents. She played a call girl in a role that is very exposed, that calls upon her to be completely naked and sexual. Yet she brought to it touches of what would become her signature irony. She may seem too self-mocking to be a prostitute, too willing to laugh at herself or, worse, one might imagine, at her customers. But that surprising extra something is precisely what attracted director Eric Rochant over the course of the auditions.

They were lots of them. "It was a big budget movie, and they didn't want a beginner. When I was chosen by the director, the producer and these other people were looking for someone who looked like a typical call girl." But the director said he wanted Kiberlain, "'because,' he said, 'I want someone with a soul.' It was astonishing—in my life, I'm the opposite of this character. But it was *super* because when we went to Cannes, people said, 'wow, it's not the same [woman].' Usually the first role is more like *us*. This was interesting for me because this first role demanded the talent of an actress, to become someone else."

Though Kiberlain's screen time in *Les patriotes* is comparatively small, she hovers over the bulk of the film, which mainly concerns the career of a young Mossad agent (Yvan Attal). The call girl crawls into the head of the young agent by flirting with him. Later, we see her showering, dressing and leaving the hotel room in the morning, and something in the alert, unclouded quality of her movements, tells you how this woman sees herself, that this isn't someone vain or self-conscious or born to this life. She is more like an amoral college student working to pay her tuition—or a slightly twisted graduate student studying human sexual response. She seems too smart for the life she has, and it's this quality that allows her to linger in the viewer's mind when she disappears and is assumed to have been murdered.

The unconventional placement of Kiberlain in this role—her un-call-girl-like quality—makes us believe that she would possess the imagination and torment the conscience of the Mossad agent who unwittingly placed her in danger. In a sense he is responding to what we are responding to, the arresting originality and moral proposition that is stardom.

SANDRINE KIBERLAIN says her acting is "an encounter" between herself and a character. "I become the character. I put myself in the position of the character, how she lives her life, what she feels. Each time I defend their personality and find reasons for their actions. Nothing is haphazard and nothing is gratuitous."

This approach—of defending a personality and finding reasons for a character's behavior—is quite literal in Kiberlain's case. What she arrives at isn't merely a subjective, internal understanding of how a character feels and thinks. Rather, the encounter between herself and the character becomes a kind of negotiation, in which Kiberlain finds reasons for the character's behavior that she, herself, would find plausible and justifiable. This process has a significant emotional component, to be sure. She is asking herself how she would feel if she were that person under those circumstances. But she is also stepping aside and acting as a kind of advocate for the character's point of view, coming up with reasons for why this person's actions might be right—not only from the character's own viewpoint—but from a rational, impartial perspective, that is, Kiberlain's own. That's the negotiation that Kiberlain is talking about.

Thus, Kiberlain on screen is never like an Isabelle Huppert heroine, who will do the reckless thing because she knows it's wrong, out of sheer perversity. Nor is she particularly like Juliette Binoche or Sandrine Bonnaire, who will do the reckless thing because they know it's right. Neither is she like Emmanuelle Béart, who will do the reckless thing because she is too irritated to be bothered about right or wrong. And she is certainly the farthest thing from Valeria Bruni Tedeschi, whose moral imperative consists of acting solely in accordance with her emotions, who would consider it a betrayal to do anything else. Rather the Kiberlain heroine does the reckless thing in full awareness that she *might* be doing wrong, but with a set of worked-out reasons that justify her actions in her mind.

You might think that such a process would result in turning poetry into prose, in confining airy, imaginatively expansive characters within rigid dimensions. But in practice it doesn't work that way. In actual effect, Kiberlain's approach takes characters that might have been vague and

makes them rich and morally dimensional. That was the case, on a small scale, with *Les patriotes*. But it has been further the case, in a bigger way, with any number of films in which Kiberlain has starred—for example, *À vendre* (*For Sale*, 1998). In that film, Kiberlain again played a role she considered "*tres loin*" (very far) from herself—"very savage, very physical, like an animal, and very lost." But Kiberlain says she "felt for her."

À vendre depicted a mysterious young woman who leaves her parents and her rural background and embarks on an aimless, disconnected life, full of poverty, loneliness, and odd, sexual adventure. In preparing for the role, Kiberlain first found "her clothes, her rhythm." She then decided that this woman "was not inhibited, she didn't mind exposing her body." At the same time, Kiberlain saw her as "always on the defensive. I felt I had a very good understanding of the pain and suffering of this character." First, Kiberlain comes into an understanding of the character's emotions and viewpoint. Then she funnels the character through her own sense of justice and her own even-keeled personality.

French cinema, at its most tiresome, has a weakness for propositions in place of character, for mysteries that are essentially empty, which are then offered as vague testament to the unknowability of the human soul. That *À vendre* doesn't go in this direction has much to do with its writer-director Laetitia Masson, but don't discount Kiberlain, who is the one holding down the fort moment by moment, grounding the character in psychologically valid detail. She invests in this character a reserve that suggests a lack of trust, which becomes, in itself, a philosophical statement. Through Kiberlain we recognize someone who is angry, who has been hurt and who is damaging herself in response.

Kiberlain has a smart and telling moment early in the film: A man picks her up and brings her to a hotel airport. He is going to be flying out of the country the next day, and he offers to take her with him. But when she wakes up in the morning, he's gone—and she barely reacts. There is a hint of disappointment, but no tears, and her bland, unpanicked reaction tells you everything—that this is someone who expects nothing from the world, at least nothing good. Later, she meets a man she likes; they go on

a pleasant date, and that night, just as they're about to go to bed, she tells him she wants four hundred francs. Heretofore, she has not been a prostitute, and she is not after the money. Rather, she is afraid to be happy. So she wants him to pay her for the happiness that she can give but is afraid to have, or lose. Again, this psychological detail is very much Kiberlain's devising. Instead of inflating and abstracting the behavior—instead of giving us another tortured French mystery woman—Kiberlain exalts the character and our perceptions by grounding her actions in tangible, specific thought and emotion. And by showing the character resisting feeling, Kiberlain allows us to see this woman as truly damaged and to infer and reflect on the possible causes of the damage.

She took a similar approach a few years later, playing a completely different personality in *Tout va bien, on s'en va* (*Everybody's Fine, We're Leaving*, 2000). The film was about a father (Michel Piccoli) who returns to see the grown daughters whom he'd abandoned many years before. As the oldest of three, Kiberlain is the most angry and strident—she is almost cruel. And despite opportunities that another actress might have found irresistible, she doesn't show us the character's pain. Instead she shows us what is *defending* the pain—and the defense is so outsized that we infer the pain is great, something far greater than any little scene of rueful introspection could have conveyed. "The character is not a bad person," Kiberlain said. "She would like her father to tell her things he never told her and show her a little love. Her sadness makes her hard."

On screen, Kiberlain can be arch and caustic, or sometimes cold and austere. So meeting her in person is a pleasant surprise. She has none of the defensive or ironically covered quality she often projects on screen. She is tall and thin, and on the day we met she was dressed in what might almost be called business attire. If you were to meet and talk to her about something unrelated to her career in film and music (she has recorded two CDs of original material), you might not immediately guess her to be an artist. Her demeanor is more like that of a creative young executive. She is very relaxed and on this afternoon she conveyed a reassuring sense of having all the time in the world to talk. Though she speaks little

English, she seemed to me much like an urban, professional American woman, socially aware and very smart. Of course, I should have realized she could not be the caustic characters that she plays in drama, but the person sensitive enough to key into their pain—as well as open and witty enough to excel in comedy.

Kiberlain's intelligence, unmistakable on screen and off, has been an essential aspect of her appeal from the beginning. Think of her first close-up in *Beaumarchais the Scoundrel*, playing opposite Fabrice Luchini, in his great role as the famous eighteenth-century playwright, politician and ladies' man. We find him in an early scene in the midst of a flamboyant duel. He drops his sword—Kiberlain picks it up and hands it to him—and they take each other in for the first time. Kiberlain made the film when she was twenty-seven, but she looks at Luchini with complete understanding, as though she adores him but also knows him—his charm, his brilliance, his weak moral nature. And he does a double take. Kiberlain said that her character's ability to understand Beaumarchais had its real-life parallel in her interaction with Luchini, many years her senior and a dazzling comic actor. "Sometimes I have a feeling I have lived other lives," Kiberlain said. They worked equally well a few years later in the comedy *Rien sur Robert* (1999).

When you contemplate Kiberlain's performances, it's astonishing how much we derive from her without specific corroboration by the script. I mentioned this quality in connection with *Mademoiselle Chambon* earlier. Two scenes in that film deserve special mention. The first comes in the aftermath of a first kiss between Veronique (Kiberlain) and Jean (Vincent Lindon), the married construction worker with whom she forges an intense bond. She surprises him one day on a job site and finds him standoffish. Seemingly in passing, but not really, he mentions that his wife is pregnant. Kiberlain's smile freezes, her eyes widen, and you know, just by this minimum of means, that her world has imploded. The second example comes in a scene in which Veronique tells her boss that she wants a transfer. As the principal tries to talk her out of it, Kiberlain listens and smiles and not a hair is out of place, and yet it's clear to us that she is

about to fly to pieces. So much of what critics praise as subtlety is often vagueness, a lack of generosity or commitment on the part of an actor. But Kiberlain is subtle in the true sense, of communicating greatly with the gentlest of touches.

In real life, Kiberlain and Lindon are divorced and have a ten-year-old daughter. When I interviewed Vincent Lindon in New York, I asked him what he thought of his ex-wife's work. "Because I'm far from France, I can say what I want," he said. "I think she's one of the two or three best actresses in France and maybe, for me, the best one."

This is not to say that Kiberlain is transcendent in everything. Her strident screen quality can be misused by lesser directors working with lesser material, such as in *A Little Game of No Importance,*a just plain bad movie by the late Bernard Rapp about a husband and wife (Kiberlain and Yvan Attal) who pretend to be divorcing and then end up estranged in reality. It's also true that too many of Kiberlain's films between 2002 and 2008 would fall into the category of near misses—films that were either weak or did not exploit Kiberlain's potential.

"I think she doesn't work as she should work because she is very clever," Lindon said. "She has an idea about everything. And sometimes directors are afraid of actors. When an actress is a little bit too clever, they feel like, 'I can't do what I want—that one might say things.' With an actress less clever, they are free to do their stuff. And Sandrine is like, 'Do what you want, but I'm not stupid. I see what it's about.' Some directors don't like that. It's too heavy for them."

Kiberlain recorded her first successful album of original songs in 2005 and released another in 2007. Following this *"moment de folie pour la chanson,"* as she puts it, she returned to her acting career in earnest, and appeared in three films in 2009, two of which—*Romaine par moins 30* (*Romaine at 30 Below*) and *Le Petit Nicolas* (in a supporting role opposite comedienne Valérie Lemercier) were comedies. Like Nathalie Baye, Kiberlain, though essentially a dramatic actress, can throw herself into farces (such as Jeanne Labrune's 2002 film, *C'est le bouquet*) with wholehearted abandon. Her skill is impressive: In *Romaine par moins 30*, she has a fear-

of-flying panic attack on an airplane that she plays for truth—the terror seems real, she is in agony—but the distress is ticked up just a notch, or half a notch, just enough that it becomes funny.

Yet if we are to discover the essential Kiberlain, it's best to look first in the direction of her dramas, among the most emblematic of which is Claude Miller's *Betty Fisher et autres histoires*, known in the United States as *Alias Betty* (2001). Kiberlain played the title character, a successful novelist who was abused as a child by a narcissistic, emotionally unbalanced mother (Nicole Garcia). Now her mother has come to visit her, and on the day Mom arrives—crazy as ever—Betty loses her son in a tragic accident. And so the mother, unbeknownst to Betty, kidnaps a little boy from the slums and brings him home to Betty, claiming it's the son of friends on holiday.

Alias Betty arrived at a fragile juncture for Kiberlain. "I often get roles that correspond to things that have just happened in my life," Kiberlain said. "I had just become a mother when I played Betty Fisher, and it's very private to explain these things. When I had my daughter I lost my father—very emotional—and then to play Betty Fisher who loses a child. Claude wrote the story when I was pregnant. Six months after giving birth, we filmed the movie. For a young mother to play this story, it's incredible. Certainly, all the feelings got mixed up. Although I insist that I only thought about the character, unconsciously these things come into play."

On top of this she was physically exhausted and looked it. "When I did *Betty Fisher*, when I had my daughter, when I lost my father, I also had a very big cerebral accident." (Kiberlain describes this as not a stroke but an incident of dangerously high blood pressure brought on by her pregnancy.) "I was very tired."

Whatever the context, the result was a perfect meeting of an actress and a role. As the daughter of a woman enslaved by emotion, who used her emotions as a bludgeon, Betty is cool and reserved and writes novels in which emotions are analyzed from the safe remove of a private study. She became an expert observer originally out of necessity, in order to survive and navigate around a mother who could at any moment turn violent.

Thus, out of this pathological environment, a novelist was born, and thus, once again, we have Kiberlain as the woman who distrusts emotion but finds herself in the grip of it—her scenes of grief are restrained but very much felt. And thus we have Kiberlain as the seemingly reasonable woman who, when the time comes to make a decision, takes the leap: When she finds out that the little boy has been kidnapped (from a neglectful, awful mother), she doesn't give him up. She *almost* does. She brings him to the nearest airport, attaches a sign to him and starts to walk away. But at the last moment—at the last possible moment—she runs back to him, scoops him up and resolves to raise him as her own.

That is the Kiberlain moment. That is something lovely and strong that Sandrine Kiberlain brings to the screen. Her portraits of modern, sensible women celebrate intelligence and rationality, skepticism in the face of hysteria, and the refusal to give into weakness. At the same time, when it matters, when it means something, Kiberlain always moves in the direction of life and risk with the courage to face the consequences.

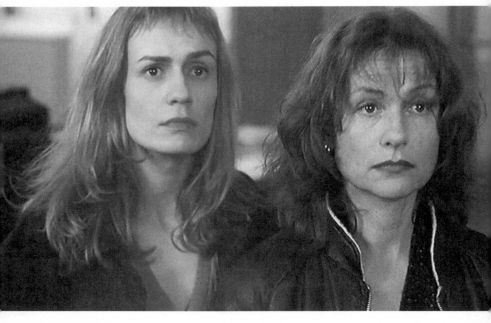

Sandrine Bonnaire and Isabelle Huppert in Claude Chabrol's *La Cérémonie* (France 3), 1995.

6 Sandrine Bonnaire, Isabelle Huppert, and *La Cérémonie*

> Sandrine is a great actress because she never approaches a part in a cerebral way. Her working tool is intuition; she takes inspiration from her own experience and feeds her characters with her personal emotions. She is the very embodiment of sincerity; she is never afraid of being absolutely sincere; she never takes cover behind a trick or a mask. She is a first-take actress; she is spot on right from the beginning. Working with her is an impressive experience, because you have the impression everything comes easily, spontaneously. Her work never shows. She is one of the best persons I have ever worked with.
>
> Patrice Leconte (*Monsieur Hire, Intimate Strangers*)

THE DEEPENING of Sandrine Bonnaire's essence over the past quarter-century has to be counted among the glories of contemporary film. Her development shows once again the uncanny capacity of cinema—without anyone consciously striving for it, with all participants, really, just out for themselves and pursuing their own separate short-term dreams—to nonetheless bend, adjust and configure around the invisible vibrations and movements of an artist's soul. Thus, after a period of years, one can look back on the work and have the illusion that, once upon a time, all anybody in the French film business ever wanted to do was to figure out ways to help advance Sandrine Bonnaire.

We saw in an earlier chapter how Bonnaire emerged as a teenager with a precocious truthfulness and a capacity for concentration before the camera that made the industry and audiences take notice. Her naturalness and youthful abandon were discovered and promoted by Maurice

Pialat in *À nos amours*, then exploited in *Tir à vue* and, ironically enough, in Pialat's own *Police*, until Agnès Varda, with *Vagabond*, recognized an actress in Bonnaire and not merely a phenomenon. For most of the rest of the 1980s, Bonnaire found herself most often playing engaging or appealing women with something skewed in their moral nature. In *La puritaine* (1986), she has a strained and tortured relationship with her father. In Pialat's *Under the Sun of Satan*, she was a woman who murders her lover and seduces a priest. In *Jaune revolver* (1988), she was a hostage who kills a bank robber and keeps his money. In Claude Sautet's *Quelques jours avec moi* (1988), she was a waitress forced to have sex with customers. Something about the combination of Bonnaire's youth and easy lack of self-consciousness was being interpreted as (or being transmuted into) moral obliviousness in the imagination of her early directors.

An important turn came in 1989 with *Monsieur Hire*, Bonnaire's first film for director Patrice Leconte. It concerned a voyeur (Michel Blanc), who, spying from across a courtyard at a careless young woman (Bonnaire), realizes that she and her boyfriend are covering up a murder. When she realizes that Monsieur Hire knows everything, she goes out of her way to charm him, and though he knows exactly what she's doing, he falls in love with her anyway. The unexpected climax—the great injustice that befalls our hero—comes when she plants incriminating evidence in his apartment, guaranteeing her boyfriend's safety and Monsieur Hire's ruin.

The curious thing is how Bonnaire plays the moment of betrayal. She is supposedly just a young sensualist, but we get the sense of an evolving conscience, so that we almost don't believe that she would do this. Deceit does not go easy with Bonnaire. It's not her natural terrain, though in casting her this way, Leconte accentuates the tragedy. It's not only that something terrible has happened to someone who doesn't deserve it but also that a young person, who could have gone the other way, has just gone over the speed bump that separates good from evil, and now there is no turning back. Just as this woman was about to recognize something deeper in herself, she turned from it, committed an irrevocable treachery, and, in the act, lost herself forever.

I'm talking in moral terms, but then morality—not necessarily traditional or conventional morality, but considerations of morality, issues of integrity, truth, emotional honesty, and empathy—would be at the heart of most of Bonnaire's subsequent work. Leconte, with his sensitive understanding of actresses, with his unfailing capacity to fall in love with who they are, saw that quality in Bonnaire and how it could elevate a thriller into something approaching a double tragedy. Think, for example, how a lesser actress might have played that role—as a femme fatale. Think also of how the young Bonnaire might have played it in the hands of one of her earlier directors—as heedless, oblivious and amoral. Leconte saw something else and, even if what he did revealed itself only in hindsight, he let Bonnaire be Bonnaire.

Monsieur Hire was the first hint of this direction in Bonnaire's career, which I see as a slow and constant movement from flesh to spirit. Directors might thereafter still cast her for her physical exterior, but the revelation would almost invariably reside in what is intangible and meaningful beneath the surface. In this way, the English-language film *La peste* (based on the Camus novel), with its clinical preoccupation with physical vulnerability, is fascinating in terms of Bonnaire's growth, though it must be said that it's far from of one of her best films and that Bonnaire herself hates it: "It's a very bad movie. Not very good, no. Oh, my God, it's a very bad movie. It's so far from the book, but far *not* in a good sense. There *is* no sense."

(This is as good a place as any to mention that French film stars are never shy about announcing which of their own films they dislike. If you like a film that they don't, they will even try to talk you out of it—and look at you with pity if you persist in your delusions. Such honesty is unheard of in America, where film actors never say anything bad about any film they've done, out of fear of creating ill will that might backfire down the line. In France, it's simply understood, or at least it's understood that one should *pretend* that it's understood, that artistic excellence is the most important value and the goal behind every endeavor. That the French actually care about whether their movies are any good—or at least care enough to pretend they care—is a refreshing difference.)

In the case of *La peste*, perhaps the kindest and truest thing that can be said for it is that director Luis Puenzo had a weak script and a weak handle on the material, but a native instinct for Bonnaire. In one scene, he gives us a close-up of her grieving face sandwiched between two male faces, a shot prefiguring one of the strongest moments in the magnificent *East/West*, made seven years later. In an early scene, as a television journalist caught in a South American city during a plague, she tells a doctor (William Hurt) that she believes in nothing but the body. Then later she tells him that she no longer feels that way and is embarrassed by her own words. Bonnaire could be talking, in these moments, about the progress of her own career. In between, we get a bizarre and haunting scene, a kind of celebration/renunciation of the flesh, in which Bonnaire—terrified that she already has the plague (she doesn't)—strips before a camera to make a farewell video for her lover back home.

IT'S ONLY BECAUSE Sandrine Bonnaire's work is so true and authentic that we don't think of her as a grand-scale, swing-for-the-fences actress. But consider, for example, the key scene in Chabrol's *Au coeur du mensonge* (*The Color of Lies*) and the complicated emotions she is required to play: She is the wife of an artist (Jacques Gamblin) who hasn't painted a portrait in years. She has just come back from a night in which she turned back from the brink of adultery. The husband doesn't know this. But at one point, he suspected it, because when she walks into the house she sees the painting he has been working on all night: A nude portrait of her about to go to bed with another man.

Think of all that Bonnaire must bring to that moment. She feels guilty as she comes through the door and is surprised by the painting, which she assumes is an accusation. At the same time, she recognizes the painting as both a tortured avowal of love and the best work her husband has done in years. And then, she sees the husband and has to gauge his reaction. How much does he know? How does he feel? She asks who the man is in the painting. The husband says, "Who cares?" She bursts into tears. So much is happening at once that the scene cannot be scored intellectually,

beforehand, as a succession of specific thoughts or emotions. It has to be inhabited emotionally and instinctively, so that many thoughts and many feelings are occurring simultaneously.

In *La soleil me trace la route*, a fine book made up of interviews Bonnaire held with authors Tiffy Morgue and Jean-Yves Gaillac, she says that when she looks over a script for the first time, she takes note of where she is going to be called upon to perform a "triple axel." The immediate example she is thinking of is the remarkable scene from *East/West*, in which she plays a French woman stuck in postwar Stalinist Russia. Her only hope of escape is for a young swimmer of her acquaintance to defect and then campaign for her release. But the young man can't defect unless he wins a qualifying race to make the Soviet Olympic team.

Director Régis Wargnier staged the race for Bonnaire to shoot her reactions. "I told her line four is freedom, line five is prison," he says on the on the commentary for the *East/West* DVD. "And what she does is really extraordinary." Bonnaire watches with a life-and-death attentiveness, and when her friend wins, there is an amazing convulsion of emotion, an exultation that looks like agony and is informed by all that has gone before, all the years of pain and terror. It was a first take.

I must say that, unique among all the actresses working today, in France or America, Bonnaire makes me wonder what it must be like to direct her in such moments: the stress it must engender, a thrill akin to terror, to look into a monitor or through a camera and see a masterpiece being sculpted out of thin air—and to know that if only someone doesn't cough, or drop something, and if a light doesn't explode, this is going to exist forever. The scene just described in *East/West* is just one such moment. So is another scene in *East/West*, in which Bonnaire is released after years in prison. The camera zooms in on her face, and stays there, as she hugs her husband and her son, with a mix of happiness and anguish and the full weight of experience. If you're an actress who can do triple axels, filmmakers start writing triple axels into their scripts.

Here is one more triple axel, of many, but this one must be mentioned: It forms the climax of *C'est la vie* (2001), a film never released in the

United States, because its premise is so uncommercial and uncongenial to American tastes that it sounds like a parody of a foreign film no one would want to see: It's about a hospice volunteer (Bonnaire) who falls in love with one of the dying patients (Jacques Dutronc). To make things even less commercial in a nation such as the United States, where death is considered the ultimate social disadvantage, the movie was filmed at a real hospice, with real hospice residents as extras. Unlike most American films about love, which skip the getting-to-know-each-other part, *C'est la vie* shows the two growing slowly into mutual understanding, affection and intimacy. By the time they are ready to admit their feelings, sex is no longer a possibility. But the bond is there, leading to the great scene in which she sits by the bedside, very near the end, and he struggles in and out of consciousness, trying to say a few words to her.

No description can do justice to the fierceness of Bonnaire's concentration and focus in this scene. She brings everything to it—this widow's history of bereavement, her intimate knowledge of the death process and of how close he is to the end, and love. Slowly, imperceptibly, director Jean-Pierre Améris moves in closer on her face, and in a beautifully framed shot, Bonnaire puts her hand on Dutronc's cheek and, with a smile that's gentle and almost shy, tells him, "*Je t'aime*" for the first and last time.

"It was very powerful to do it," Bonnaire said in 2008. "We had some real people, sick people on the set, and we lost two or three of them during the shooting. They were talking to us all the time, and it was very powerful, because all those people, all of them, said, 'We are at the end of life, but we are still *in* life, so we live life very deeply.' It was very essential for them, these last moments of their lives. So we were nourished by that all the time. We were listening all the time to the farewell of life—we knew that—and it was very strange—because we were playing that, it wasn't real. Yet we knew that right beside us we had people for whom it was real. We didn't have the right to lie."

We didn't have the right to lie.

People like to talk in superlatives about who is the greatest in the various fields of endeavor. Such things are easier to measure in sports

than in acting. What do you measure? Versatility and range? Emotional power? Longevity? Body of work? But of Sandrine Bonnaire two things can be said definitively: No one can do what she does. And no one could be a better custodian of that which she does. Bonnaire practices the art of acting as a humane calling.

IN 1995, Claude Chabrol brought Sandrine Bonnaire and Isabelle Huppert together for what turned out to be the actress pairing of the decade, *La Cérémonie*. Huppert came into the film as one of the most prolific, artistically ambitious and accomplished talents in France. Now in her early forties, she had, it can be fairly said, created her own brand and genre in the international cinema. Through repetition and variations on a theme, she had established what might be called the "Isabelle Huppert film," a flexible entity but one usually centering around a difficult, somewhat withdrawn, usually courageous woman who, without overemphasizing in any way the state of mind that might provoke such an act, does something extraordinary, sometimes difficult and often appalling. Huppert, it must be said, insists that she did not consciously strive to make a certain type of film ("so thoughtful, or so cerebral or so tragic or so whatever") or to craft a particular screen persona. "I just have this little ability to bring this kind of feeling to the surface, but I never knew where it came from. I guess it mainly has to do with the kind of people I've been working with, so it creates a whole image." In any case, the image was created.

Huppert's work is vast and of high quality and can be studied endlessly. But even a cursory discussion of career highlights leading up to *La Cérémonie* must make mention of *Story of Women* (1988), also directed by Chabrol, a subject they turned to after discovering that their initial idea, to make *Camille Claudel*, was already in the works with Isabelle Adjani. Another fact-based tale, *Story of Women* is about a wife and mother who ran afoul of the government in Nazi-occupied France for performing illegal abortions. As such, it's rather like the anti–*Vera Drake* (the Mike Leigh film about a saintly, dimwitted abortionist in postwar London). Marie (Huppert) is an unfaithful wife, physically revolted by her poor,

shell-shocked husband. She has never had anything, but after figuring out how to give her next-door neighbor an abortion, she realizes the monetary potential of this new enterprise. She leases a room in her house to a prostitute. She makes friends with Nazi collaborators. She is a strange creation and a piece of work. In one scene, people show up at her house and tell her that an unsanitary abortion she performed has resulted in a woman's death. She remains blank-faced, as only Huppert can, and it's not the blankness of someone who cares deeply but won't reveal it. It's the blankness of someone who doesn't care at all but knows she can't say it.

Yet when she gets arrested and convicted, she becomes sympathetic, not only because the legal system is made up of collaborators trying to demonstrate allegiance to Nazi eugenics ideology. She becomes sympathetic because her selfishness, naiveté and immorality are at least true expressions. We admire her for having the courage to be herself—and marvel that it doesn't occur to her to be anything else.

What is the meaning of a career such as Huppert's? She presents us with perversity and dares us to make a personal connection. She dares us to enjoy it, and we do. From *Going Places* on, she has given us portraits of pristine entities of strangeness, people who can be understood but not explained. She shows monsters who are not monsters and yet are monstrous. Her women are insistent. They refuse to be ignored, or to make terms with us, or assume the subtly reassuring shape of characters in a film. Huppert won't even use the word "characters" for the entities she plays. She prefers "states" or "persons":

I always felt that the notion of a character was something diminishing for me. It draws an arbitrary contour to a person. It just imprisons you in something arbitrary. I'm always interested in being myself. What you want on-stage or screen—you don't care about the character. You want life, a real person. That's why I always managed to create that exact encounter or fusion between me as a person and the character. That's what I'm interested in.

This approach shows a philosophical sophistication, beyond its implicit understanding of artistic truth and audience response. Yet I imagine

it arises mainly out of Huppert's recognition of her particular abilities. She is not a screen chameleon. True, she is not without versatility—she can be quite funny, for example. But she plays versions of herself; she is a personality, albeit a complicated and distinct one. Ultimately, the greatest thing she brings to the screen has nothing to do with philosophy or morality, but is rather the record of her questing, unique and indelible consciousness.

Like anyone, she has limits. Her *Madame Bovary* (1991), also for Chabrol, is too coldly observant for a woman driven by impulse—she just seems mean. But her skills are wide, and she can play against expectation, as in *Love After Love* (1992) in which writer-director Diane Kurys uses our previous knowledge of Huppert to make us believe that she is the offending party within a marriage, then reveals that she is in fact the victim of her husband's colossal and ongoing infidelity. The role is a study in private suffering, a familiar theme in Huppert's work. When she herself has an affair, it ends with her standing in a hotel lobby, desolate and dumbfounded, watching from a distance as her unwitting married lover cavorts happily with his kids.

Yet it is a curious thing about Huppert: We can say she is "desolate and dumbfounded" on screen, because that is what her performance communicates. But roll the film back, and she barely moves a muscle. "She has the invaluable gift," Chabrol once said of her, "of being able to convey emotional upheaval without any change of facial expression." Of her ability to convey it, there can be no doubt. But what is it that we're actually seeing? Is this emotion or an actress's consciousness of the medium, a consciousness experienced enough to know that if she stands perfectly still, the audience will fill in the emotion for her? Is Huppert playing an internal life of desolation or being technical? Yes, the effect is the same, but sometimes you just want to know if you're being fooled.

"I don't consciously think of [the technical end]," Huppert said, "although I know, of course, it works the way you say it works. But it's also my way of doing it. It's a mixture of what I unconsciously and instinctively know works, combined with my own way—my idea of being emotional. I

manage to work with directors like Benoît Jacquot, Claude Chabrol, and Michael Haneke who are the least emotional people on earth."

LA CÉRÉMONIE is a distinct and important entry because it takes two enormous talents and invites each to do something completely new. Chabrol gave Huppert the choice of playing either Sophie, a repressed, psychotic maid, or Jeanne, a cheerfully extroverted, *almost*-psychotic postal worker. "But that was like a little joke," said Huppert. Chabrol knew Huppert would take Jeanne, because she was different from anything she had done.

Huppert's performance is filled with a wealth of amusing, insightful, inspired and intuitive touches, as when she first walks into the house where Sophie (Bonnaire) works and looks around. She is buoyant, delighted and covert, taking in everything like a happy child who is about to steal something. And she does wonderful things with gum in this movie, sticking it under a counter when she makes a phone call, popping it back into her mouth when she finishes.

The gum bit came spontaneously, during shooting. "It's nothing. It's never anything you can prepare. It happens. I was chewing gum in the scene, because the character is the kind that would chew gum as she speaks, and then I have to put it somewhere. I oftentimes think about characters in terms of rhythm, and she was definitely a fast character, walking fast, talking fast, living fast. She goes at a brisk pace all the time. And the whole thing evolved around that."

Chabrol, famous for not giving detailed direction, left the actresses to work out the specifics among themselves. In the film's backstory, Jeanne was accused and acquitted of killing her child, in what was eventually ruled an accident. And Sophie's father died in an arson fire. Huppert and Bonnaire decided that Jeanne accidentally killed her child, perhaps accidentally on purpose, but not consciously. But Sophie intentionally burned her father alive. "Sophie is keeping everything inside her," Bonnaire said. "[Jeanne] is less dangerous, because she is expressing herself all the time, so she has less anger." Out of the crazy alchemy of these two personali-

ties—neither would have acted without the other—comes the spontaneous act of mass homicide that ends the film.

In the more reserved role, Bonnaire is thin, withdrawn, watchful, clipped in speech, and she has bizarre cropped bangs. She lives in terror that her secret might be exposed, that she is illiterate , and every time the mistress of the house leaves her a note, she retreats to her room with a book of phonetics and tries to sound out the words, her face red and distorted by tension. When the household's teenaged daughter (Virginie Ledoyen) finally asks, "Are you dyslexic?" Bonnaire utters a sound—"haa?"—and you can almost feel it physically, her insides caving in.

For the role of Jeanne, Huppert went on to win the César Award for Best Actress. (She had been previously nominated *seven times* and hadn't won, and yet Adjani had won four by this point—what on earth were they thinking?) Yet perhaps an even more appropriate prize came that year from the Venice Film Festival, which voted joint acting honors to both Huppert and Bonnaire.

IT SHOULD BE POINTED OUT that a third French actress of note shared the screen in *La Cérémonie*—Virginie Ledoyen, who was eighteen and at the dawn of her career. She was, already at this point, clearly up and coming and had just filmed Benoît Jacquot's *A Single Girl* (1995), which would be a major showcase. But even so, to hold her own as a teenager opposite two of the most lauded actresses of the day—and to do so in scenes in which she had to exude the complete relaxation of social and economic superiority—was impressive. If she felt any diffidence or deference, not a flicker of it comes through on screen.

So Ledoyen was no average kid, but an unusually poised star in the making. Her best opportunity came in 1998, with two films made ten months apart, though released in America on back-to-back Fridays the following year. In *Late August, Early September,* Ledoyen was on fire as the young, temperamental girlfriend of a middle-aged writer, a woman so volatile that every time she appears on screen, director Olivier Assayas changes his technique, turns into Wong Kar-wai, and goes into quick cuts

and mad swerves of his hand-held camera. Ledoyen followed up this tense impression with *Jeanne and the Perfect Guy*, a musical very much in the style of Jacques Demy's *The Umbrellas of Cherbourg*. *Jeanne*, ultimately about a woman who falls in love with a man with AIDS, attempted to tell a gritty story in the romantic comedy form, to show the magic in the mundane and the beauty inside the coarse.

Early in the film, Jeanne meets a man on the Metro and has sex with him in a subway car, yet another reason to avoid Paris taxis. "If the sex isn't good, it's not love," she sings. The mix of the crude and the lilting form a commentary on the nature and necessity of musicals; that is, they give us life as it's experienced subjectively: Two people humping on the subway is vulgar, except when it's you. And in the midst of this, Ledoyen found one of her best roles, embodying in her essence the qualities the movie strove for. Her delicate prettiness, combined with a deep voice that sounds as though she has been smoking forever; her innocuous young woman's deportment, combined with a much older nobody's-fool aura, were in harmony with those combinations of dark and light that the movie kept in arresting balance.

Anyone seeing these late nineties films might well have expected Ledoyen, who was twenty-three at the turn of the millennium, to go on to become one of the leading lights of French cinema in the next decade. I expected it and wrote that at the time. So did the French critic Jean-Michel Frodon. But in fact, Ledoyen's subsequent filmography, either through lack of luck or ambition, has not lived up to those high hopes. To be sure, she continues to work as an important star, and she appears on the covers of magazines. But for the most part, her career has been consigned to weak romantic comedies and to unflashy roles in ensemble films.

It is just possible that Ledoyen is simply not neurotic enough for greatness—neither neurotic enough to project a fascinating turbulence, nor personally neurotic enough to need to work, to care about acting above all things. Too often, Ledoyen has been cast as the voice of reason, as someone mediating between two opposing sides, or as a bland woman of sanity and decency watching the hijinks of immature and selfish people. That might be her natural métier.

In any case, there was a touch of madness in the beginning that seems to have gone away with maturity. Our loss, perhaps her gain. Or maybe something else happened. Maybe something in Ledoyen soured as a result of traveling to the United States in 2000 and making a Hollywood movie.

Kristin Scott Thomas in *Petites coupures* (Axiom Films), 2003.

The Allure of Hollywood

HOLLYWOOD IS THE DREAM for many screen actors worldwide. Its allure is hardly a mystery. When foreign actors succeed on American shores, they lose none of their home audience—American films are shown everywhere. They get more respect in their home countries, too, plus world fame, plus tremendous money, plus the personal satisfaction of having made it in their field's most competitive market.

For French stars, there is an artistic allure as well. Unlike American screen actors, who often know shockingly little about film history pre-Spielberg, most French stars are familiar with American films and genres and have notoriously good taste. They grew up on American movies, admired them and were inspired by them. (There are more repertory houses in Paris showing classic American film than in New York.) For some, it's almost as if they think of themselves as working in an American art form, so that going to America is like returning to the mothership. "France is an old country. I think that's why I love America," said actor Yvan Attal. "There is something very creative—cinema, music. It's very cinematic." Or as Vincent Lindon put it, "Just put your camera in New York—take an actor, make him walk down Fifth Avenue. Put Bob Dylan on the soundtrack, and you say, 'Wow, what a movie.'"

It's understandable, then, why for many French stars Hollywood should be such a magnet. It has an irresistible triple appeal—the prospect of personal advancement, the romance of history and the lure of artistic excellence.

Yet America has just about nothing to offer French actors, and in the case of French actresses, making the move to America is usually a mistake, or at least, ultimately, a disappointment. There are exceptions, of course, just enough exceptions to keep the dream alive. Juliette Binoche has had great success in America, including an Oscar for *The English Patient,* and she enjoys an international career. And recently, Mélanie Laurent and Marion Cotillard seem to have stumbled onto the best way of working in America—to do quality Hollywood projects when they come their way but to maintain their French careers and French identity.

Still, it's worth remembering that the two most notorious box-office disasters of the 1980s had a major French star named Isabelle in the lead role. Isabelle Huppert, riding high from her work with Téchiné, Chabrol, Pialat and Godard, went to Hollywood to play a nineteenth-century Wyoming bordello madam in Michael Cimino's *Heaven's Gate*—and met with ridicule and failure. To date, she has never again appeared in a big-budget Hollywood film, which, as it turns out, is probably a blessing for the cinema, even if Huppert doesn't agree. ("You can't really bless such an historical mistake; you can only feel sorry at such a disgrace for such a masterpiece.") And Isabelle Adjani, despite being a known quantity in the United States, found herself in the calamity that was *Ishtar* (1987). Adjani followed this up in 1996 with the epic bomb, *Diabolique,* a remake and destruction of the 1955 Henri-Georges Clouzot classic of the same name.

Actually, Huppert and Adjani were lucky in that the message was so clear as to be unmistakable. Far worse is when a French actress stars in a Hollywood film that does well, because then the real lessons can be obscured. For example, aside from the financial benefit, how was Emmanuelle Béart served by appearing in *Mission: Impossible?* Her role was bland. Americans didn't really get to see her, that is, not the distinct, willful, powerful screen entity that she can be. They saw a placid ornament, who could have been anybody.

This often happens in American films. A French actress arrives from Paris with an aura of mystery and complexity and gets fed into machin-

ery that turns her into nothing. Look at Virginie Ledoyen, of whom we spoke in the previous chapter. In her first few years on screen, she was on fire. Everything she did was arresting. Then she made *The Beach* (2000), opposite Leonardo DiCaprio, not a terrible movie, but Ledoyen sure had a terrible role in it, with none of the passion or interest of her French work. Since then, she has appeared in a handful of American independent films, in similarly nondescript roles.

There's an important moral to be gleaned from this, and it's not simply that Hollywood tends to diminish French, European or foreign actresses. Rather it's that this kind of diminishment is happening to *American* actresses every minute of every day, but we never recognize it, because in most cases we simply don't have a reference point to show us what these women can do. We never find out what they're capable of, and neither do they. It's only because Béart, Ledoyen and others have a track record of other work that we can see the contrast and, from that contrast, come to understand the cookie-cutter, I'm-with-him, blanding-out process that women undergo in most American films and genres.

France has the largest, most lucrative cinema in Europe, making it the second most successful cinema in the Western world (a distant second, monetarily), and in terms of roles for women, it's unquestionably in the lead. When a French actress comes to America, she leaves a cinema interested in exploring her essence in favor of one that's not interested in anything about her, that's even hostile to the notion of making movies about women at all. She leaves home in favor of a country in which a large segment prides itself on its xenophobia and considers it a black mark on a presidential candidate, for example, if he can speak French. So why get up from a small, elegant bistro serving up lovingly prepared food to go work in a huge, popular cafeteria dishing out slop?

Fortunately, not every French actress wants an American career. In the case of Sandrine Bonnaire, even when she was in love with the American actor William Hurt and living part of the time in America, she had no interest in working in the United States or staying here indefinitely. Recalling those days recently, in her book with Tiffy Morgue and Jean-

Yves Gaillac, Bonnaire talked about living in America as "the death of the soul" and said she had "no love, no affinity for the culture or way of life of the Americans" (my translation). Of course, she would never say that to an American interviewer, even a sympathetic one, because any actress of Bonnaire's intuition knows that nobody wants to hear their country described as soul-dead. However, in an interview for this book, she did say that American stardom is "a big dream in France, but it's not mine. If there is a good opportunity, a nice character and a nice story, I'll do it. But it's not my dream."

Ludivine Sagnier, the delightful young actress who became known in the United States after appearing in François Ozon's *Swimming Pool*, likes it here a bit more. She is smart and familiar with Hollywood film history and wouldn't mind working in the United States—but only under the right circumstances, and those right circumstances are hard to come by. After *Swimming Pool*, in which she was seen naked by a pool, Hollywood literally "offered me dozens of parts where I have to get naked in a pool. They didn't really understand it was something I created. I am not a bimbo. They thought that was my identity. I didn't intend to give them the satisfaction."

A few years later, Sagnier auditioned for Brian De Palma's *The Black Dahlia*, in the role ultimately played by Scarlett Johansson. "I remember he said, 'Why don't you learn English, learn a proper American accent and come down to L.A.?' And I was like, 'No, I'm sorry, sir, I don't want that.' And he was like, 'Come on, you lazy cow.' But no, it's not a question of being lazy. It's a question of what you have to do. I have a French accent, and I just want to blossom in nice roles, whatever the geography."

For some actresses, one American experience is enough. Géraldine Pailhas, who played the main love of Johnny Depp's life in *Don Juan DeMarco* (1994), said, "I remember feeling a little lost because I needed to share my feelings, my desires about very obvious things like wardrobe, hair, makeup—things that in my mind had to be set after discussions. And I discovered that was not the case. The producer says, 'This is the way,' and you don't say a word. I knew in this moment that we were in a much

better situation here [in France] because we were able to speak about problems quite easily. I never had problems like this in France."

Alas, the French art of infinite discussion is apparently not appreciated in bottom-line, budget-conscious Hollywood.

French actresses have fared best in English-language films made outside the studio system. Huppert, for example, has gone back to America every seven years or so to appear in auteur pieces and art films. Fanny Ardant, already known in America for her Truffaut films and for high-profile imports such as *Colonel Chabert*, brought mature sensuality and good humor to her brief role in *Elizabeth* (1998) as Mary of Guise. And Charlotte Gainsbourg has become well known in the United States for her work in English-language independent films (*The Cement Garden, Jane Eyre, I'm Not There*), though Gainsbourg is a special case. The daughter of singer Serge Gainsbourg and English actress Jane Birkin, she is as English as she is French. In fact, her English is so perfect—so upper-class and with no hint of French—that when she plays a French person speaking English, she puts on an accent.

"I always feel ridiculous, because it's like trying to be Inspector Clouseau," she said in 2009. "I have this voice in my head thinking I'm going really over the top."

THE CASE OF SOPHIE MARCEAU IS INSTRUCTIVE. Her flirtation with an American career is by no means a horror story. In some ways, it's a success story—but one that illustrates the limits of the success that is attainable.

Marceau's stardom in France is enormous and long-running. It began in 1980 with *La Boum*, the smash hit that introduced her to the world when she was barely a teenager, and it extends to the present day. In 2008, she was voted the most popular actress in France in a newspaper poll. A three-decade (and counting) run is extraordinary by any standard—Clark Gable lasted that long—but a three-decade run at the top is virtually unheard of, especially among actresses.

Even compared to great careers, Marceau's stature in France is notable. Take an identical stretch of time, the twenty-eight years from *La Boum* to

that 2008 poll, and examine the career of Bette Davis. That's the distance from Davis's breakthrough in *Of Human Bondage* (1934) to her harridan-hood in *Whatever Happened to Baby Jane* (1962). Marceau, by contrast, is still a glamour star and is very much thought of as one of the current era, not as a classic.

In person, there is nothing of the diva about Marceau. She is wryly funny and reflexively self-deprecating, with a lightness that has made her a natural for comedy, though she is not limited to that. Her smile is one of connection and complicity, and she makes you feel within the privileged circle of that complicity, whether you're in the same room or in an audience. Her idiosyncratic charm is truly something extraordinary. Have you ever broken up with someone and for days afterward found yourself flashing back to how he or she looked, laughed or gestured? Sophie Marceau's charm is such that you can have those flashbacks for days, after just being in her company *for an hour*. This is a strange, rare gift that the gods have conferred upon this woman, a gift guaranteed to make anyone in possession of it wealthy and renowned, but one that could also be, on a daily basis, a colossal nuisance. No wonder that Marceau has such a healthy sense of the ridiculous. One either gets the joke or ends up a narcissistic basket case.

After a period as the Molly Ringwald of France, Marceau slipped easily into adult roles. To see any still from *Police* (1985) made when she was eighteen, you would think this young actress belonged in *The Breakfast Club*, not in a hard-boiled urban drama. But to actually see her in the film is to believe her as she was cast, as someone on the fringes of the underworld, as a hard, strong, always thinking, always calculating, complex woman with a dark understanding of human nature.

Marceau's early French career was a mix of genre movies (romantic comedies such as *L'étudiante* and *Fanfan*) that some people liked but no one took seriously, plus art films such as *L'amour braque* and *My Nights Are More Beautiful Than Your Days* (both by Polish director Andrzej Zulawski, who became Marceau's companion for twelve years). There was also a swashbuckler thrown in for fun, Bertrand Tavernier's *La fille de d'Artagnan*.

Then Hollywood called, and she had a supporting role (and a nice show-case) as the French Queen in Mel Gibson's *Braveheart*. This began the American and English-language phase of her career.

More than most French stars, Marceau in the mid-1990s would seem a natural for American stardom. Her appeal was universal, and her English is close to perfect—any more perfect would be a disappointment. Moreover, aside from her art films, her body of work was in artistic harmony with Hollywood product. Then and now, Marceau gravitates toward the kinds of movies that we see in America—crime thrillers, historical dramas, romantic comedies. She tends to shy away from the small, psychological dramas and romantic dramas that many French actresses specialize in.

She played the title role in Bernard Rose's *Anna Karenina* (1997), an unfairly maligned film in which Marceau did a couple of things that previous screen Annas had failed to do: She played Anna as reckless and as genuinely attracted to Vronsky. Such would seem obvious, but Greta Garbo herself overlooked that last detail. Marceau followed this with a good mood piece called *Firelight*, playing a governess. Even her role in a James Bond film (*The World Is Not Enough*), worked out well (they often don't). What could have been a pure sellout became a personal success. She got to be playful and diabolical and show English-speaking audiences the quizzical, self-mocking personality that French audiences already knew and appreciated.

But even an actress whose work is sometimes considered middlebrow in her own country is too highbrow for garden-variety Hollywood product. Some of her American films were a waste of time—worse than a waste when you consider the work she might have been doing at home. What madness, for example, possessed this most popular of French actresses to star in the leaden romantic comedy *Lost & Found* opposite David Spade? Likewise, what are we to make of Marceau's appearance in *Alex & Emma*, in which she played neither Alex nor Emma and in which a man in love with two women ultimately chooses Kate Hudson over Marceau. Is this romantic comedy or science fiction?

Fortunately, after a flirtation with America—five out of six of her late 1990s films were in English—Marceau went back to being a French actress. It couldn't have escaped her notice that her very best film from this period was by a long margin the French film, *Marquise*, a seventeenth-century period piece in which she rises from the depths of poverty to become the premier actress in the age of Molière and Racine. Marceau got to show this woman's artistic and emotional progress and made us believe, in some difficult stage scenes, that this was a very great actress. Nothing she was offered in Hollywood required anything close to what *Marquise* demanded of her. And do you think Marceau took *Lost & Found* because she was fielding better Hollywood offers? Such are the limits of Hollywood stardom for a French actress.

Marceau wanted to make good movies. When I interviewed her in 1997, she complained about the *French* cinema being too commercial:

We try to save our cinema by stopping the American flow into France—with laws. I think it's ridiculous. Then they try to do the same kind of films as American films. We used to be good in the sixties and seventies when we made—I don't like this word—intellectual films, author's films. It was less commercial but at least we were at the head of the train. I'd go to movies for entertainment, but I have enough entertainment in my life.

Marceau has made good movies since, art films such as Andrzej Zulawski's *La fidélité* and Marina de Van's original and rather twisted *Don't Look Back* (in which Marceau morphs into Monica Bellucci—it could have been worse); and popular entertainments such as the comedy *LOL*, the irresistible thriller *Anthony Zimmer* (with Yvan Attal), and the violent World War II drama *Female Agents*. She just hasn't made them in the United States.

WHEN I INTERVIEWED ISABELLE HUPPERT, I mentioned in passing that she has the strongest body of work of any actress in the world. She insisted otherwise, and I insisted back, and she denied it again, and I conceded that maybe, just maybe, Meryl Streep might be tied with her in

the magnificent résumé department. To which Huppert said something quite interesting:

You know, it's more again a symptom—I mean it really tells something about our relationship to cinema in Europe, which is slightly different [than here in the U.S.]. Here it seems like, you reach a certain point, actresses work less. And maybe also we have this idea to make movies more cultural than entertaining, a more existential thing than here. And so together it makes [for] a different relation to our craft.

Not to put words in anyone's mouth—and you, the reader, are free to disagree—but it strikes me that Huppert, in the politest possible way, is saying two very significant things. She is saying, "Your movies suck," or, at the very least, that most are not particularly ambitious. And she is acknowledging that American cinema has a bad habit of throwing away its actresses past a certain age. Given the context, that this was in answer to a question about her résumé as compared with that of Meryl Streep, she was implying something else—that Streep is the only American actress who *can* be compared to her because she is the only one who has continued to work in important roles in important films over the course of thirty years. If things were different, the idea goes, maybe we'd have more Streeps. And maybe some Hupperts.

Keeping this in mind as we consider the paucity of women's roles in Hollywood, it does indeed seem strange that the migration of French talent should flow in our direction. Really, the immigration should be going the other way. After all, when French actresses come to America, they are unknown, few care about them, and there are limited opportunities. On the other hand, when English-speaking film stars go to France, they arrive in a country in which they are already famous, one containing a cinema capable of accommodating them and an audience interested in women's stories.

Alas, language is almost always an obstacle. But it hasn't been one for Charlotte Rampling and Kristin Scott Thomas, English actresses who speak French and have achieved acclaim for their work in French films.

Rampling has worked on and off in France since the 1970s. She never concentrated on French films exclusively, but in the first decade of the new millennium she received more notice for them than for her English-language work—even in the United States. Two films for director François Ozon made Rampling once more a name to contend with and gave her a second career in her more mature incarnation. The first, *Under the Sand* (2000), in which she played a woman in denial about her husband's death, reestablished her in the public mind as a serious talent.

Ozon's next film with Rampling, *Swimming Pool*—the same film that made Ludivine Sagnier known in America—got as much attention for Rampling's nude scene (at age fifty-six) as for its virtues as a thriller. ("It was not a problem for her," Ozon said. "She has always been provocative. Charlotte has something mischievous in the eyes.") More than any other film, *Swimming Pool* defined for Americans the attitude toward—and possibilities for—middle-aged and older women in French cinema. The revival of Rampling's English and American career is no doubt a consequence of the interest she has garnered through her work in France.

Kristin Scott Thomas, even more than Rampling, has pursued a bilingual career. Her first screen credit was for an appearance on French television, and only during a period from the mid-1990s through the early aughts did she work almost exclusively in Britain and America. During that time she made most of the movies for which she is known in the United States: *The English Patient, Angels and Insects, The Horse Whisperer, Random Hearts, Up at the Villa,* and *Gosford Park.* But since 2003, she has moved increasingly toward French cinema, and a look at Pascal Bonitzer's *Petites coupures* (2003) will tell you why. Thomas is suddenly sexy. She plays a neurotic, dangerous, high-strung woman, a role that had to be fun to play, not to mention a welcome departure from the steady diet of propriety that her English-language career had forced upon her.

In recognizing this, it is important to acknowledge that Thomas had (and has) an exceptionally good career for an actress in English-language

films. She made intelligent, quality pictures and was nominated for an Academy Award for *The English Patient*. *Petites coupures*, by contrast, is not even an especially good movie. But the effect of seeing Thomas in it is one of revelation—"Oh, *that's* who she is, *that's* what she's capable of doing on screen, *that's* what's fun about seeing her in a movie." Just as French actresses have to make American films just to let us see how boring they can be, Kristin Scott Thomas had to go to France for people to understand the exciting, vital, not-mired-in-tastefulness, not-doomed-to-dignity actress that she had always had inside of her.

Thomas says working in France "is a bit of a no-brainer, really, because there are such great roles that I keep getting offered. French cinema seems to make these fantastic stories about women in my age group, women who are going forward, not constantly regretting lost youth or worrying about their child. They're stories about women, not about what those women once were." She feels freer in these roles "because I don't have to wear curly gray wigs, and because I'm not having to reflect on my past beauty, or my past success, or my lost youth."

Her performance in *I've Loved You So Long* (2008) provoked awe and astonishment at Thomas's depth and abandon. It is one of the great performances of the decade, probably the best in its year, and it yields new riches at every viewing. Her explosion in the final scene—in which she reveals the secret she has carried for years—is like nothing in her previous filmography. Just as striking is the quieter monologue that follows, in which she tells of her young son's illness and death, while wiping away tears. She wipes them away with rough, thorough gestures, like someone who has cried so much in her life that she has developed an impatience with the physical process.

In *I've Loved You So Long*, Thomas is troubled and at times ravaged and downcast, yet she is attractive as a person. It says something about the differences between the French and English-language cinemas that just a few months later, Thomas found herself in a British production, *Easy Virtue*, only this time not as the lead, but as the spiteful mother-in-law of the heroine, played by Jessica Biel. What a comedown, for anyone

familiar with Thomas's true range, to see this powerhouse playing second fiddle to this most lightweight and unskilled of American actresses.

But then the universe righted itself again. Thomas, once again in her element in France, starred in *Partir*, as a frustrated upper-middle-class wife who embarks on a reckless affair with a building contractor. Once again, she was the center of audience contemplation, as the obsession of two attractive men, the husband (Yvan Attal) and the lover (Sergi López). Directed by Catherine Corsini, the film explored the inner workings of a woman ready to throw away her old life and leap into the unknown. And it showed the frustrations that might make reckless romance seem the more attractive option. In one scene, she brings out dinner. Her son asks, "Poulet, encore?" and she drops the tray on floor. She has reached her limit. *Partir* also includes a series of intense love scenes, or rather sex scenes, with lots of frank nudity.

To see *Easy Virtue* (2008) and then see *Partir* (2009) is to realize an obvious and seemingly impossible truth. At forty-eight, Kristin Scott Thomas was already an old lady in England. But she needed no fountain of youth to restore herself. All she had to do was cross the English Channel, and at forty-nine, she was young again.

This process was repeated months later. In 2009, curly wig and all, she played John Lennon's pinched, fretting, reserved Aunt Mimi in the English film, *Nowhere Boy*. Then back to France again for *Crime d'amour* (2010), in which she was a dangerous, flirtatious and glamorous business executive.

"People need somebody to be the evil aunt, and that's who I have to be, I guess," Thomas said in a 2010 interview. "And for some reason in France they don't want me to do it. I think French society and French culture embraces older women, and it's certainly able to accept that older women have appeal—I mean sexual appeal as well as other kinds of appeal. It doesn't have to be naughty-naughty wink-wink, it can also be quite serious—stories about the psyche—somebody's character, and it can be about a woman's situation that maybe does involve desire."

No wonder that in 2010, Thomas, who lives in Paris, was talking about taking out French citizenship. Wouldn't you? The real surprise is that so many French actresses still think Hollywood has anything to offer besides marginalization, mediocrity and disappointment.

Nathalie Baye in *La Baule-les-Pins* (CNC), 1990.

8 Alone at Midlife

Nathalie Baye in the Nineties

I F THIS WERE A HUNDRED YEARS FROM NOW, it would be very easy to talk about the deliberate motifs in Nathalie Baye's work. We might say how in the nineties, as in the eighties, this actress set out to make a series of films showing complex modern womanhood in collision with the punishing realities of modern life. We could argue that it was no coincidence—and thus, a matter of intention—that Baye's films, including and even especially her love stories, left her alone at the finish and that her protagonists' victories were mainly about finding inner strength and maintaining one's selfhood. "Clearly" and "obviously," we might conclude ("clearly" and "obviously" being the words we use to amplify when we know we need to hedge), Baye pursued a specific agenda in her choice of films and consciously sought to make specific points about the women of her time.

But this is not a hundred years from now, so we do not need to guess about Nathalie Baye. We can just ask her. And when we do, we find out that Baye makes movies on the basis of the script and the director and not to embody a social idea or state of mind. At no point has she ever consciously set out to tell the story of modern women through her body of work, nor has she ever looked back and noticed that she has pretty much done precisely that. Baye doesn't really think in terms of a body of work and is not particularly interested in the kinds of things that fascinate critics. She is simply doing it, and to the extent that she is thinking about it at all, she is thinking hard—very hard, in fact—about the role, the scene and the film. Point out, for example, that she usually ends up

alone in her movies, and she is at first skeptical, then surprised and then interested, but not too interested. Perhaps she chooses and attracts these roles, she supposes, because she has "an obsession with freedom." Freedom, after all, is what attracted her to acting in the first place. "I never said I wanted to be a star. Never. I wanted to work and be free and have the chance to live with my work and run my life."

Yet here's a thought: Such a thing is exactly what you would expect Nathalie Baye to say, isn't it? By that I mean, if this were a movie and Baye were playing a movie star, could you even imagine her (in anything outside a farce context) ever being presumptuous or self-conscious enough to talk about posterity or her own social importance? No, she would just be doing her best in a tough business and trying to get by.

She played an actress doing exactly that (minus the talent) in the 1990 film, *Un week-end sur deux* (*Every Other Weekend*), the defining role of Baye's early middle age. Shot when she was forty-one, it starred her as a once major attraction—with a César in her past—now newly divorced and teetering on the brink of spiritual collapse. She takes an emceeing gig at a Vichy hotel, and because this is her turn to have the kids for the weekend, she brings them along. Her performance allowed Baye to be seen in a new way within the industry:

For the public, I was always a woman who could be a friend, so for a long time they just asked me to play those kinds of women—very nice, very kind—and I wanted to try more dangerous characters, more opaque. This film changed that. I loved this movie and I loved this woman. She's not really a good mother. She's an actress who has no real talent. She's not a good wife. She's lost, and she tries to love her kids, but her kids look at her like she's a little crazy. And I found that after this film, even years after, I had a lot of offers that were more interesting *because* of this film—women who are a little broken, or alcoholic, or hard to read.

Un week-end sur deux places a woman's crisis all under one roof—the failing career, the increasingly strained relationship with her children (especially her son) and her own self-doubt and desire. What emerges is

the portrait of a forty-year-old woman who has never grown up. When she puts the children to bed, she goes to the hotel bar and dances by herself like a woman in her twenties. On the beach she does cartwheels. The physicality of the role was a natural form of expression for Baye because of her dance background. "It was a way for me to create this character. It's difficult for her to talk to her children, but it's not difficult for her to play on the beach, with her body. She feels much better in her body than in her mind." Through such physicality, Baye and Garcia show us that this woman feels, physically, just as she did when life was easy. So what is she to make of the indignities she must deal with, like provincial Vichy merchants expecting her to take their convention seriously? Or an ex-husband angry that she took the kids out of town? *Un week-end sur deux* is about someone who got very used to being young and very rewarded for it, and now she finds herself in middle age with no idea how she got there. Baye, with her light, lilting movements and the dark awareness intrinsic to her nature, was the ideal actress for bringing out this contrast.

I use the word "intrinsic" with regard to Baye's awareness because, in a dramatic context (and often even in her comedies), this awareness is essential to her nature. It is who she is. Thus, when she plays someone flighty, we don't see her as insubstantial or heedless but as someone in pain who is in conscious *flight* from awareness. Likewise, when she plays someone grounded, we see her as wise, perhaps wiser than she would even like to be. Such awareness we recognize as an awareness of pain. Baye's touch may be light, and she may smile easily. Yet even in the surest of situations, her smile is a curious mixture of pleasure and knowledge. It combines an unguarded, wholehearted appreciation of whatever or whoever she looks at, but with a hint of sadness, as though the smile itself were just a respite from melancholy. Always, always, there is a sense of a darker world outside the circle of light that she is savoring and creating.

At the end of *Un week-end sur deux,* the ex-husband catches up with her in Spain, interrupting her plan to kidnap the kids indefinitely. He wants to reconcile, but she rejects him with a force that surprises us, the force of a mature woman; whereupon, he pushes in her face with his hand, as

though he wants to smash it. Watching, we can't tell if the husband is crazy or if she has driven him crazy. In any case, we do know this marriage has landed where most Baye relationships end up: In the void.

ACTORS AND ACTRESSES have moral meaning on screen, especially stars. In the words of Edgar Morin, they "bear witness to the presence of the ideal at the heart of the real." This "ideal" is not ideal in the sense of perfection, but in the Platonic sense of embodying, in pure form, an idea or condition. Indeed important stars, like Baye (or Greta Garbo, John Wayne, Clint Eastwood, Katharine Hepburn, etc.), virtually mean something just in the act of standing there. Some rare performers in that position know what qualities they suggest and can handle that knowledge, but most are better off either not completely knowing or at least not dwelling on such considerations. Sandrine Bonnaire has talked about how awkward it was, early in her career, to realize that everyone loved her smile. (Should she smile more or less?) And certainly, it would be very easy to attribute some of the later indulgences of Isabelle Adjani—or for that matter, Marilyn Monroe or Joan Crawford—to an overconcern with image or a misconception as to the nature of its meaning and appeal. As Dashiell Hammett once commented on writing, "It's the beginning of the end when you discover you have a style." If anything, the pratfalls of self-consciousness are even worse for actors, for obvious reasons.

Nathalie Baye is one of those actresses who does not dwell on the effect she has on screen. Still we can say without fear of contradiction—just by looking at the filmed record—that in the 1990s Baye continued to explore states of loneliness, the anatomy of romantic disappointment and the ephemerality of love. Through her own choices and predilections, whether conscious or unconscious; or through directors' responding to something in her screen quality; or through some likely combination of both, her work deepened as her films began addressing, sometimes directly, sometimes obliquely, the challenges of midlife.

Her first film of the 1990s, Diane Kurys's *La Baule-les-Pins*, found her as a wife and mother who separates from her husband and goes on

vacation with her children. Leaving them mainly in the care of a nanny (Valeria Bruni Tedeschi), she carries on an affair with a much younger man (Vincent Lindon), in a role with some definite similarities to the one she would soon play in *Un week-end sur deux*—that of a woman, still young but getting older, feeling an intense desire to be carefree again and to escape the patterns and mistakes of her life. Again, practically just by virtue of being herself, Baye suggests, behind what would seem to be an amoral choice, a mature consideration of both personal needs and personal responsibility. She gives the character energy and exuberance, though it's an exuberance not rooted in joy but in finding, within herself, the strength to take what she wants.

The problems of midlife are often the problems of marriage, and just as Baye has played her share of straying wives and Other Women, she has often been cast as the betrayed partner. *Mensonge* (*The Lie*, 1993), the least known of the significant AIDS films made in the early nineties, was framed as a case of epic betrayal: A pregnant, happily married woman rides down a steep, slow escalator into the Metro (i.e., the abyss), and to pass the time, she idly opens her mail. There she finds the result of a recent routine blood test—AIDS—and collapses. As is often the case with this actress, it's an impressive acting moment that does not feel like an Impressive Acting Moment but rather like something real has just happened to somebody.

Not for the first time on screen, Baye is put in the position of discovering that her husband is not the man she thought he was, and this time the consequences are life-threatening. She becomes frantic, desperate, terrified and self-destructive—and as viewers, we feel the full weight of her torment. But as in any Baye film worth seeing, emotional devastation cannot be the endpoint. It is this actress's lot on screen to represent and depict the strength of the average intelligent person. So first she knows it—whatever awful thing there is to know. Then she deals with it.

Baye's heroines are fighters, not victims, though Baye's worst films sometimes have been confused on that score. Thus, we get the ridiculous crime thriller, *Honeymoon* (1985), in which she played a French woman in New York who marries an American man, then finds out—oh no!—he

is a psycho killer. And, in the nineties, we get *La machine* (1994), a sci-fi film with Baye as a wife who does not realize that her scientist husband (Gérard Depardieu) has switched brains with a violent criminal. I suppose, in a certain sense, these films are almost interesting, in that they conform, albeit in a lobotomized sort of way, to the Nathalie Baye pattern: The world is menacing, and the men are disappointing. In doing so, they suggest that there is something about this actress that consistently communicates a specific set of qualities and that communicates them even to the most clumsy and primitive of artistic consciousnesses.

But *La machine* was the only film Baye made in 1994, and she did not make another full-length feature until 1996. The fact that she even made *La machine* indicates another of the challenges of midlife, especially for actresses, a challenge one might imagine that Baye, with all her success, has always been insulated from: As a woman gets older, finding good roles worthy of her ability is not always easy.

BAYE IS METHODICAL IN HER PREPARATION. "The main thing I do is read the script, read the script, read the script until the end of the last day of shooting. Because when you read the script, even in scenes when you're not there, you have some key to the character," she said. "Reading the script is not about reading lines but about understanding the psychology of the character." Such an approach is no-nonsense, diligent and extremely trusting of writers: In parsing the script, she is taking on faith that what she is looking for is actually there. Baye also does field research. "I don't stay in my world—I'm very curious. In my job, I have the chance to go to places where it's impossible to go. Sometimes I ask a surgeon if I can watch an operation. I love to watch everything, not because it's awful— it's not awful, it's beautiful."

Baye is focused on her work and not blithe or overconfident. Her approach to being interviewed was focused and diligent as well. Speaking a language not her own, she seemed intent on getting the interview right. She rushed into the Cafe Fleurus, near the Luxembourg Gardens, at a little after three in the afternoon. She announced that she was in the

middle of a horribly busy day and then proceeded to answer every question I had, thoroughly and thoughtfully, with no eye on the clock and no rueful glance at the pages of questions across the table. Then, when it was over, bam, out the door, to do whatever it is that Nathalie Baye does on a late September afternoon in Paris.

Such a serious and concentrated approach to one's work tends to submerge the ego. "My real pleasure is not success," she said. "It's to act, to play. The fantastic moment is between action and cut. That's great, because in that time I have the chance to live many lives."

But there was a period in the mid-1990s when Baye wasn't working as much as she would have liked. We might look at her filmography and see few gaps, but Baye knows the reality. "When I look at the titles of my films, I think, 'Okay, on that film I had two days of shooting, on that one I had one day of shooting. In those two films, I had three days.' So in two years, maybe I worked a week. Yes, I came back. But first, I think, you have to disappear."

The dramatic upsurge came in the late nineties. Baye turned fifty in July of 1998 and followed that milestone with the release of three significant features in succession. With these, she broke through to the next stage. Baye had been a star as a young and then youngish woman. Now, firmly planted in middle age, she would stay a star. The films were *Si je t'aime, prends garde à toi* (*Beware of My Love*); the international hit, *Venus Beauty Institute*; and the art house success *Une liaison pornographique*, known in English as *An Affair of Love*.

For *Beware*, director Jeanne Labrune cast Baye as a successful screenwriter, who, rebounding from a devastating breakup, embarks on a sexual adventure with a strangely aggressive and angry man (Daniel Duval). A thrill seeker with a cold streak, she regards the man, for all his bluster, as a mere diversion from her real life. And she is so worldly that, though we find him alarming, she sees him as a type and is mildly amused. In one scene, after some particularly boorish public behavior on his part, she tears into him, but in a way that only Baye would. Look at these lines. Even allowing for the awkwardness of the English translation, this would be a

very difficult speech for any actress to pull off without looking crass or falling victim to something counterfeit about the dialogue:

Don't try your exotic gigolo pimp routine on me. You're a good lay. You're smart. You want me to suck you, I do. But that's enough. In real life, you bore me. . . . Don't get used to boring me like that. Here's how it goes. I'm no dumbass broad wetting for you to screw her. I'm not mad for your looks. I'm someone different, one who has seen all colors, sizes and shapes, who's not impressed by that, who knows what it means to be loved. . . . Dick-wise, you're OK. Mentally, you need more work.

Baye not only gets away with this, but she turns it into a moment of character revelation. She does it by speaking with cold directness during the first half of the speech and laughing through some of the second half. She is serious and means every word, yet she is too little invested in this guy to care all that much. So she can stand back from the situation and see its ridiculousness, too. I have watched this scene several times, marveling at the seamlessness of Baye's inspiration, how she can take a crudeness of the script and transform it into one of the high points of the film.

Beware of My Love is very much about sex and contains a number of interludes in which Baye, who was closing in on fifty at the time of filming, appears naked. No one in France considered this worth remarking on, in stark contrast to the American reaction a year later to Rene Russo's topless scene, at forty-four, in *The Thomas Crown Affair*. Russo was treated in the media as either a feminist pioneer or as something uncovered in an archeological dig. Or both.

Venus Beauty Institute came a year later. It's a much more somber film than its pink poster would suggest, about a beautician who works in an otherworldly, candy-colored salon but who leads a promiscuous, seamy life in her off hours. During the filming, Baye feared that the salon scenes and the private life scenes would seem like two different films. "I asked [director] Tonie Marshall a lot of questions. I wanted to understand absolutely everything. When I don't understand anything in a script, I ask questions, even if I feel silly. I don't want it to be artificial." These

conversations allowed Baye to arrive intuitively at a characterization that integrated moments of farce and drama and that found a harmony between the woman's zaniness, her professional competence and her life disappointment and bitterness.

What Baye eventually decided was that she and Marshall were not creating a film out of balance but rather a characterization in harmony with modern reality. "I love this Angèle," Baye said. "When I was shooting the film, I was going home sometimes very late, and I was looking at the people on the street, thinking there are many Angèles in Paris. Those women who are quite alone—in their job everything is okay, but outside of the job it's not so perfect." It's a tender observation from an actress whose work has been speaking to and for the Angèles of the world for decades.

In *Venus Beauty Institute*, the salon is a place of delusion, a temple to women's surfaces, and yet notice how not one customer exits the salon looking better than when she went in. The salon is like the embodiment of everything Angèle willingly believed years earlier, and now she has nothing to show for it. Her private life is a mess of wrecked relationships and squalid scenes. She does meet a man (Samuel Le Bihan), and the movie does end in a romantic clinch, but the man is ridiculous—too young, and too hysterically devoted not to cool off. He is exactly the man a director might place in a final shot if she wanted the audience not to believe it—or if she were making an ironic comment on the similarity between movie romances and beauty salons. Both sell dreams, and because these are dreams everyone wants to believe, they don't really have to try hard.

Une liaison pornographique—Baye prefers the American title *An Affair of Love* but likes the Italian title, *Una relazione privata*, best of all—was another hopeless love story. But this time the hopelessness was part of the design, with Baye and Sergi López meeting through the classifieds in order to share a very specific (but never revealed) sexual fantasy. Over the course of the film, the two indulge the fantasy but also have sex in the traditional way and appear to grow close. But they ultimately go their separate ways. Baye describes her character "as a woman with a big sense

of freedom," one with "liberty of choice." Yet as is so often the case in Baye's films, such liberty ends up in people living solitary lives.

IN A COUNTRY in which there are dozens of popular working actresses, and in which romance is a subject of endless interest, one would naturally expect the cinema to abound with stories of unattached women in their thirties and forties. As we know, this is indeed the case. One might also reasonably expect a number of the women in these stories to remain unattached and alone, following some romantic connection. This is less common, though it happens: Jean-Marc Moutout's *The Feelings Factory* (2008) dealt in realistic terms with the romantic difficulties of a successful professional woman (Elsa Zylberstein) in her late thirties. The woman is shown going to speed-dating sessions, interviewing, in effect, a dozen potential husbands in the course of an hour. The film's chief merit, besides Zylberstein's clear-eyed performance, was in its willingness to hover in ambiguity and to resolve her story unromantically: She does marry, but when we meet her five years down the line, she has short hair (in French movies they always have short hair five years later) and is cheating on her husband.

Valérie Lemercier, usually a comedienne (and a very funny one), had a straight dramatic role in Claire Denis's *Friday Night* (2002), as a woman who is all set to move in with her boyfriend, then meets a man (Vincent Lindon, who gets more action than anybody) and has one of those life-transforming one-night stands. But there is no Saturday night in *Friday Night*.

In recent years, Juliette Binoche has disengaged from the costume roles that defined her early career and has placed herself squarely in the twenty-first century, playing single (usually divorced) women who are harried and sometimes frantic with middle-aged responsibility: *Flight of the Red Balloon, Paris, Summer Hours, Certified Copy*. Rarely, though, are Binoche's films about being solitary. She may start her movies romantically unsatisfied, but the lives of Binoche's women are invariably crowded with people, very often children. And to the extent that her films do concern themselves with romantic prospects, Binoche usually ends up with a man. Why wouldn't she?

In any case, we can find similar examples in the filmography of any French actress, one or two movies that could be argued as conforming to the Baye pattern. But it's only in Nathalie Baye's filmography that such films are the dominant strain, and only Baye's films are consistently, directly and sometime poetically engaged in the phenomenon of her aloneness, an aloneness almost never deserved but that must be faced.

"Maybe I get that kind of character because I don't seem weak," Baye said. "Of course, I'm like everybody. I'm not a superwoman, I'm a woman. But when you're an actress—for the public, for everybody, people have an idea about you. People think I'm much stronger than I am."

Maybe they do. But I doubt that Baye's connection with her public in these roles is because people think she's strong. I think her public believes that Nathalie Baye is just like them.

Karin Viard in *Le rôle de sa vie* (Studio Canal), 2004.

9 The French Meryl Streep

> Actresses are very often people who are not the most
> comfortable in their own skin. They become actresses as a
> way of transcending shame. So their bodies and faces are the
> scenes of an internal struggle, and that struggle comes to the
> screen as something interesting. As the gap between what the
> woman is and what the role is disappears, the actress agrees to
> allow her imperfections to show. And that's what beauty is.
>
> Karin Viard

SOME GREAT ACTORS are like musicians who just happen
to be brilliant at their instrument. They are, in every
other way, perfectly normal, but they have this extraordinary ability, and
the instrument they've learned to play is their own emotions. Sandrine
Bonnaire is like that. So is Sandrine Kiberlain. Others are people whose
emotional lives are so interesting in themselves that there is no question
that they belong on screen. Valeria Bruni Tedeschi falls into this category.
Their craft consists of transforming their hypersensitive natures into a
kind of instrument, flexible enough to assume the shapes and contours
that their various characters require.

Karin Viard, who emerged as a major star in 1999, is not in either of
those categories. She is not playing an instrument. She is not creating an
instrument. It is more as if she *is* the instrument. Her talent is so huge,
and her access to it so immediate that she requires no process to turn Je-
kyll into Hyde. Obviously, this is too facile a description to be completely
accurate or to do justice to the effort that her performances require. But

one really does get the impression that Viard could get thrown into any artistic ocean and end up doing an Olympics-worthy butterfly stroke in record time.

The turn of the millennium saw great work from established stars, such as Binoche (*The Children of the Century*) and Bonnaire (*East/West*), as well as the emergence of actresses who would become important over the next decade. Eighteen-year-old Émilie Dequenne, from Belgium, debuted in the Dardenne Brothers' film *Rosetta* in 1999, the same year that Géraldine Pailhas began a strong decade-long run with the fantasy film *Peut-être*. And Isabelle Carré, who would soon become one of the most interesting of French actresses, chalked up six screen credits in 1999, though she still hadn't broken through to stardom.

But it was the thirty-three-year-old Viard whose stature underwent the most profound transformation. Viard had the lead role as a promiscuous, drug-addled mess in Catherine Corsini's *La nouvelle Éve* (*The New Eve*), an audacious comedy. Then she turned around and starred in Sólveig Anspach's *Haut les coeurs!* (*Battle Cries*), playing a pregnant woman with cancer. She was inspired in both. Thus, she began the year as a comic supporting player and ended 1999 as a bankable star and an actress of artistic importance.

In the United States, virtually no one knows Karin Viard. To the few who do, her obscurity on this side of the Atlantic is mind-boggling, even if explainable: Viard doesn't speak English, has no American ambitions, her movies are rarely exported, and so on. Still it feels almost akin to us somehow keeping Meryl Streep a secret. The Streep comparison is not an idle one. Obviously, Viard, who is fifteen years younger than Streep, has neither Streep's résumé nor her international regard. But Viard's range is wide. She is immediately accessible, likable and identifiable. Her talent is unmistakable. So is her own delight in her talent.

Like Streep, Viard relishes the chance to show an audience what she can do. We believe in the characters she plays even as we are simultaneously conscious, in the very moment of appreciating them, of the enthusiasm and innovation that the actress brings to the effort. When watching

Viard, there is never any forgetting that this is Viard you're watching, just as there is never any forgetting that this is Meryl Streep doing an Italian accent, or a Polish accent, or lamenting the dingo that ate her baby. Our awareness of Viard's virtuosity is integral to the pleasure of the Viard experience: Wow. Look at her go. Look at her tear into this one. Look at her do it—again.

Viard doesn't disappear into her roles. She knows this and attributes it to a specific variety of truth that she looks for in all her performances. "I don't like when things are imitative of reality. I always try to find the escape, to get away from reality. I try to find the drama in comedy and the humor in the tragic," Viard said in a 2009 interview for this book. "That's me, every time. I do that even if I don't think about it."

In this way, Viard creates an atmosphere around her, one that is, to varying degrees, consistent from film to film. To describe that atmosphere as one of absurdity would be too strong, because there is no quality of distance in her approach. Rather, Viard brings to all her characterizations an ever-present possibility of honest silliness, through which she makes drama more real (more dimensional and poignant, certainly) and injects into comedy an unexpected aspect of actual pain. She carries with her the suggestion of an artistic world all her own. I interviewed her in the kitchen of her house in Paris. The telephone rang, and watching her talking and pacing back and forth, I was suddenly inside a Karin Viard movie.

Often she plays women who are obsessive, oblivious and self-centered—that is, comically unbearable. This aspect of the Viard persona is well known in France. In 2009, she appeared in Maïwenn Le Besco's mock documentary, *Le bal des actrices*, which followed several real-life actresses going about their daily lives. Supposedly playing herself, but really playing up the persona, Viard is seen at a taxi stand, asking the man in front of her if she could cut the line. When he says no, she whispers to Maïwenn, by way of explanation, "He didn't recognize me." In another scene, when the interviewer asks if Viard's pursuit of a Hollywood career will put a strain on her family, she answers that her family is absolutely the most

important thing in her life, more important than anything else. "But my career comes first."

If you didn't know Viard and just happened to stumble onto this documentary, it would take a while to figure out that Viard is not, in fact, a careerist fiend and that this is a send-up. Here as elsewhere, Viard never telegraphs the joke, never steps back to reassure the audience that she is not what she is playing. Viard explains her approach this way: "I never like to think of myself as being more intelligent than the character. I don't find that interesting." In 2008, Viard took a small role in the Cédric Klapisch film *Paris*, playing another appalling character who considers herself reasonable and delightful—a racist baker who hires a North African girl to work in her shop. With Viard, the comedy is often in the distance between how a character sees herself and how we see her, how she truly is.

In person, Viard is as blazingly self-assured as the women she plays, but she is not discourteous and not clueless. I kept noticing how spontaneously warm and solicitous she was of the other people in the room. In stark print some of her pronouncements can seem cold, because she doesn't bother with the false modesty that seems obligatory in Europe. But if everybody around her knows she's great, how could she be kept out of the loop? If she can do things other actors can't, how could she not notice? And if everyone else is moved or delighted by her work, why should she be the lone holdout? The ego monster that she often plays was not created out of thin air. It's rather some variety of self-parody, a version of herself, only one without talent or self-awareness—both of which she has in abundance.

Unlike a lot of performers, Viard is not afraid of examining the mechanisms of her own performances. She thinks about her work, watches it ("for self-criticism"), and assesses it. "I am narcissistic and self-confident," she said, "so I know when it's wrong, and I know when it's good." She is the magician and the rabbit combined—or the dairy farmer and the cow. Her attitude toward herself is anything but precious. She played a TV executive in the comedy-drama *La vérité ou presque* (2007) and to

every other eye seemed to do just fine, but Viard knows she was just phoning it in. "I could have done better than that. When I look at my work in this film, I realize that I pretend well—but I understand that I'm pretending."

For Viard, the relationship with the director is "fundamental. In fact," she said, "I do this job to see through the eyes of the director. I have the maturity to do my job without everybody, but I want to share—to be here and play with everybody—I need everybody around. If there is trouble, I take that—and I will play with that, I like it. A director creates the ambience, and if the director wants a tense atmosphere, that's fine with me. I'll take that ambience and make something from it."

The notion that Viard could be, metaphorically, thrown into any ocean and become an Olympic swimmer is supported by Viard's description of her own process. "I never think that I know everything. When I act out a person, I have no fixed idea in the beginning. I like spontaneity. Through the movie I discover who I'm acting out, and at the end of the film, I say, 'OK, now I know this character'—at the *end* of the movie."

When we talked in 2009, she said she preferred comedy to drama, because "it's too easy for me to do drama. You just follow the river of emotion—that's all. You just have to find the good emotion." But what to Viard may be as obvious as a river might be the tiniest, least obvious stream of emotion that only she would find. Just one example—dozens more are available—can be found in the film *Les ambitieux* (2006), a comedy-drama directed by Catherine Corsini and well suited to Viard's complex range of abilities. She plays a self-centered, powerful literary editor, deceitful and narcissistic but at some basic core still likable, possibly because we see her pretension and vulnerability though she sees herself as a superwoman. In the scene in question, Viard opens a box containing the personal effects of her father, whom she never knew. She has put off opening this box for months. Now she does, and in her familiar spirit of impatience, she rummages through papers and passports, then unzips a little purselike photo holder. She comes across her own childhood and baby pictures, which her father apparently had saved, and immediately starts to cry.

But being Viard, this is nothing like typical crying. It's like some violent, unwelcome eruption. Viard finds a highly specific variety of crying that illuminates this particular character's specific variety of pain. Viard reaches inside and locates a "river of emotion" that most other actors couldn't find with a map and detailed instructions.

Some actors represent an idea; others, a moral state. Viard represents neither. What she offers cinema is a gargantuan talent that collides with our expectations and expands our understanding of people.

IN OPERA CIRCLES, Maria Callas had her breakthrough in 1949 when she sang Wagner's *Die Walküre* and then followed that, eleven days later, with her debut, in the same theater, in Bellini's *I Puritani*, a role that called for a completely different style and technique. Viard did something similar, in terms of French cinema, when she went from *La nouvelle Ève* to *Haut les coeurs!* in the same year.

La nouvelle Ève is one of the few Karin Viard films to be released in the United States. When I saw it in 1999—my first Viard film—I watched as she played a pathetic, repellent young woman whose entire life consists of taking drugs and having sex with strangers, and not until the end of the movie did it fully dawn on me that what I'd seen had been a performance. This was comic acting completely without comment, without any subtle signaling of some distance between the actress and the role. Catherine Corsini, who wrote and directed, neither endorsed nor passed judgment on the heroine as she threw up (twice), passed out and bored her family with angry denunciations of married people and capitalist society. Corsini's ambition with the film seems to have been to show an aspect of current French youth culture, and as Viard says, "*La nouvelle Ève* is very sociological, if you want to know what it was like to be a French girl in the 1990s." Corsini assumed audiences would be interested, a heck of an assumption, but she was right, because she had Viard.

Her performance is full of smart, funny character touches, as when someone hugs her and a wild look of impatience, like some animal desire to flee, flashes across her face. In another scene she gobbles up pills, walks

into the wrong party and sits in between two people having a conversation. In a dazed way, she seems to be trying to follow what they're saying and then, in a graceful gesture, as if engrossed in the discussion, she takes a glass from a man's hand. The timing is of a high order, and the lack of vanity startling. "If I have this humanity in my characters," Viard said, "it's because I'm not afraid of looking ridiculous. Every time I try to push that a little bit, the ridiculous. I want to be a little bit ridiculous."

La nouvelle Ève opened at the end of January. *Haut les coeurs!* arrived in theaters that November. Written and directed by the Icelandic documentarian Sólveig Anspach, and based on her true-life experience, it cast Viard as a pregnant woman who finds out that she has breast cancer and needs to undergo aggressive treatment in order to save her life. But because the treatment is toxic to the unborn child and would require an abortion, she chooses to pursue a different therapeutic route with another doctor. Anspach, who survived her illness and is still working today, told *Cahiers du Cinéma* at the time that at a certain point in the process she realized she was writing with Viard in mind. But Viard was at first skeptical about taking the role, not liking movies about suffering. She also said, in the same *Cahiers* piece, that she had some reluctance about shaving her head "for one of those small movies seen by three people." But after meeting with Anspach, she decided to take the plunge.

Because illness is so disturbing, so terrifying, people react to it by trying to make sense of it. In life, we do this by explaining to ourselves why it makes sense when someone *else* gets sick. Likewise, in art, people try to make sense of illness by constructing stories in which the sick person was somehow marked for such a fate. Perhaps they are too good to live. Perhaps they are too evil to live. Perhaps they are noble, or tragic, or special, or doomed. . . .

But Viard, in her screen essence, is none of those things. She cannot be aggrandized or demonized to a spiritual size or stature commensurate with a life-threatening ordeal. She is simply imperfect and normal in the usual ways. Thus, the spectacle of her illness in *Haut les coeurs!* makes no particular sense to the audience—and thus, the point of the film is made

almost by virtue of the casting. The shock and terror can't be ameliorated by the fake reassurances of pathos. Anspach shows Emma (Viard) getting the bad news from her doctor in a series of extended shots in which Viard barely changes expression, and it's an agony to watch, because Viard isn't better than us. She could be us.

In the face of that devastation and terror, the woman nonetheless pursues a courageous alternative course of treatment. This decision, as played by Viard (and, thankfully, encouraged by the director), is nothing like courage as found in textbooks or movies. It's more like a frantic impulse, a decision that she makes because she is almost unable to consider an alternative. "I didn't act [the] spirituality. I played the combat, the struggle—a fight between life and death in the body."

At the end Anspach leaves open the question whether the woman will live. "I decided for myself that she will live, of course," Viard said. "But I like very much that the film doesn't answer this question." The ending was the best of three imperfect choices. Had Anspach had the woman die, she would have appropriated something outside her own experience for this most personal statement. Had she shown her surviving, she might have made something almost happy out of something that is tragic for many. (She might have also felt she'd be jinxing herself.) By leaving things up in the air, Anspach stayed true to her own story while maintaining faith with those who had died. She resisted the pull to rejoin, with unseemly enthusiasm, the world of the healthy.

By the end of 1999, Viard was a movie star, and she embraced her newfound status with her usual candor. "I am very ambitious, I like money, and now I want to have the power to be in films that would not exist without me," she said at the time.

In other words, she wanted to make Karin Viard movies. And she did. In the decade that followed, Viard would be an acting machine, making up to three films a year in a variety of styles. She was an alcoholic in *La face cachée* (2007); the attentive middle daughter to a cruel mother (Carole Bouquet) in *L'enfer* (2005); and a dreamy, dying woman having her last fling in *La tête de maman* (2007). ("I wanted to be white, white like the

table, I wanted to be sad and white," she said of *La tête de maman.* "It's an interior feeling—I wanted to be here and not here.") These were dramas.

Mostly Viard has focused her energies on comedy-dramas, such as *Les derniers jours du monde* (2009), in which she appeared naked ("I want to be courageous at my age. I want to have audacity"), or flat-out comedies such as *Embrassez qui vous voudrez* (2002), in which she played a status-conscious woman who is spending her husband into the poorhouse.

"For comedy you have to be inside and outside, too, because you don't have time to stay inside, because there's a rhythm you have to keep. You have to be inside and outside all the time, and it can be difficult. And sometimes with comedy, if you have a director who likes easy effects—which I don't like—sometimes you have to fight to put something dark in the comedy, to make things more essential. Sometimes a director says, 'You make me laugh, that's okay,' and I say, 'No! It's not enough.'"

I spoke to Viard right after she made *Les invités de mon père* (*My Father's Guests*), in which she played a grown daughter who idolizes her politically active father. She helps him bring a Moldavian refugee and her daughter into France without papers, only to discover that the refugee is a thirty-five-year-old bombshell. Next thing she knows, the old man is in a sexual relationship with this woman, and she, Viard, has been cut out of the will. The film walks the line between comedy and drama—the line Viard loves to walk. "It's very funny, very cruel, very overwhelming. It's exactly what I like in humor. I know I did a very good job."

IN 2004, Karin Viard costarred in a film called *Le rôle de sa vie* (*The Role of Her Life*), playing an aspiring author, Claire, who takes a job as the assistant to a major film star, only to find herself losing her own identity. It's a film that she herself regards as among her best, and it contains one of her most inventive and original performances. Still, she "detested making this movie. It was a nightmare because of the other actress," Viard said of Agnès Jaoui, the highly successful actress-director who was cast as the movie star, Elisabeth Becker. "It was terrible for me. There was

some feminine rivalry, and the director didn't know how to say, 'Okay, now stop.' It was bad, really bad."

Jaoui, remembering the experience in 2010, just said, "The truth is we didn't become very good friends. It's true."

Whatever was the source of the tension between these actresses, we will never know. Both have egos large enough that it might be hard stuffing them into the same room, much less the same frame. But whatever was happening off screen, it either had no effect or ended up enhancing what turned out to be, in retrospect, the aughts' answer to *La Cérémonie*—that is, the most successful actress pairing of the decade.

Viard transformed herself for the role. If this were your first Viard film, you might easily imagine she is always as she is here—bumbling, stumbling into furniture, smiling meekly. You would assume that this is a fully developed persona that Viard carries from film to film. Far from the smooth, clueless person she often plays to perfection, Viard is practically the reverse here, someone who watches everything and picks up on the subtleties of interaction, even though she is awkward, ingratiating and easy to overlook.

In *Le rôle de sa vie*, writer-director François Favrat offers an honest and hardnosed study of the dynamics surrounding a major film star. Elisabeth, as played by Jaoui, is not intrinsically awful—she has many engaging and positive qualities—but she is so powerful and in-demand that there is nothing, besides her own conscience, to check her selfish behavior. No matter what she does, she will experience no pushback from anyone, and that is a terrible freedom to have, especially in the midst of a life of stress and public exposure. Though the film has shades of *All About Eve*—one of Jaoui's favorite movies, incidentally—it's not a morality tale. That would have been the American way to tell the story. Rather it falls into the traditional French zone of exploring the intricacies, ambiguities and contradictions of human behavior, without assigning blame.

As a celebrity, Elisabeth finds it annoying always to be treated like the most important person in the room. Yet having gotten used to it, she is also annoyed when she's *not* treated in this way. "I think she's not so

bad," Jaoui said of the character. "I think in a way she's selfish, but she's much less perverse than [Claire]."

Viard's role, more comic, more sympathetic and less mysterious, also had fascinating subterranean elements. Ambitious to make it as a writer, she becomes caught in the force field of Elisabeth's fame and starts becoming obsequious and servile. Yet this could not happen if her own motives were entirely pure, if she didn't crave the fame she finds herself drawn to. There is something within her, and by extension most people, that is vain and corruptible. We see that in Viard's performance, even as we root for her, and the movie's conclusion is resolutely ambiguous in its moral viewpoint.

When I talked to Viard in 2009, she said that throughout her career, whenever she got "fed up" playing one kind of character, she was offered something different, and in this she had been lucky. "But now I realize that every time I have the same part"—that is, someone imperfect who learns some kind of spiritual lesson. But now, she said, she "would like to be a very bad girl. I feel I would be able to make a very bad girl very sensitive, too. Ambition, the thirst for power, can lead to a very evil line. It would be interesting to act the role of someone destroyed or broken— with big suffering."

It's funny. No sooner does Viard start imagining playing someone evil than she starts thinking of how to make the evil person sensitive. No sooner does she begin imagining herself playing perverted ambition than she couples it with big suffering. Viard is a versatile actress—she really can do almost anything—but being truly dislikable may be the one thing outside her sphere.

Agnès Jaoui as the bartender in *The Taste of Others* (Canal Plus), 2000. The film was also directed by Jaoui.

10 Agnès Jaoui

T HERE COMES A MOMENT IN MANY, perhaps most, of Agnès Jaoui's films in which she looks at someone as though gazing into their depths . . . and then smiles as though, having taken their measure, she has found them worthy of attention. These are always warm moments, because in those seconds, she is also looking, in a sense, at us, and we feel the glow of her approval.

Yet these are ever-so-slightly disconcerting moments, too, in that we register that the objects of her gaze have been on trial at every moment leading up to that smile. And we see in the sureness of Jaoui's expression someone who does not doubt her opinions. Not necessarily someone who can't be wrong, but someone who really cannot entertain that as a possibility.

Such decisiveness, also found in the actress herself, no doubt serves Agnès Jaoui well as a director. It also makes her a pleasure to talk to, in that you don't feel she is putting on any kind of an act—that she couldn't be bothered—and it makes her highly quotable. She is confident and voluble and—not that this is important, but it's something to notice—she looks exactly as she does on screen. Not shorter or taller, not fatter or thinner, and not even older (despite the fact that, whenever you meet people, you are meeting them, by definition, at the oldest point in their lives so far). Jaoui is inescapably Jaoui, and it doesn't seem she wants to escape, nor does it seem that she should.

Karin Viard spoke of working with her as a nightmare, though she also said, with a laugh, that when I met Jaoui, "she will be very smiling.

And when you speak with her about me, she will say, 'Oh, Karin is very nice, I liked her very much in this movie.'" So I went in prepared to be charmed and determined not to be fooled. This was in 2009. Three days later, I arrived to meet Jaoui at a cafe on the Île de la Cité and stood outside the place for two hours. She never showed up.

Flash forward one day less than a year later, same café, on a gorgeous warm afternoon with white clouds suspended in a blue sky—one of those days that make you think that every day you don't spend in Paris is a day wasted—and there was Jaoui breezing into the café, all scarves and energy, apologizing for the year before and carrying with her an atmosphere of things-getting-done.

Impossible not to like her. Impossible, also, not to realize very quickly that you would not want to get in this woman's way and you would not ever want to give her any reason to decide that you're an idiot. Because once she did, the odds of your being able to reverse that opinion on appeal would be hopeless.

Jaoui is a writer and a director, in addition to being an actress. Hence she not only knows what she does but she knows how and why she does it. Actors tend to be much more instinctive. Some try to explain their process, but can't. Others will look at you like an emissary from the land of prose trying to soil the purity of poetry with such earthbound questions. But Jaoui's life is spent in the muck and machinery of art, trying to turn ideas into screenplays and screenplays into finished films. Her victories come page-by-page and scene-by-scene, and when it's over, she knows exactly what strategies she employed in order to win.

In 2000, after several major successes as a screenwriter, working with her cowriter/husband Jean-Pierre Bacri, Jaoui directed her first film, *Le goût des autres* (*The Taste of Others*). The story of a group of loosely related Parisians in several walks of life, it was written for an ensemble cast, with Jaoui and Bacri in prime roles. It was a resounding success, truly off the charts—the biggest hit of the year in France, with 3.8 million paid admissions. No director could hope for a more emphatic welcome.

The film was picked up for distribution everywhere, and to help it on its journey throughout the world, Jaoui followed the film from country to country and festival to festival over a period of six months. In the process she got an education in the realities of international distribution—namely, that Americans control most of it and that European films don't stand much of a chance, even in Europe. "I mean, if a theater wants the last Spielberg, it has to take ten other bullshit movies," Jaoui said. "They also put some money in French movies so they can also control that. It's always a fight."

The Taste of Others won four Césars (two for Jaoui) and was nominated for an Academy Award. Jaoui went to Hollywood for the Oscar ceremony. For an artist of strong opinions and snap judgments, there was a lot to take in:

I was completely shocked by the way you just have two seconds to speak. Everybody was thanking God and their parents and family, things so bullshit and conformist to me. I was thinking, "They are supposed to be artists, my God, they behave just like robots, like in a dictatorship." Also you couldn't smoke for the whole five hours! I'm not speaking about in the room, of course, in the theater, but, you know, when there were commercials, I thought, "OK, we go and smoke." No! It was impossible. We were jailed, like a gold jail.

Jaoui's impression was that Americans didn't know "other countries" even "exist." She planned, if she won, to address this by saying precisely that: "It's sad and even dangerous not to know that other cultures exist."

"Yes, it was quite stupid," Jaoui remembered:

I wanted to be very polemic, in saying you probably don't know France, because I was very shocked by that, I must say. Again, because they are artists. I don't expect some guy in Texas will know French cinema, but when I went to the Oscars, of course, I was very honored and happy because it's a country of cinema. Great cinema (not all, but a lot of it). The people I met in the reception, I thought, maybe they will know and have seen a little bit

of the movies, but no. I was naive in a way. We are a little country—big cinema, but the American people don't know.

On the one hand, it is comical to contemplate the formidable Jaoui arriving in Hollywood and becoming scandalized at not being a big shot in the United States—then extrapolating from there the notion that Americans are culturally bereft and living in a state of drooling ignorance with regard to people outside their borders. On the other hand, Americans, including movie stars, really don't know Europe, don't know French cinema, and, if they did know French cinema, they would and should know Jaoui. Also, contemplate for a moment when Jaoui would have been making her acceptance speech, in early 2001, at a time when the United States was on the brink of eight years of unilateralism and "Freedom fries." Indeed, American ignorance and uninterest in the rest of the world can be dangerous and has been dangerous in the past.

"Exactly," Jaoui said. "It was not completely wrong."

While in the United States, Jaoui met with American producers and distributors. She remembered one incident in which two women, "quite powerful," offered to finance a picture that she would make in the United States. "They told me, 'we are the only producers who give the final cut to the director. Except, we will decide together, before, how long the movie is going to be.' So I thought, 'OK, you want the power.' Because even if my movies are always the same rhythm and the same timing, I don't want to say that beforehand. I want to be free. I want the power."

JAOUI HAS ALWAYS WANTED THE POWER. She often says she wanted to be "a princess" from childhood and from her early career she insisted on power before she had much in the way of leverage. Her healthy sense of self is not the product of her success but the cause of her success. When she was twenty-six, she and Bacri wrote a play for themselves and a handful of their friends, all of them just beginning their careers. A major theater in Paris wanted to produce it but insisted on a different cast—"we want names." They might have been willing to take Bacri, they said, whose

film career was beginning to get traction, but Jaoui was out. So she and Bacri decided to pass on the offer and opened the play in a small theater. "But it was such a success," Jaoui recalled, "that after six months the big theater said, 'Please, can you come back?' So it was great."

The play, *Cuisine et dépendances*, was subsequently made into a movie, directed by Philippe Muyl, and the first day on the set, Jaoui realized she wanted his power, too. "When I saw the guy working, I discovered he knew much less than me, because I knew the subject, I knew the point of view, I knew on which character the camera has to be on at which moment. Very often I was thinking, 'Why does he do that?'—right until the end [of the shoot], in fact. I didn't agree with his point of view. He didn't know what he was doing."

Cuisine et dépendances launched Jaoui's real screen career. Before that, her filmography consisted of small roles. Full-fledged arrival came with the next play, *Un air de famille*, which was also a success and was made into a good movie, this time by a good director, Cédric Klapisch. Jaoui played a waitress who works in a bar run by her older brother (Bacri). Jaoui and Bacri won Césars for best screenwriting and then won in that category again the following year for *On connaît la chanson* (*Same Old Song*). The latter was a French go at the style originated by British writer Dennis Potter (*Pennies from Heaven, The Singing Detective*), in which characters burst into old recordings of ancient songs that supposedly illuminate their inner state.

To my eyes, the wry, reflective cinema of Jaoui-Bacri makes an uneasy translation into a Potter-type universe, and neither benefit from director Alain Resnais' cute, mannered approach. But French audiences liked it, and even Jaoui approved. "Unfortunately, you can be very talented and a bad guy, and a wonderful guy and have no talent. I meet that all the time. Resnais is a wonderful director and a wonderful human being, so it's good to meet someone like that—because it's very rare." Wonderful or not, it was providential that Resnais, whose comic hallmarks are distance and zaniness, did not direct *The Taste of Others*. Everybody wants power. At least Jaoui knows how to use it.

From a directorial standpoint, the entire success of *The Taste of Others* derives from two qualities that Jaoui brings that are very unlike Resnais or anyone else. The first is the film's unique tone, which is warm in the way of comedy and yet not comic. The second might be called Jaoui's directorial philosophy, which takes all the characters and their concerns seriously. There may be minor characters in a Jaoui film, but the characters themselves don't seem to know it. They just go about their lives. Everyone is made real, everyone gets a fair shake. These qualities are hallmarks not only of *The Taste of Others* but of Jaoui's subsequent films, *Comme une image* and *Parlez-moi de la pluie*.

Such empathy and humanity are not what you'd automatically expect from Jaoui, who, though far from unpleasant, is not someone you'd reflexively associate with warmth, giving and nonjudgmental affection toward her fellow creatures. The lady is tough and busy, and yet her work has a gentleness at its core and a willingness to spend time revealing people in their totality. In a Jaoui film, we see the character's strengths and weaknesses, what they want from life and what they're searching for—human connection, respect, and perhaps an experience to take them out of themselves.

This directorial stance goes hand in hand with the fullness of Jaoui and Bacri's writing. In their films, we get to know people as we might know them in life. We have an initial impression, but sometimes an initial impression might be wrong or incomplete. In *The Taste of Others*, a diligent business executive (Xavier De Guillebon) is revealed to be harboring an unexpressed and legitimate grievance against his employer. In *Parlez-moi de la pluie*, a seemingly affable husband shows a distinct lack of courtesy and respect toward his housemaid. "It's very jubilating for me when somebody I really don't like, suddenly, because of this event or moment, I discover I was wrong, that he has a beautiful humanity. Of course, I don't like when somebody I thought was wonderful behaves like a shit. So again, to be human. It's life."

One of the main characters in Jaoui's third film, *Parlez-moi de la pluie*, is a documentary filmmaker named Michel, played by Bacri. At first he

seems capable and successful. Then we realize he is an idiot. Then we realize that he's an idiot but not *only* an idiot. He did make one good film in his life. He's a good father. He can sometimes be good company. He may still be an idiot, but in a Jaoui film, there is always more to the story. So, in the case of Michel, how did Jaoui and Bacri arrive at such a complex characterization?

"Oh, he's a friend of ours." Laughing: "That's very easy."

Jaoui's equable treatment of the characters extends to those that she herself plays. Directors who are good at directing themselves may be common in comedy, but in drama they're much more rare. The temptation to throw oneself an extra close-up or two (or ten or fifty) or some tender moment of beautiful introspection has been Barbra Streisand's undoing, certainly. Jaoui is able to strike a balance because, she says, she wouldn't dare do otherwise, and because "Jean-Pierre wouldn't allow me to do it." She also seeks the advice of others when choosing which of her own shots to use, "because sometimes you think you're so beautiful there and so moving there, and others say, 'No. Not at all.' So you're not always a good judge." Nor does Jaoui make the opposite mistake of being too self-effacing.

A good example of her smart use of herself comes in *The Taste of Others*, in the scene in which Jaoui, who plays a barmaid, watches by an upstairs window as the man she has been dating gets out of his car, on his way out of town, and walks to her door. If he rings the bell and comes up the stairs, they'll probably be together for years, or forever. If he doesn't, they'll never see each again . . . And at the last minute, he decides to walk away. Jaoui puts the camera on herself, in medium shot, as she turns from the window and leans against the wall. This is the end of hope, and one of the film's climaxes. It's very affecting, and yet when you go back and watch the scene again, you see that it's only a few seconds. Just enough time and not one second more.

Whenever I watch a movie written by Jaoui and Bacri—or rather, think about it, having seen it—I am always struck by how they manage to hold audience interest without conventional narrative hooks. Their

films have stories, of a kind, but not ones as to make audiences watch in the conscious anticipation of seeing some plot point resolved. Instead, their movies drop us into a world in which ten or a dozen characters are going through various emotional and professional crises. And, ultimately, at a place that seems to make perfect sense, though it's never clear exactly why, we leave them to go about their business, and the movie ends.

Actually, this is a familiar cinematic recipe—but for bad movies. The vast majority of filmmakers who make films in this way end up with an awful mess, with one or two good characters and a few scattered moments of interest, at best. But Jaoui's films are held together by the strength and specificity of the characters, by the quality of the individual scenes, and by a certain thematic integrity, which might barely register consciously with the viewer. "We start with what we want to say," Jaoui said. "Then we want to hide [it]."

No writing is easy, but this way is particularly difficult, because it requires a certain intuition just to know the thing will hang together once it's on its feet:

Sometimes we spend two or three months working on a theme, and then we discover that we have little to say or that the message we have is not very interesting. *The Taste of Others* was supposed to be a thriller—for two or three months, we wrote a thriller. Then we discovered that the message of the thriller had to be in the head of somebody who just wants money. We didn't know what to do with that. It was just cliché on cliché on cliché, full of American movies in my head, so we just said, OK. Let's stay with the characters, but let's do another story.

When I spoke to Jaoui in September of 2010, she said she and Bacri had been working on a new screenplay for a year and only then had begun writing the dialogue.

FOR ALL THE HUMANITY OF HER FILMS, there is something merciless about Agnès Jaoui on screen. She often plays women who are smarter than their situations and exasperated by the inferior people surrounding

them. Personally, I like this—she always has her reasons—but it rubs some viewers the wrong way. When she played Elisabeth in *The Role of Her Life*, Jaoui thought, "She's not so bad. Then I discovered that all the audience was saying, 'Thank God, you are not like this woman.' People always identify with the poor and the not-successful."

This experience was repeated when she played a feminist author coping with a bumbling, incompetent documentarian in *Parlez-moi de la pluie*:

I mean, maybe I'm very antipathetic—no, no, really, I'm not fishing for compliments—I'm really sincere. I notice in my movie a lot of people didn't like this character. I think the last journalist I met told me, "Why did you write for yourself such a nasty character?" And I told him, "But it's *me*, I love her." People identify with the weak. Each time I'm playing a strong woman, people don't like me so much. Some yes, but a lot? No.

Off screen, Jaoui can turn this mercilessness on herself. In *Parlez-moi de la pluie*, one of the characters refers to her as fat. You don't need to be an expert on marriage to know it was Jaoui and not Bacri who wrote that line. In 2005, Jaoui starred in *La maison de Nina* (2005), a fact-based film that she did not write or direct, about a woman who ran a home for Jewish children orphaned by World War II. There is a scene in which she finds out, for the first time, about Auschwitz—an American officer shows her footage shot by the liberating army. I was impressed by Jaoui's reaction in the scene, but she talked me out of it. "It was, as usual, at the end of a day. We didn't have one second to do it, and we did [one or two] shots, I don't know. I was not happy with what I did."

Jaoui's aggressive intelligence, her cutting honesty and her impatience with anyone in her way all contribute to making her not the most immediately lovable of screen presences, but any negative impression is usually leavened by the fact Jaoui is almost always on to herself. Her women are too smart and too honest not to see through to their own faults as well. On screen, she has a particular power: Love her, like her or neither, you can't help but come away feeling that, if she were to like *you*, it would probably mean something.

IN THE UNITED STATES, we have only a few notable women directors, but with the boosterism that seems to be our birthright, we take victory laps over symbolic breakthroughs, such as Sofia Coppola's Oscar nomination for *Lost in Translation* or Kathryn Bigelow's Oscar win for *The Hurt Locker*. Meanwhile, the gender imbalance in the American film industry remains enormous, and this disparity remains an impediment to actresses looking for suitable work on screen.

American actresses need women directors today more than they did in the studio days. Since the collapse of the studio system, films have been generated by directors, writers or individual producers, not by studio heads looking for products by which to showcase individual star-employees. If the director or screenwriter is a man, more often than not the film will revolve around a male protagonist. There may be a woman somewhere in the story, a wife or a girlfriend, but the supporting players will also be male and the story will, at least nine times out of ten, revolve around male concerns presented from a male perspective.

There is an ideal symbiosis currently at work in the French film industry that doesn't exist in the United States. A strong base of women stars is there to support the efforts of women directors, and women directors provide vehicles through which the stars reach audiences. And both are supported—this is crucial—by a public interested in their work. Needless to say, without the public's interest, there would be no product. Yet, at least to some degree, the reverse must also be true: Without the product, there could be no interest. People can only develop an interest in the work of certain artists if proper work exists to showcase them.

An in-depth study of women directors in France is outside the scope of this book. Their prevalence with regard to actresses is more a contiguous than a concurrent phenomenon. However, it is safe to say that fully a third or more of the actress vehicles filmed today in France are directed by women, that this number is increasing and fostering women in French cinema, and that the presence of a woman behind the camera, whatever she happens to be directing, is no longer seen as a novelty.

Women directed many of the films already mentioned on these pages. Diane Kurys made *La Baule-les-Pins* (Baye, Tedeschi), *The Children of the Century* (Binoche), and *Après l'amour* and *Entre Nous* (both Huppert).

Catherine Corsini made *La nouvelle Ève* and *Les ambitieux* (both with Viard) and *La répétition* (2001) (Emmanuelle Béart). Tonie Marshall made *Venus Beauty Institute* and two other films with Nathalie Baye—*Enfants de salaud* (1996) and *Passe-passe* (2008)—as well as *France Boutique* (2003) (Viard).

Nicole Garcia made *Un week-end sur deux* (Baye) and *Place Vendôme* (1998) (Catherine Deneuve). Laetitia Masson made *En avoir (ou pas)*, *À vendre*, and *Love Me* (2000) (all with Sandrine Kiberlain). Jeanne Labrune made *Beware of My Love* (Baye), *Tomorrow's Another Day* (2000) (Baye, Carré), and *C'est le bouquet!* (Kiberlain).

Claire Denis made *Nenette and Boni* (Tedeschi), *White Material* (2009) (Huppert), and many other films. Catherine Breillat, who specializes in provocative films dealing with taboo sexuality, made *The Last Mistress* (2007) (Asia Argento), *Sex Is Comedy* (2002) (Anne Parillaud), and *Anatomy of Hell* (2004) (Amira Casar). Anne Fontaine, whose films are fairly popular on this side of the Atlantic, made *Coco Before Chanel* (Audrey Tautou), *Nathalie . . .* (Béart, Fanny Ardant), and *Entre ses mains* (Carré), among other titles.

This is not an exhaustive list. It is barely the beginning of a list, and I curtail it both in the interest of space and in recognition that readers skip over lists anyway. But I should also mention actresses who have turned to directing, starting with those who have gone on to make it a main artistic focus. Noémie Lvovsky, a familiar presence as a sardonic supporting player, has made two films with Tedeschi, *Oublie-moi* (1994) and *Let's Dance*, as well as *Les sentiments* (Baye, Carré). Josiane Balasko, an accomplished comic actress, has written and directed a number of her own vehicles, including *Cliente* (2008) (in which she has a supporting role opposite Nathalie Baye). Zabou Breitman, a glamorous dark-haired actress, has made a number of somber and effective dramas, such as *Je l'aimais* (2009) (Marie-Josée Croze), *Se souvenir des belles choses* (Carré), and *The Man of My Life* (2006) (Léa Drucker).

Among actresses we still think of primarily as actresses, Sophie Marceau, Brigitte Roüan, Valérie Lemercier, Tedeschi, Bonnaire, and Ardant have all directed films, some more than one. So has Valerie Donzelli, who rocketed to prominence in 2011 with the Cannes debut of her autobiographical drama, *La guerre est déclarée*.

Jean-Luc Godard once said, "The history of cinema is boys photographing girls." Photographing girls is something that Godard himself did exceptionally well, and it's a history that for many reasons can be embraced and celebrated. The male gaze can be coldly voyeuristic, but it can be also full of love and fascination and a celebration of mystery. Much of the allure of Anna Karina is of Godard's seeing Anna Karina, and the same can be said of Von Sternberg's seeing Dietrich, or any of Greta Garbo's silent film directors' responding to the challenge and phenomenon of Garbo.

There is no one way of seeing. Nor is there a right way of seeing. Yet simply to accept the notion that both the male and the female gaze are equally valid and equally to be valued in cinema (and in life) is to welcome with relief the rise of women directors. Needless to say, there are whole aspects of human experience that women are much better positioned to explore, including friendship between women, anxieties about women's careers, women's parenting and aging, women's social concerns and, as in the work of Kathryn Bigelow, men as seen through women's eyes. Likewise, though romance may be of equal concern to both sexes, a woman's perspective will inevitably be different. For example, Brigitte Roüan's take on the issue of adultery in her startling *Post coïtum, animal triste* has aspects that a male filmmaker would hardly consider.

But adultery in cinema is a very special subject, one that's rarely ever about adultery alone. It's a big topic deserving separate consideration.

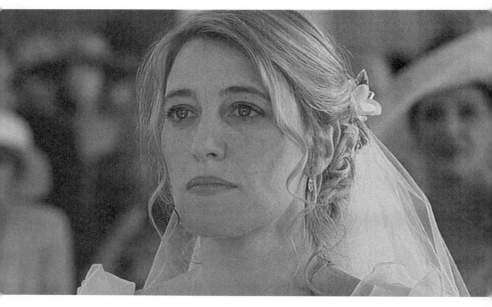

Valeria Bruni Tedeschi as a bride in François Ozon's *5x2* (France 2), 2004.

11 Marriage and Adultery (Same Thing)

Aman and a woman see each other on the street after fifteen years, and proceed to blow up their lives. They had a romance in their twenties. Now they're married to other people, but the magnetic force between them is too strong to resist. What follows is ninety minutes of on-screen agony and ecstasy, mixed with shades of irony, as the two decide to run off together (to Barcelona), then one backs off, and then years pass, they meet again, and the whole cycle threatens to repeat once more.

The film is *Les regrets*. It stars Yvan Attal, who is the best French actor out there for playing reasonable men in the grip of unreasonable obsession, and Valeria Bruni Tedeschi, who has precisely the right combination of turbulence, idiosyncrasy and sensuality to drive a middle-aged man out of his skull. The film's director, Cédric Kahn, is known mainly for action movies, and the romantic interludes are played with that kind of visceral charge. We watch and think, well, how could they help it?—even as the story takes pains to make nothing easy for the man. His wife (Arly Jover), for example, is perfectly nice and doesn't deserve this betrayal, and she is quite pretty—she has everything Tedeschi has, except whatever it is that Tedeschi has. But, as we all know from French cinema, sometimes love is like an epidemic, leveling everyone in its path.

Les regrets was never released in the United States, not into theaters, not even on DVD. And no movie anything like it was made and released in the U.S. that year. But that same season, the fall of 2009, saw two other prominent films released in France concerned with women in adulterous re-

lationships: the aforementioned *Partir*, in which Kristin Scott Thomas leaves her husband (Yvan Attal, of all people) for Sergi López, and *Mademoiselle Chambon*, with Sandrine Kiberlain as a single woman coming between a married construction worker and his wife.

The following statement might seem absurd, but to watch the various cinemas of various countries at different times is to see this tendency borne out in practice: The sympathetic and understanding depiction of adultery with regard to women, whether in the role of Other Woman or faithless wife, is virtual evidence of a film culture with a mature attitude toward sexuality and a more-than-feigned belief in women's equality.

Now finding something good to say about women lying and betraying their husbands or busting up other people's marriages—in real life— isn't easy. At the very least, adultery is not a heroic practice. But adultery movies are about more than adultery, and they express values beyond the notion that on some occasions it's all right to do whatever you want. Specifically, the nonjudgmental presentation of a woman's infidelity indicates a culture's understanding that women can have overwhelming passions, irrespective of social or moral strictures, and that the actions resulting from these passions are worthy of interest, depiction and examination. Such sympathetic treatments assert, simply as a matter of course, a respect for women's sexuality as something of equal importance, urgency and emotional complexity as that of men.

We would expect this attitude to be present in any western cinema. Yet in America, for all the lewdness of our current culture, we remain uneasy, or at least judgmental, about women's lust. In our movies, even an *unmarried* woman who chooses to have sex for purely carnal reasons is usually presented as evil, pathetic, dangerous—or too frivolous to be the lead character. With married women, the situation is more constrained. Under the reign of the Production Code (1934 to 1968), cheating women invariably ended up either as alone as Anna Karenina, or as dead. Still today, you will have a hard time finding a comedy, for instance, in which a married woman (even one estranged from her husband) has an affair. (Sex can *almost* happen, but if it actually takes place, the movie must become a

drama.) A comedy like *Ah! Si j'étais riche,* in which an estranged husband and wife (Jean-Pierre Darroussin and Tedeschi) have wild sex with other people and then return to the marriage bed in time for a happy ending, is as foreign to the American mentality as a medieval samurai epic.

In France, stories of adultery place women in a pressure cooker, so that their lives and values are revealed—as in the film alluded to at the end of the previous chapter, Brigitte Roüan's remarkable *Post coïtum.* Roüan, who wrote and directed, played an attractive book editor in her late forties, who meets a handsome man some twenty years her junior and just can't control herself. She consents to a dinner date, even though she is married and has two kids, and just as she is retreating to the ladies' room and telling her own reflection what an idiot she is, the young man bursts through the door, and they have sex in one of the stalls.

We're seeing lust, but this is about something else, too: For the rest of the affair, she is as hapless and delighted as the early Woody Allen when presented with the possibility of erotic transport. In one scene, the young man leaves the bedroom and Roüan instantly undresses and arranges the lighting—she does this in a comic frenzy, like Allen in *Play It Again, Sam.* Roüan, the filmmaker, is not operating within an artistic vacuum. She knows that such scenes are usually played the other way, from the male perspective. In playing it her way, she is making a statement that women can want what men want—and they can feel the same about wanting it.

But if Roüan had stopped here, *Post coïtum, animal triste* would have been merely a programmatic role-reversal comedy, with a pat message not unlike something you'd find in a Hollywood film. Instead, Roüan takes her premise to the next step: When the affair ends, the film's tone shifts, and the heroine goes into a near-suicidal depression that ruins her career and damages her marriage. Even a woman who wants what a man wants, Roüan is saying, does not have a man's emotional nature. Roüan's film starts off as a comedy about adultery, but that's just a pretext for the film's examination of the similarities and differences between men and women with regard to love and sex.

In this way, the movie examines the strengths and vulnerabilities, thoughts and romantic aspirations of a woman at the door of fifty. In a scene familiar to every woman of a certain age, yet almost foreign to cinema, Roüan looks at her face in the mirror and pulls at her skin: "Time for a reconstruction." Then she opens her shirt and casts an eye on her breasts: "Hello old men," she says. Ultimately, when the "reconstruction" comes, it's of a healthier variety—a reconstruction of the spirit, a move back into the world.

THERE IS NO SINGLE ATTITUDE toward adultery in French cinema, except to say that it's something that happens. It happens in different ways and for different reasons and to all kinds of people. And there is no set of specific lessons to be learned from it. Indeed, taking scenarios on a case-by-case basis, the lessons learned may be in complete opposition. Depending on the circumstances and the people concerned, the same action can be wrong or right. It's just a matter of who is doing what and why.

This subjective, case-by-case approach is one with which tens of millions of Americans would probably concur. Yet our films almost invariably take the opposite view. American films tell us that, although we may think our circumstances unique, in the end they wind up illustrating eternal verities—verities that we should have paid attention to before we lost control and slipped over the edge. French filmmakers, because they don't feel impelled to glean a moral lesson from every circumstance, have the freedom to be more specific and detailed in presenting adulterous situations, even if those details make us more uncertain as to the proper course, not less.

The point is that sometimes, as Madame de Staël once said—no surprise that a French woman said it—to know all is to forgive all, which is why American filmmakers sometimes make sure not to know all: it can be artistically inconvenient. But the French embrace ambiguity, almost reflexively, and sometimes with lovely results: In Zabou Breitman's *Je l'aimais* (2009), a traveling French businessman (Daniel Auteuil) falls in love with his translator (Marie-Josée Croze) over the course of a meeting, and in a way that is obvious to everyone in the room. The affair starts—he's

married, she's not—and over time it becomes clear that this love is real and enduring. Still, he is torn. He has a wife and child. When he tries to leave his wife, she becomes so distraught it alarms him, and so the status quo is maintained for a number of years, until the mistress can no longer endure this shadow life. By the end, you feel sorry for every character in the film—for the wife, who deserved better; for the other woman, who loved a man she never really had; and for the man, who lost the love of his life. There is no *point* to the movie, no larger message beyond "This is something that happened" or, perhaps, "This is the kind of thing that happens." Still, those happenings are rendered in such rich and heartfelt detail that it happens to us, too. And so our experience and understanding are expanded.

Adultery in movies is always about the desire for more. It can be presented as cheating, as the "more" that's forbidden. Or as tawdry, the "more" you should not want. It can be presented as love, as the "more" you always deserved and finally are getting. When the cheating partner is a man, it's possible he might be a louse—in *Le grand alibi*, for example, the serial philanderer, played by Lambert Wilson, is murdered, and there is no sense of a blessed spirit leaving the universe. However, when the cheating partner is a woman, the treatment is almost always sympathetic, because there's usually a compelling reason. That is, unless the film stars Isabelle Huppert—Huppert is her own reason. In *Madame Bovary, Story of Women, Gabrielle* and other films, Huppert acts mainly out of boredom and contempt. *Gabrielle* contains a classic Huppert moment, in which she sits, expressionless (of course), listening to her husband (Pascal Greggory) lecture her about her affair. When, with great ostentation, he arrives at his conclusion—"I forgive you"—she explodes into laughter, and what a wonderful laugh it is, one of childlike delight and infinite amusement. That moment could be transposed, without much difficulty, into a half-dozen other Huppert films.

Adultery can also be presented, as in *Mademoiselle* (2001), as a self-contained entity, a moment in time with its own pains and satisfactions, something that happens once and then exists only as a secret, pleasant

memory. In this film, from director Philippe Lioret, we get the story in flashback, as the memory of a wife and mother recalling an interlude that took place just a few years earlier. A business executive (Sandrine Bonnaire), away from home at a convention, falls in with a group of traveling entertainers and, by chance and circumstance, ends up spending the day with them. Soon she develops a rapport with Jacques Gamblin, a moody and rather guarded actor—what he seems to be guarding, none too well, is his immediate attraction to her.

The French are very good at depicting the power dynamics within relationships, mainly because they're willing to admit such dynamics exist. In *Mademoiselle*, Bonnaire is in the power position throughout, a power that she wears in such a nice, relaxed way that we might not notice it as such. Though happenstance keeps throwing her and Gamblin together, her decision to skip the late train and take another train the following morning—so that they can sleep together—is her own. This is not an American film, in which the decision to have forbidden sex is almost always just a caving into irresistible impulse. After deciding that the lovemaking will take place, she also signals when it's to start. Such is the movie's matter-of-fact romanticism and Bonnaire's essential probity that we never think of the story in cold-blooded terms, as that of an upper-middle-class woman who cheats on her husband in a onetime, premeditated way with a low-level entertainer.

Another scene you would never see in an American film, though it could just as readily occur in American life, comes the next morning as they wait in a station café for their respective trains. Her hair is wet and pulled back and she looks worse than she has looked at any point in the movie, as of course she would: It's seven in the morning, she has been up half the night, and she just took a quick shower before leaving for the station. The two sit, morose and smoking, though he is more morose than she, because she has a life to return to. ("Are you married?" she asks. He answers, "After last night, yes.") These are the last minutes they'll ever spend with each other, but with the real yet artificial intimacy that sex brings, they're together as they would be on this morning after, outside

the realm of mystery, no longer looking only into each other, but as a kind of temporary unit, looking out at the world.

I suppose Bonnaire finds herself in films about adultery because it's so easy to picture her as a wife. In her next film for Lioret, *L'équipier*—based loosely on a story that Bonnaire alludes to in *Mademoiselle*—Bonnaire was a lighthouse keeper's wife who falls in love with her husband's handsome young assistant. Again, it's one of those things: There is nothing wrong with the husband, just an emptiness in her life that the new man is able to fill, at least for a time. In 2008, Bonnaire said the following, not only of *L'équipier*, but also of love in French films in general:

Love gives you something better, even if it doesn't work. We have this kind of optimism about love—it's very French. Even if we know it won't work, it's good to try anyway. Maybe it's more calculated here [in the United States]—if you give something, you have to receive something—America is like that. In France, you can give something, and if it doesn't work, it's better than nothing.

These twin Lioret/Bonnaire adultery films have something in common. They're both movies about a woman, but they're directed by a man, from scripts written by Lioret in collaboration with other men. And they present the aftermath of an adulterous liaison in terms distinctly different from the devastated picture given us by Brigitte Roüan in *Post coïtum*. Perhaps Lioret is not really giving us a woman's story at all, but a man's experience with the sexes reversed. Or perhaps he is merely giving us a fantasy. In any case, there is something arresting even in this and in the simple dignity that Bonnaire, almost innately, brings to these roles.

MATHILDE SEIGNER, one of the most commercially popular French actresses of recent years, has devoted much of her career to playing married women who are unhappy or dissatisfied. Seigner is a screen presence with lots of power. She is usually stone-faced, often angry. Occasionally she does smile, but it almost seems like it hurts her face to do it. Whatever her characters do on-screen comes with an implicit assumption that

they have a right to do it—and with an added quality of assertion and a hint of exasperation, as if in awareness of others who might disagree.

Playing supporting roles in early films such as *Venus Beauty Institute* and *Alias Betty*, she was typed as something of a floozy. She has a face—or a body—that suggests an improvisational morality. At the start of the last decade, it might have seemed that Mathilde would always remain in the shadow of her older and more patrician-seeming sister Emmanuelle, who began her career working for Godard and became famous in the films of her husband, director Roman Polanski. But ultimately, Mathilde emerged as the one with a greater hold on the public imagination, an actress with a decidedly middle-class quality, whose self-assertion—like that of Julia Roberts in America—seems on behalf of more than herself or her characters but on behalf of unseen millions who see themselves in her portrayals.

Curiously, her best film and arguably her breakthrough, *The Girl from Paris*, (2001), had nothing at all to do with sex or marriage. It was about the relationship between a young Parisienne who buys a farm and the old farmer (Michel Serrault) who, at first skeptical, comes to respect her new methods and old-fashioned tenacity. *The Girl from Paris* provided a beautiful meeting of a role and an actress. Seigner looks tough enough to work the land. She looks like she can take it, but she also looks in her element. The film shows that Seigner's particular brand of on-screen power needn't be confined to comedies and dramas of sexual transgression, that to some degree she has been typecast.

And what a trail of destruction she has paved: In *Mariages!* (2004), she cheats on her husband—at a wedding!—and isn't terribly pleasant with her lover, either. In *Palais royal!*, Valérie Lemercier's satirical take on the life of Princess Diana, she is the sleazy longtime mistress of the Prince. In *Détrompez-vous* (2007), she is utterly shameless as a married woman having an affair with a married man (Roschdy Zem). In *Quelque chose à te dire* (2009), she is a talented painter who has had "one abortion after another" and busts up a man's marriage (though she does stay with him in the end). A hallmark of Seigner's interpretation of these roles is that she never shows the slightest moral uncertainty.

Danse avec lui (2007) reversed the pattern, with Seigner as the wronged spouse in an agonizing and well-acted opening scene. The film is actually a kind of hybrid of Seigner's usual material and *The Girl from Paris*, her best film. It's a domestic drama that moves to the great outdoors, with Seigner, now on her own, returning to the land and learning life lessons from an old man—in this case, Sami Frey, who teaches her to become a horsewoman. Once again, Seigner, who radiates athleticism and vitality, seems at home in the outdoors setting.

Charlotte Gainsbourg has been somewhat less transgressive in her on-screen marriages. She made two films costarring her longtime partner Yvan Attal, both times as his wife in a film dealing with adultery. In *My Wife Is an Actress*, which was popular in the United States, she played a film star whose husband is obsessed with fear that she might cheat on him with her costar, a ladies' man. But unlike what would happen in an American film, she almost certainly does have an affair (even if there is a touch of Gallic ambiguity). "There is that scene where he says, 'Did you sleep with him?'" Yvan Attal recalled. "And she says, 'No.' He looks at her, and he says, 'You're a great actress.' Because maybe she can lie to me. Maybe I can believe her. He doesn't know . . . but he loves her."

. . . *And They Lived Happily Ever After* (2004) was ungainly and less pleasing, but it was more ambitious, focusing on a seemingly happy marriage in which the husband finds himself irresistibly drawn to another woman. As the wife who knows something is wrong, Gainsbourg had a vehicle well suited to her intuition and sensitivity. "We end up [back] together," Gainsbourg said, in our 2009 interview, "but it's very cruel. For me it was a horrible ending, because he's having this affair with his mistress, and it goes on at the end. In the French version, he makes a phone call to his mistress, even though they're happily back together."

Gainsbourg, whose vibe is quite bohemian—she looks like a younger, prettier Patti Smith—is very often, and quite effectively, cast as wives in conventional marriages. Perhaps it's precisely Gainsbourg's cutting-edge aura that makes her domestication appealing to people. Gainsbourg, when cast as a wife, just by her essence implies that the character's life

doesn't represent a compromise to convention but the intelligent choice of a free-thinking woman who just happened to find happiness within a conventional arrangement. In the process, Gainsbourg suggests a whole generation of new women bringing a different kind of value and sense of themselves to the institution.

"There's a very innocent way of thinking about love at first," Gainsbourg said, contrasting the French cinema's treatment of marriage with the American. "As a young woman you think that faithfulness is the most important thing. You just grow, it becomes a bit different. We don't tend to have this morality—or we do have it, but it becomes second."

IN *ANNA KARENINA*, Tolstoy famously wrote, "Happy families are all alike; every unhappy family is unhappy in its own way." Yet, though one should not lightly start an argument with Tolstoy, I wonder if the opposite might not be the case. After all, families, and to be specific, marriages, most often fracture along familiar fault lines: money, in-laws, infidelity, substance abuse, domestic violence. Meanwhile the alchemy of a happy marriage is a mystery even to those in the midst of one, and certainly there is nothing more unfathomable than *other* people's happy marriages, even those of our closest friends. Far from being too small, trivial or common for art, marriage is too big for it, too subtle in its movements, too specific, too private and too elusive to be fully summarized or understood. To write about "marriage" is like writing about "life," too enormous an enterprise. Only when marriages crack along established patterns are the pieces small enough to be digested by art. Then with that come all the opportunities for nuance and detail, the handling of which will make a masterpiece, a cliché or something in between.

For this reason, marriage as a cinematic subject is almost synonymous with adultery. It's the easiest way into the real subject, marriage itself, the most readily dramatic way of exploring the mystery of that intimacy, its creation and destruction. Therefore it's no surprise that one of the best recent films about marriage is about adultery as well—François Ozon's *5x2*, which chronicled the genesis and disintegration of a marriage in five

scenes, told in reverse order. It begins with the finalization of a couple's divorce and ends, five years earlier, with the two on the beach in the first glow of mutual attraction.

In the backwards structure, adultery doesn't enter the picture until four-fifths into the film. On the couple's wedding night, the wife (Valeria Bruni Tedeschi), feeling restless, goes for a walk around the hotel grounds and ends up having sex with a total stranger in the woods adjoining the property. In Ozon's take on the situation, this act—spontaneous, immediately regretted and never revealed—becomes this marriage's version of original sin. It's the poison that dooms it from within, an event that the husband never knows about and yet seems to intuit unconsciously. When the wife gives birth, the husband takes an unreasonably long time getting to the hospital, as if understanding on some animal level that the child isn't his.

As the wife, Tedeschi's reverse journey—from life fatigue and disdain, to cynicism and resignation, to confusion, to womanly joy and enthusiasm—is full of emotional insight and fine technique. In addition to the psychological penetration, Tedeschi brings a perceptive physicality to the role. You understand what it feels like to inhabit the body of the tired, middle-aged woman at the start of the film—and the joy and confidence of the young married woman who dances at her wedding and anticipates a life of happiness and sensuality. Ozon closed down production between the filming of segments three and four to allow the principals to lose a little weight and get into optimal shape so they could look five years younger. By the end, Tedeschi makes us believe that she's practically a girl. It's not just her appearance; it's the lightness of her spirit. This is a performance of inspiration and intellectual precision.

French cinema continues these explorations of marriage and adultery. I was in Paris in the fall of 2010 when Antony Cordier's *Happy Few* happened to open, a film about two couples switching partners. It's particularly graphic (to my eyes, either actress Marina Foïs really does have intercourse on screen with one of her costars or Cordier cast her opposite the one actor in France who doesn't have a penis), and it concerns ideas

that Americans have not looked into since the early seventies: Is there an alternative to monogamous marriage? Can two couples fall in love and trade partners within a closely knit circle? Could they maintain such an arrangement, or would they give way to jealousy and suspicion? And if so, would the jealousy and suspicion be a consequence of the arrangement or a manifestation of the simple weakness of people unable to overcome their own cultural indoctrination?

Happy Few is not even a particularly good film, but I do like that in France you can make a movie like this and expect to sell tickets. In America, such a film would not be possible, not because Americans are prudish—though if it were remade here, it would definitely have a moral of some kind—but because American audiences would not be interested. By the time most Americans are old enough to see a movie like *Happy Few*, they have made the transition from believing in sex to believing in money. Far from too sophisticated, *Happy Few* might actually be naive.

The French never seem to make that transition from sex to money, at least not completely. Their loyalty to sex is lifelong—as if the world depends on them for that.

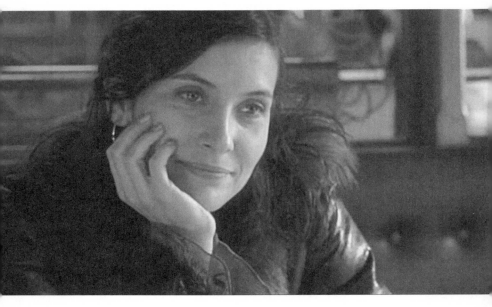

Géraldine Pailhas in *Le coût de la vie* (M6), 2003.

Géraldine Pailhas
and Building a Career

> You know Géraldine Pailhas? I think she's a great actress.
> I like her mystery.
>
> Sandrine Kiberlain

F RENCH CINEMA IS SO RICH in opportunities for ac-
tresses of talent that a career needn't build quickly,
with a few star-making turns. It can build slowly, over the course of years.
An actress can make the most of ensemble and supporting parts, grow
in popularity, grow in ability and ultimately find herself, some ten years
down the line, in possession of a major career. A good and particularly
satisfying example of this phenomenon is the case of Géraldine Pailhas.

Pailhas was still in her twenties at the turn of the millennium, but by
then she had already been in films since the early 1990s. She had achieved
a respectable degree of success, critical notice and professional acknowl-
edgment. But it would take most of her thirties for a full sense to emerge
of what Pailhas meant as an actress and what a Géraldine Pailhas movie
brought to cinema.

Pailhas on screen is practically a mood or state of mind, a calm but
alert reflection gazing out on confusion. Usually, though not always, she
plays shy or quiet women. Invariably, she plays women with a quality of
reserve and watchfulness. What Sandrine Kiberlain admires as Pailhas's
mystery seems to consist of an innate dignity, a placidness, and an abil-
ity to think and process thought on camera—combined with a distinct

yet natural and unadorned beauty. Pailhas has a stillness and a softness, an internal quality that draws in viewers.

This is what's great about Pailhas on screen. What's great about Pailhas in person is that she is nothing like the way she is on screen, which means it's possible to ask her about her work and get an answer. Anticipate someone quiet, inward and introspective and what comes through the door is someone exuberant, full of enthusiasm and laughter. There is no aura of mystery. Somewhat taller than she appears on screen (perhaps 5′5″) and less delicate-looking, Pailhas is completely down-to-earth and talks with considerable animation, in a voice slightly husky from years of smoking. The smoking, the impassioned talking, the gesturing and liveliness might suggest, on the page, a nervous personality, but that's not the sense that one gets. Pailhas rather gives the impression that she is bursting with energy, intellectual, emotional and instinctive, and that she is very much awake to everything around her.

"I think most of the time the thing I do, which I think I'm not too bad at, is to listen to the actor I'm playing with," Pailhas said in a 2009 interview for this book. "I let go when I am in front of the camera. But I *really* let go. When it's done, it's done. It's behind me. I give what I can give to the director, to the movie, and the movie can keep that forever, not me. I abandon that. I think it's the most artistic way of doing it, to become the living object of one movie."

She doesn't consider herself a natural actress: "I'm not sure I became an actress when I actually started to work." But she was inspired by movies as a teenager. "One of the first films I really loved was *À nos amours*. I didn't know I'd be an actress at this moment. I wanted to be *in* the movie. I was so touched by all of it, the images, the sound." Less than ten years later Pailhas was herself working with its director, Maurice Pialat, in *Le garçu*.

Pailhas studied to be a dancer, then switched to acting and broke into success quickly. "It was easy and scary at the same time. I was cast in two or three TV movies, and then I had my first role in a feature film. And I got the César for best newcomer immediately, and I didn't even have time to wish I was in that position."

The film was *La neige et le feu*, a story of resistance fighters in the last days of World War II, with Pailhas cast well as a young nurse who becomes the romantic focus of three men. She was, one might say, not only the film's female principal but its Female Principle, the men's respite and ours from scenes of combat and strife—both a lovely young woman and a kind of all-purpose symbol of love and sex, fertility and nurturing. She was only nineteen when she made this film and already her mature self. The César voters were right to recognize her specialness and to expect big things.

For Pailhas, such instant success "was amazing. And weird. Because I really felt that it went *too* fast. I had the feeling that I was the girl of the year, saying yes to everything, just a charming newcomer who wouldn't last if I didn't take this into my hands. Fame was not my goal. I really wanted to work, and work with people I admire."

And so, having broken into the film world, she hovered in place for a number of years, working steadily but not too often and in particular on projects that attracted her. "I was called 'la discrete'—'We like her but we don't see her enough.' Always written before my name was 'la rare' or 'la discrete.' I was like, I'm not discrete, I'm not rare, I want to be seen, but not in a creepy way."

She had a flirtation with English-language cinema, first as Johnny Depp's love interest in *Don Juan DeMarco*, as an idealized, zombified abstraction; then in *Suite 16*, from the Flemish director Dominique Deruddere, which she enjoyed, though the movie was twisted, misogynist trash: Pailhas played a young woman chosen at random to be murdered by a young hustler, acting out the perversities of a wheelchair-bound sadist (Pete Postlethwaite). Years later, Pailhas is the only reason to see the film. She lost none of her charm in speaking English, and she already had the confidence of a star.

Following that, she returned to France and made the kind of film she wanted to make, *Le garçu*, for Pialat. She initially read for the role with Pialat's wife, who gave her two words of advice just before the screen test—"No intention"—which Pailhas took to mean, "Don't pick anything

from outside, just be in the scene. It was the first time I didn't have to be around the role or come from the outside but really to take it from the inside." Cast as the wife of a mercurial, philandering man (Gérard Depardieu), Pailhas had a number of scenes of emotion that demonstrated she was much more than just an engaging screen presence. "When I had the opportunity to work with Pialat it was like my ideal. I didn't work for a while after that. I didn't know what to do. Nothing had any taste anymore. I had done the thing that I liked the most, so what could I do after that?"

Le garçu was released in October 1995. It would be a year and a half before she would appear in her subsequent film, *Les randonneurs* (released March 12, 1997), a popular ensemble piece about hikers, and then more than two and a half years before her next film, *Peut-être* (released November 10, 1999), Cédric Klapisch's fantasy, set in the then-very-near future of New Year's Eve, 1999. Until *Peut-être*, Pailhas's career had been a series of starts and stops, with promising films and official recognition, interrupted by English-language detours, periods of silence or undistinguished assignments. There was achievement, but no build. From *Peut-être* on, everything changed. It is as if she suddenly became ambitious or found her place and discovered a love for what she was doing. She started working twice as often as she had before, mainly with good directors in prestige assignments, usually in a costarring capacity, sometimes in support, sometimes as the leading lady to the male star. She became distinct; the roles improved, and she continued to grow.

In *Peut-être*, Jean-Paul Belmondo arrives from the year 2067 to the night of his conception, December 31, 1999. He has come to make sure that his parents—young lovers Pailhas and Romain Duris—have sex and conceive him. At one point, Belmondo finds himself at a New Year's Eve party, where he runs into his mother, who, at this stage of life, is a young, sexy woman in a leather skirt. They meet in a corridor and later share a dance, and though the encounter is partly played for laughs (she has no idea why this old man is so emotional around her), it's also quite touching, thanks to the truth with which both actors play the scene.

"I was shaking," Pailhas recalls. "I just totally believed this situation—that there was something about this man that I deeply knew, but it was so deep that I couldn't make it into words. You just recognize somebody. You can't explain. It's just there. It's funny what we can know unconsciously."

Another landmark for Pailhas was her appearance in 2003's *Le coût de la vie* (*The Cost of Living*). It was a supporting role, but a change from the quiet, reserved women she'd been playing—for example, as the confused wife of murderer Daniel Auteuil in *L'adversaire* (2002). In *Le coût de la vie* she was a high-priced call girl who seduces tightwad Fabrice Luchini into coming up with the cash—and in the process, she helps cure him of his stinginess. The role was a gem, just a handful of scenes but all of them fun and memorable, the best in the film.

"This one kind of saved me from the image of the light and shy and proud woman that I was playing," she said. "I wanted to show something else. I'm really not those women. It's not me at all. After a while, it's always weird when you feel that everybody's wrong about you, and they don't see a different level of your personality. I had to fight for [*Le coût de la vie*]. The director was like, 'Okay, I like you a lot, but I don't think you're my character. . . .' I know I was seen differently after this one." For the performance, she was nominated for a supporting actress César, her first nomination since winning Best Newcomer in 1991.

One of Pailhas's favorite roles came the following year in *Les revenants* (2004), an intellectual horror film known in America as *They Came Back*. "They came back!" Pailhas laughs. "That's very American." A thinking person's zombie movie, *They Came Back* had an irresistible premise: One day, in the course of several hours, the dead wake up, leave the cemeteries and start walking home. Pailhas had the role of a woman whose husband returns, and she found herself overwhelmed by emotion in the scene in which she and her husband make love for the first time after his return: "I was suffocating. Really, it was devastating. The idea of this memory of the flesh—it was too real, too concrete, it was almost unbearable. And so we cut, and the director [Robin Campillo] says, 'Why are you in that state? Just don't go through that.' And I couldn't. I was too moved."

Pailhas continued to mix starring and supporting roles through the middle of the decade. She appeared in just one segment of *5x2*, as Stéphane Freiss's long-term girlfriend, soon to be dumped for Valeria Bruni Tedeschi. When she agreed to take the role, she told François Ozon, "'Please don't make me a sad and desperate victim, not again.' He put in little things that I could play with." Instead of being sorrowful and vulnerable, the girlfriend was "harsh and tough, because you can feel that she knows that she's losing, that this couple is breaking up. I like the reaction of this woman. Instead of crying and being hysterical, she was being ironic and aggressive." The result was something more realistic and true to life than what's normally seen in movies—a real investment in the emotional life of a woman we're not necessarily supposed to care about.

Ozon gave Pailhas another gift, a simple moment, but one not usually reserved for ancillary characters. One fateful morning, she and Freiss are supposed to go on a hike together, but he doesn't show up, and with that, she knows it's over. She walks away from a group of hiking tourists and stands apart, on a rocky cliff overlooking the ocean. That is where we see for the first time the vulnerability and fear that she has been covering over with irony and aggression.

GÉRALDINE PAILHAS'S screen quality—the subdued attentiveness, the carefulness, the suggestion of some inner sadness or skepticism—remains fairly consistent, and yet it has shown itself to be nicely adaptive, capable of incarnating a wide range or roles and bringing forth a whole spectrum of emotions. Some performances are hardly worth mentioning—such as the love interest (a superior officer) in *Sky Fighters* (2005), an action film about jet pilots. But 2006 saw Pailhas in a pair of interesting and different films: *Je pense à vous*, as a woman going through marital difficulty (and dreading a tell-all novelist's exposure of her love life), and *Family Hero*, as the angry, resentful daughter of a club owner.

Family Hero, which was written by Pailhas's partner, Christopher Thompson, and directed by Thierry Klifa, gave Pailhas a chance to be outright vicious on screen, not wicked but certainly cruel. Pailhas laughed

at the idea that these men in particular should cast her as a horror show: "It's not only the man I love but my best friend—I see Thierry three times a week. No one knows me better than these two." In one scene, she tears into her father (Gérard Lanvin), taunting him with his financial difficulty and the anticipated loss of his nightclub. "I was like a late adolescent talking without limit," Pailhas said. "I was like, I have to go farther so he might want to slap me in the face." Actually, Lanvin did slap her—but the following year, playing her lover in *The Price to Pay*.

In 2008, Pailhas had the title role in *Didine*, a romantic comedy. French romantic comedies tend to be a little off, to have something harsh and discordant about them, and *Didine* is not exactly outside that pattern. It's amusing, not really funny. It's occasionally unpleasant, occasionally silly. And it was not, it should be mentioned, a hit in France. On the contrary, it was a massive bomb, with only 39,000 paid admissions in the entire country. Yet it is one of Pailhas's favorites of her films, and that makes sense, beyond the obvious reason that it's a completely loving showcase and an unambiguous starring role. What redeems the film above the lukewarm material is Pailhas herself, who gives the film a gentle humanity and is a vision of warmth, beauty and quiet humor throughout.

Pailhas says that director Vincent Dietschy cast her as Didine on the basis of the moment in *5x2* when she takes in that her lover has left her. Something about that aura of loss appealed to him for Didine, a woman in her mid-thirties who rather aimlessly hops from relationship to relationship, ministering to friends in need and going nowhere in her career despite genuine talent as an independent designer. Pailhas's Didine is someone who can more or less function in the world, and yet the fact that she can function at all is almost, in itself, a mystery. She seems without ambition, without drive and without any kind of aggressiveness.

This is, of course, not Géraldine Pailhas. Or at least this is hardly the face that the real Pailhas shows to the world. Pailhas talks fast, walks fast and is full of ideas. At one point she gestures with an unlit cigarette and I watch as it goes from one hand to another, back and forth, back and forth, as she explains some finer point of her process. She is spontane-

ous, not self-conscious; funny, not airy; self-aware, not oblivious; sensitive, but not delicate. Yet *Didine* feels like a modest but definite fruition of something, not a realization of Pailhas herself, nor a realization of her art—that would give the movie too much credit and Pailhas too little. But *Didine* is something like a point of arrival in the enunciation of what it is that Pailhas brings to French cinema: this sensitivity that has taken up residence in a disappointing world and has made terms with it. Pailhas has given us a certain kind of a woman who might not even be an expression of some inner self but is, in any case, *somebody, somewhere*, because we greet her with recognition.

Of course, you cannot spend time with Géraldine Pailhas without wondering why someone like Christopher Thompson doesn't write a role for her that captures her natural vivaciousness and confidence. Actually, her role in Thompson's *Bus Palladium* (2010), as a ballsy record company executive, at least comes close to her off-screen manner. But Pailhas says she isn't looking for the perfect fit. "I'm not able to trap what I am in a few words. That is probably why I'm an actress, because I want to be everything," she said. "Something that I would love to do right now would not have pleased me years ago. My position as an actress, waiting on the other's desire, is something that I like, and if something comes that is not totally satisfying, that's okay. I don't think you have to have everything in one role."

JULIE GAYET has also recently become a full-fledged star after spending her twenties and half of her thirties playing supporting roles or within ensembles or as the star of smaller features. Born in 1972 (a year after Géraldine Pailhas), Gayet was discovered by Krzysztof Kieslowski, who picked her out of a line of extras for a small part in *Blue* (1993). That this should happen is easy to believe, as Gayet has a way of standing out, particularly in person. It is difficult to say whether it's an advantage or a disadvantage that someone in movies should look better off screen, but there is something in Gayet's coloring, and a glow and an electricity about her expressions, that doesn't completely make the translation into

celluloid. She is tall and has a quality of mischief and insinuation about her. Cast as the female lead in Agnès Varda's *Les cent et une nuits de Simon Cinéma*, she was charming in it, but the role was mainly decorative. Gayet first jumps out as a talent in *Select Hotel* (1996), a film about the life and death of a drug addict/streetwalker. It was little seen at the time, but anyone who sees it, remembers it.

"I saw a documentary about prostitution on TV. Documentaries are for me the best tools for actors," Gayet said in 2010. "There are these young women who have been raped, and they get into drugs, and you don't know if they're prostitutes for the drugs or if the drugs are because of the prostitution. I saw the interview, and I was so moved. The woman was my age at the time, and she was completely out of her head. Then I heard someone was doing a film about prostitution, but that he was not looking for an actress, so I lied. I went to a bar and took two beers, and I don't drink alcohol. I said [she rocks in her seat and doesn't make eye contact], 'Hi, my name is Julie. . . .' And I was playing the part."

One can only imagine director Laurent Bouhnik's delight. Here he was looking for an authentic drug-addicted hooker, and in walks one as radiant and healthy-looking as Julie Gayet! Considering his desire for realism, one has to wonder if he'd ever driven through a red-light district and seen what a real drug-addled hooker looks like. In any case, Gayet played the role exactly as such a person might—staying withdrawn and with little hint of any higher thoughts. No wonder she fooled the director, who didn't find out until halfway through the shoot that he was working with a different kind of professional than he thought. "He was reading the newspaper and saw an article about me. He came back on the set the next day screaming, 'Why did you lie to me?' And I was like, 'Come on, you're so stupid that I needed to lie.' How stupid not to want an actor. He wanted a girl from the street, yeah."

Select Hotel became an enduring reference point in Gayet's career. "At the same time," she recalled, "because I was a young actress, people thought I was really like that. Which is a great compliment for me, but they did believe I took crack." It wasn't until eight years later, with the

romantic drama *Clara et moi*, that Gayet arrived, and she has been grow-
ing in prominence ever since, reserved but flirtatious as the narrator of
Shall We Kiss? and tormented as an unemployed woman, estranged from
her family, in *Eight Times Up*.

There are other examples of slow- or late-blooming stars. Anna Mou-
glalis, a young actress with a lot of authority and presence, has mostly
played in support, but in 2009 she brought her authority wonderfully to
bear as Coco Chanel in *Coco Chanel & Igor Stravinsky*. Valérie Lemercier
took years to go from a minor player to a major force. Today she's one
of France's premier screen comedians, hysterical in films such as *Agathe
Cléry*, in which she plays a white racist who finds herself turning black.
Marina Foïs, a comic presence who for years seemed on the periphery of
the film business, has emerged just in the last few years, through a series
of well-played supporting roles (*Le code a changé, Le bal des actrices*), to
be on the verge of real stardom. In 2010, at age forty, she was one of the
partner-swapping quartet in *Happy Few*, a more dramatic film than that
title would imply (they're few, but they're not happy). Foïs took the bulk
of the reviews.

Chiara Mastroianni's slow and steady climb to stardom is of particular
note, in that she faced unique obstacles and temptations. As the daughter
of Catherine Deneuve and Marcello Mastroianni, she grew up with an
impossible act to follow on both sides. With her pedigree, any number of
directors might have been glad to let her go in a glamour direction. But
to do so would have required Mastroianni's competing with her mother's
legend, a hopeless task.

Instead she intentionally started small and pursued a career in more
modest, independent films. "Maybe it was the only way for me to enter
that world in the sense of my mother being so glamorous already," she
said in our 2010 interview. "And I think maybe there was something for
me that I had to find my own identity and that I needed some training as
well. I had to learn, you know? Acting—the first years for me were like
a bellyache. I still have the bellyache, but I do have pleasure on top of it
now, thank God, after all these years."

Warm, loquacious and engaging in person—she speaks English with a French accent, but her unguarded manner seems distinctly Italian— Mastroianni has gravitated toward troubled, anxious, frustrated, and angry characters. "It's true the way my face is done, my mouth is the other way around and there's something very melancholic about my face. So it's true that it's going to be more obvious to them to offer me the part of a victim." Yet these characters have deepened and grown over time, to the point that by her mid-thirties (she was born in 1972), an actress who could have been the Frank Sinatra Jr. or Julian Lennon of international cinema had developed a distinct screen identity.

In recent years, she has become the muse of screenwriter Christophe Honoré, who cast her in *Les chansons d'amour* and then wrote the 2009 film, *Making Plans for Lena* for her (awful, but Mastroianni was good in it). She also appears as herself in Honoré's *Homme au bain* (2010) and, with her mother, in Honoré's *Les bien-aimés* (2011).

The slow blossoming of a notable career is sometimes a matter of a talent finding its way. Sometimes it's a matter of audiences coming into a gradual understanding of who that talent is, and sometimes it's a combination of both. The important thing is that the opportunities are there for this interchange to take place. Not only does it make for more and better actresses, but it provides an environment for completely original and distinct talents to emerge . . . which leads us to an actress named Isabelle Carré and her gallery of eccentricity.

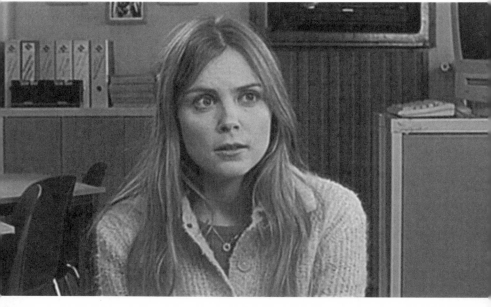

Isabelle Carré in *Se souvenir des belles choses* (Hugo Films, France 3), 2001.

13 Isabelle Carré and Madness

I SABELLE CARRÉ on screen suggests an aging child, one who woke up one morning and saw that she was thirty-five. One who was too stunned to scream and then became amused by her newfound power and said nothing. But one who knows—in a way true adults never do—that the monsters in the closet are real . . . And so beneath the playful surface, she is terrified.

This is Isabelle Carré—an actress who mixes the light and the joyful with the brutal and the uncompromising. Her heroines know the awful truth, and try to block it out, but can't. Carré combines innocence with a deep, deep loneliness. She evinces a happy faith that is always and inevitably in the process of being damaged. There is a scene in her breakthrough film, *Se souvenir des belles choses*, in which Carré is caught in a sudden rain shower. She is a patient in a mental hospital (of course she is), and at the first cloudburst, everyone else runs for shelter, but she runs out into the open, frolicking and shouting and dancing, in a display that is touching and happy and yet grotesque, not true joy but some frenetic attempt to generate its counterfeit and ward off pain. That is the essence of Isabelle Carré.

She was born in 1971 and discovered a love of movies in her teens. "My parents divorced when I was fourteen, but it wasn't just a divorce, it was a mess, a total mess, horrible, a *bordel*," she said in our 2009 interview. "Watching movies, I felt within a structure. Today what I like about horrible roles is that I know what is going to happen in the end, unlike in life."

Carré is very much her own thing and for a long time directors didn't quite know what to do with her. Starting in films in 1989, she had to wait eight years for her first great opportunity, *La femme défendue* (1997). The story of a love affair between a young woman and a middle-aged man, it was shot with a subjective camera as seen through the man's eyes. That meant that the audience's attention was not on the perceiver but on the perceived: Carré. The level of scrutiny was beyond description. Carré had to look directly into the camera and play to it over the course of long conversations, dinners, drives, arguments and romantic encounters. The film announced Carré as an actress of skill, concentration and spontaneity. But as Carré said in 2009, "The role was so special that it did not attract other directors." It also could not have helped that *La femme défendue* was emotionally tame and narratively flat and didn't transcend, or even particularly justify, its experimental nature.

At the turn of the millennium Carré was still misunderstood. In *À la folie . . . pas du tout* (2002), there was a role ideally suited to her—an irrational and dangerous woman who starts stalking a doctor. But the role went to Audrey Tautou, who played it as one might expect, just fine, with her big-eyed *Amélie* stare. Meanwhile Carré, in the same film, had the innocuous role of the doctor's wife. "At the beginning," Carré remembered, "it bothered me to be chosen for roles on the basis of how I look. I'm blonde, I'm soft, I'm easy-going." Fortunately, seven years later Carré got to star in *Anna M.*, which has a scenario very similar to *À la folie . . .*, involving another delusional woman who fixates on a married physician (Gilbert Melki). Carré brought a rigorous rationality to her portrayal of a madwoman, listening fiercely each time he tries to distance himself from her and then, with complete assurance, misinterpreting all he has said as a sign of love. Watching her is genuinely unsettling.

Eventually, Carré achieved a kind of prominence through a succession of small roles. By the end of the nineties, she had already been nominated three times for the Most Promising Actress César (without winning). Finally, in 2001, writer-director Zabou Breitman found in Carré the right combination of qualities for *Se souvenir des belles choses*—an oddly buoy-

ant yet tragic film about a thirty-two-year-old woman who, by some fluke of genetics and circumstance, becomes afflicted by Alzheimer's disease. In one scene, she tries to bake a cake and keeps counting the same three eggs. In another, fighting dementia and groping for words, she pins down the doctor about the true nature of her condition. Carré's concentration is titanic, and it's an affecting spectacle to see such courage and intensity coming from this gentle source.

The end of that film finds her isolated, no longer able to process the meaning of other people's words and speaking only gibberish that, to her ears, sounds coherent. It's a poetic tableau that seems so right for this actress that we should find her reduced to childlike burbling, oblivious and enchanted—and yet on the edge of an abyss of terror once she grasps that everyone is beyond her reach and that she is beyond theirs. This film defined Carré—not in the sense of narrowing her but in the sense of making her comprehensible—and she won a César, for best actress.

With Isabelle Carré, there is always something deeper and more mysterious hiding underneath the ostensibly reassuring and harmless surface. You look at the women she plays, and you understand: There is damage here. Perhaps this damage is also within Carré herself, not more than she knows or can control, but enough so that she understands it and can see into other people's damage—and through it. Her women are often scattered and sentimental, but Carré, in her art, is about as sentimental as a surgeon: She does not operate from pity. In Noémie Lvovsky's *Les sentiments* she played a people-pleasing and impossibly kind young wife whose sweetness has no real warmth behind it, just neurotic, selfish need. She is heartless, but the character never knows this. Carré does. She shows us a character's limitations without having to emphasize them.

Smart directors, like Lvovsky, know how to use this darkness within Carré, whether it's the darkness of mental disturbance or some unconscious malice. Jean-Pierre Améris (*C'est la vie*) cast her as a bipolar housewife in the TV movie *Maman est folle*, a woman who is practically cuddly, but she has the attention span of a child and lives in fear. She took the role, she said, because "it made me think about my mother. My mother is a grand

source of inspiration for me." Carré laughed when she said this, but she was not joking. And so, the obvious question: What is another role that her mother inspired? *"Entre ses mains.* I often think of my mother."

In *Entre ses mains*, from director Anne Fontaine, Carré played a seemingly normal wife and mother—"seemingly normal" is the recurrent pattern in Carré's work—who falls in love with a man who turns out to be a serial killer. As played by Carré, it's not bad luck that draws her to this man. She intuits the violence inside of him, and that is what attracts her. "It's what she needed. She is reborn. When she was an adolescent, she would cut herself. She needs to be hurt to be alive. Finally, she is more mad than he is."

IN PERSON, Isabelle Carré is remarkably nice and unaffected—not nice by movie star standards, nice by people standards. In her manner, she is not unlike the laughing, enthusiastic woman she played in *Les sentiments*, only smarter, more confident and not at all creepy. On the day of our interview, I was told to go to her apartment and was given the entrance code to her building. Needless to say, this is not how we do it in the United States. A French critic who comes to Hollywood will not get invited up the house by Julia Roberts.

When I arrived, Carré stood at the top of one of those endless Paris stairways, wearing sweat clothes and glasses with black plastic frames, and on this day her apartment had boxes of chocolate everywhere. She was preparing to play a veteran chocolate maker and was making chocolate all day and everyday "so that the gesture is credible." The subsequent film, *Les émotifs anonymes* (*Romantics Anonymous*, 2010), would result in Carré's eighth César nomination, though by the time you read this, there will probably be more.

Carré's work combines this kind of inspiration with practical research. For *Anna M.*, she had read a book three years before about an erotomaniac. When the film came along, she read it again and brought the book onto the set with her. "I would read it and re-read it before doing a scene," she said. "I was so touched by it."

Carré's career has not been limited to playing women losing their minds to physical or mental illness. She played relatively unremarkable characters in the romantic comedy *Quatre étoiles*; in Alain Resnais' Alan Ayckbourn adaptation, *Private Fears in Public Places*; and in Bertrand Tavernier's *Holy Lola*, about adoption in China. In recent years, she has shown a new and unexpected color, playing tough working-class women who have nothing in common with her previous characters and who don't at all resemble her off-screen manner. In *Cliente*, she was a hairdresser horrified to find out that her husband has been earning his living as a gigolo—and yet, confronted by economic pressure, she ultimately encourages the husband to go back to his lucrative sideline. Fear, shame and desperation are clear in Carré's performance. Also clear is a certain spiritual shallowness. Carré's unsparing understanding reveals things her characters don't know they're showing.

In François Ozon's *Le Refuge* (*Hideaway*), from 2009, this quality in Carré's acting was yet more evident. She played a pregnant heroin addict, and what I find most interesting is the look in her eyes throughout—the look of someone who could accept this self, this drug-addicted self, as her identity. Carré gives us neither the expected shame nor the equally expected self-assertion and defiance (in reaction to shame). Rather, she gives us the illumination of limitation. She shows us enough so that we notice what is *not* there: A healthy self-respect, an ability and a willingness to engage with the world. Carré does not ask herself the sentimental question that another actress might ask—"How would I behave if I were a heroin addict?" (The answer to that is always the same: "I would be charming. The audience would like me.") Instead, by some odd gift of intuition, she creates someone new, someone rough, hard to know and hard to love.

Carré's insightful portraits of these mad and troubled women, of women living on the edges of experience, make you grateful to a cinema that is interested in exploring such personalities. It also makes you grateful for a cinema capable of providing steady opportunities for its particular and singular talents. Think about this: Carré said she studied Meg Ryan's

superb work in Jane Campion's *In the Cut*, that it was helpful to her in approaching her role in *Entre ses mains*. Sadly, *In the Cut* is likely to remain the highlight of Ryan's career. But Carré had several showcases equal to *Entre ses mains* just in the few years following it.

With regard to Carré, I sometimes think of the American actress Amy Adams, who is also quite talented and is enough like Carré in look, aura and temperament that they would probably compete for roles if they worked in the same country. The play of thought on Adams's face, her ability to show a steady flow of conflicting and evolving emotions in the course of single monologue, is a marvel and demonstrates a rare gift. Certainly, she has a neurotic and slightly tortured quality that French directors would be unable to resist. Yet this actress, who could achieve greatness, continues to find herself stuck at the promising stage and still often appears in schlock like *Leap Year* and the sequel to *Night at the Museum*, or in two-dimensional roles, such as the barmaid in *The Fighter*, which was unaccountably hailed as some kind of breakthrough. The things that are different about Adams make it difficult to cast her in America. Yet what is different about Carré has made her name in France.

TRADITIONALLY, in French literature, madness has often been a way for authors to punish women for transgressive sexual behavior. This motif is difficult to find in contemporary French cinema, though an argument could be made that *L'autre* (*The Other One*), starring Dominique Blanc, falls into that tradition. In that film, Blanc played a forty-seven-year-old professional woman who breaks up with her young lover, for no reason but that she never has been on her own as an adult. But as soon as the boyfriend starts seeing another woman, she begins, slowly, to come undone. Blanc's performance delineates a beeline into mental illness and makes us wonder about the psychic underpinnings of our own lives. At one point, she earns herself a free trip to the emergency room by hitting herself in the head with a hammer.

Then there's divine madness. In *Séraphine*, as the scrub woman turned painter Séraphine de Senlis (1864–1942), Yolande Moreau sat on a tree

branch, looked at the sky and convinced us she was God's instrument. When she painted, it was like watching Harpo Marx play the harp; something else was coming through her. The performance was very much in harmony with the paintings themselves—primitive nature studies with flowers that seemed to be pulsing, suggesting an artist who had come face-to-face with the source of life and existence and had gone both mad and transcendently sane.

Valeria Bruni Tedeschi has been institutionalized twice on screen (*Normal People* and *La parola amore esiste*), but in 2009, she was not quite satisfied with her history of mental illness. "*Les gens normaux* was almost mental disturbance, *La parola amore esiste* was almost mental disturbance," she said in 2009. "But I would love to play *real* mental disturbance."

In *Actrices*, a 2007 film that she wrote and directed for herself, she played a highly neurotic stage star who becomes even more frazzled when she finds out, in the course of a medical exam, that her fertility window is very near closing. Tedeschi described the character's dilemma in this way:

As an actress, if you do a movie, another movie, another movie, another movie, you are protected by the fiction. But that's dangerous. You are in an imaginary world all the time. This character wakes up at the doctor's office and finds out that she didn't come back to earth for years and years. You see, time is not the same when you're doing a movie or a play. It doesn't pass. If you do a play, you come back to the same world, the same scenes. Time doesn't pass—*but it passes.*

ISABELLE HUPPERT's career remains the gold standard for explorations of "*real* mental disturbance." Indeed, just in the new millennium, she has doubled down and incarnated some uniquely sick individuals, however much they all wear the Huppertian mask of implacable functionality. For Claude Chabrol, the actress did what practically amounted to a delicious self-parody in *Merci pour le chocolat* (2000), playing a prim, impeccably polite chocolate heiress whose specialty is drugging people with hot chocolate. Huppert was placidly, peacefully and rather contentedly out of her

mind in that one, and to see her, acting like a space alien impersonating a hostess and offering people refreshment from her scary thermos, was worth the price of admission.

"We never really thought about it as a comedy, but from the first minute of the film I found myself speaking with this strange voice," Huppert said in 2010, "a little bit oversaid, overprojected. I guess that was my way to create—to find a clue to get into the character. I had to find a way of speaking, a little bit slow, a bit too much. Just to make her look a bit strange."

For the final shots of the film, Chabrol stays on Huppert, in close-up, as a single tear runs down her immobile face, as she waits for the police to take her away, either to jail or, more likely, to a nuthouse. Here is one example of Huppert's blankness in which we can't be sure if this is depth taking the form of blankness or actual vacancy. In fact, this is both. This is Huppert actively projecting psychic vacancy and limitation. "The emotion was like something that came through her, it was not a direct emotion," Huppert said. "It was like the strange voice all throughout the movie. At the end the emotion is not real emotion. It was only tears, but it was not like she was crying. It was more like an abstract confession. Not like a first-degree direct emotion, but more like, almost like, a painting."

It is difficult not to see *Merci pour le chocolat* as an invitation, by her favorite director, for Huppert to do Huppert. At a certain point in any great star's screen life, the legend becomes its own reward. The result was undeniably entertaining, and yet it should have told us something: The summation and apotheosis of the Huppert madwoman, when it did come, could not come from Chabrol. Things had gotten too self-referential, too in-house and too enjoyable for that.

Instead, the opportunity was provided by director Michael Haneke, in a film called *La pianiste* and known throughout the English-speaking world as *The Piano Teacher*. It was a film about the limits of art, about a woman of frenzied passion unable to satisfy her longings within the cloister of the conservatory. And so we meet her as she is cracking and is about to crack completely.

"I hardly read the script of *The Piano Teacher*," Huppert recalled. "Michael came up to me and said, 'I won't do it if you don't do it,' which is already very flattering. So I read this script quite vaguely, and I said, 'Okay.' When I was flying to Vienna on the plane, I read the script more carefully, and I thought, 'Oh, my God, what am I going to do with this?'"

In *The Piano Teacher*, there can be no doubting the turbulence underneath Huppert's impassive surface. Every shot, every gesture screams it—she is about to explode. We see her interacting with her students, who assume her to be the kind of exacting but benevolent taskmaster they've seen in movies. We know those movies, too, so we assume the same—until we look deep into that face and know: She wants to destroy them. She undermines one student psychologically and sabotages another physically—by causing her to cut her hand on broken glass. When she listens to conservatory auditions, she listens behind a stone face that might as well be a stone wall. She is defensive, always threatened. In her spare hours, she goes to a pornographic peep show, picks up a used tissue at the bottom of the booth and brings it to her nose. In the bathroom at home, she cuts her genitals with a razor blade. In one memorable moment, she tries to have sex with her elderly mother (or, as Huppert once described it, tries to crawl back into the womb). When she has a chance at a relationship, or at least some pleasant sexual release with a handsome young man (Benoît Magimel), she spoils it by insisting on masochistic games. At the end of the movie, she takes a butcher knife and sticks it into her shoulder, not in an attempt at suicide but in an effort to feel something. "It was such a strong part," said Huppert, "and I was so much in tune with this complexity of feeling."

The performance had such force, depth and courage that thereafter there could never be any doubt of Huppert's towering place in world cinema. Huppert herself notes the film as a "turning point. I really felt there was a before and after. The movie was quite daring and provocative and yet very emotional; otherwise, it wouldn't have been as successful as it was. It really carried an emotional dynamic and dimension, and it was a love story, in very perverse and strange ways."

Drama and comedy are the polite genres, founded on collectively agreed-upon ideas, perceptions and truths. But life, as subjectively experienced, is not like comedy or drama; it is much more disorganized and grand, intimidating and embarrassing. It is much more like opera and farce. Opera shows how we really feel at our most pained or selfish or exultant, and farce reveals how we receive the world in its raw, unsifted form. Or to put it another way, opera is how we really feel about ourselves. Farce is how we really feel about strangers. And both genres tell the true story of life as it is lived.

The Piano Teacher, neither comedy nor drama, was both opera and farce, with Huppert as both diva and *farceuse*. Throughout, Huppert believes and gives passionately, and yet stands back, in full awareness. Life is more than we think, bigger but also ridiculous. The middle-aged woman you see walking down the street, wearing a kerchief, who could be anybody, might in fact be feeling an avalanche of pain and all the rages of hell; she might be writhing with frustrated ambition and professional disappointment and simultaneously be living a life of towering ludicrousness.

Crying is easy. Laughing is easy. *The Piano Teacher* and Huppert are about neither. They are about wonder and shock and making you see—everything.

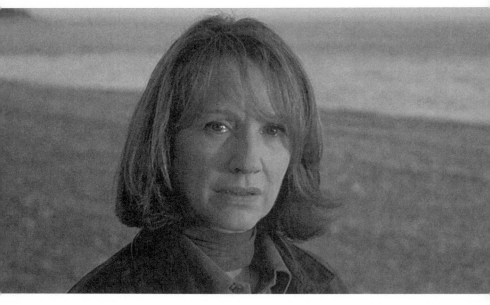

Nathalie Baye in the closing seconds of *Le Petit Lieutenant* (Studio Canal), 2005.

14 Les Femmes d'un Certain Age

I N THE EARLY 1970S, Catherine Deneuve's commercials for Chanel No. 5 were missives from a world of very adult sexuality: *He gives me Chanel No. 5 because I love to put it in a special place . . . behind my knee.* Contemplate, for a moment, how many women started immediately putting perfume behind their knees—in vain. Think, as well, of all the men who started searching for perfume behind knees for years thereafter—without ever finding it. Think of all those lovelorn Americans never meeting each other.

When that first Chanel commercial aired, rooms went silent, as suffering humanity took in the sight and sound of Deneuve with that special ache all of us feel when confronted by something foreign to our lives yet essential to our existence: *He takes me by the waist because he knows it touch me very much. . . . He understands I cannot talk about feelings.* And then, eyes burning through the lens: *He lets me show him in other ways.*

Wow.

This is the image that most Americans have of Catherine Deneuve. She will always be thirty, beautiful . . . and wary. In an era that could be giddy around the subject of sexuality, Deneuve's beauty brooked no nonsense. She was careful, coldly discerning. Yet always you just knew that somewhere there was a guy, someone you could never be or ever meet— probably French or better yet, Italian—bringing her coffee *always in a small cup, because it is precious to me.*

As a young woman, Deneuve worked with directors such as Demy, Berri, Polanski, Bunuel, Truffaut and others. The image of the young and beautiful Deneuve is as indelible and as much a part of the French cultural

consciousness as the image of any screen star, living or dead. Yet there is something about Deneuve in her more recent, older incarnation that I prefer. Too often the routine films of her youth—not the classics, but the typical entries—coasted on her icy beauty. She was not vulnerable then, but she is now. "I am much more touched by her work now than before," Nathalie Baye said in 2010.

In person, Deneuve's reserve certainly looks forbidding, not necessarily unfriendly, but you would not want to test that hypothesis. (I sure didn't, when I saw her at the 2006 Venice Film Festival.) Still, one hears stories—a couple pushing a stroller in Venice, distracted by the city, only to look down to see a woman cooing over their baby. Then the woman stands up and it's—*oh, my God!* Chiara Mastroianni, Deneuve's daughter, having heard all her life that people are terrified of her mother, said that Catherine only *seems* intimidating. "My mother is the shyest person—you would not imagine—and she's funny. Some people, you see something [on screen] and it has nothing to do with what they are for real. My mother is someone who likes to garden, she likes to cook, she likes to play cards, she's *fun*. What she shows on screen is nothing to do with what she is in life."

Even with this description, when I finally got to meet Deneuve in an interview setting I was struck by the distance between the persona and the person. Anyone, particularly an actress, and most particularly an actress speaking to the press, can arrange to be in a good mood. But with Deneuve the difference is not merely one of demeanor but of kind. She's earthy. She's grounded. She's approachable. She has a big laugh and laughs often. It would perhaps be stretching things to say that she is practically one of the guys, but it is far less a stretch than you might imagine. "People who don't know me see me as a very sophisticated, cool person, as a cool French lady, and my daughter sees me in everyday life, on the weekends, in the country, with my friends," Deneuve said. "And she knows the image I have, and [the reality] is not the opposite, but it's very different."

Perhaps that is the secret appeal of the later Deneuve films—that more of the actress's essential self is being revealed. This quality of revelation might be by virtue of the roles themselves or something within Deneuve

that is allowing herself to be seen, or it could be a combination of both. "I suppose it's called life, you know? Time. And experience. I think you have certain barriers that fall after a time, and as you age, things peel off that allow you to be more open. You fear less. It doesn't mean you have no fear, but you fear less. Also, the life I've had, the children I have—my relationship to people is quite protective."

In her later career Deneuve has been gravitating toward dramas in which she plays strong, protective women (often mothers) and comedies in which the humor turns on the upsetting of her composure. In the first category, we find, among others, director Régis Wargnier's *Indochine* (1992) and *East/West* (1999). In the former, she is a plantation owner. In the latter, she is a great stage actress who arranges the defection of a French woman (Bonnaire) unable to flee the Soviet Union. The no-fuss, businesslike manner with which Deneuve takes up Bonnaire's cause feels authentic, as though we are seeing her simultaneously play both the role and some ideal version of herself. There is a quality of warm empathy and motherly affection that we might not have suspected in the younger Deneuve. Indeed, if we were to extrapolate a vision of the older Deneuve from the younger, we might rather have anticipated someone like the woman in *Mères et filles* (2009). In that, she is the stern, unloving mother of an adult daughter (Marina Hands)—but it's an atypical role.

Deneuve has appeared as the mother of grown children in a series of films—as the ailing matriarch in *A Christmas Tale* (2008) and as a mother recovering from the unexpected and devastating death of her son in *Après lui* (2007). For her frequent collaborator, director André Téchiné, she was the mother of the title character in *The Girl on the Train* (2009), opposite Émilie Dequenne. In one especially good scene, she has lunch with her daughter and her daughter's oddly aggressive new boyfriend. Clearly alarmed by him, this wise mother also knows she has no power, that in fact the only power she does have is to make matters worse: If she tries to separate her daughter from this young man, she will only cling to him more.

In her most recent work, Deneuve has often played women of external composure who become confused and discombobulated by the irrational,

the unreasonable or the unexpected. In her dramas, shocks can come as the result of illness, a family difficulty, or the arrival of an unwelcome stranger. In her comedies, the contrast between her attempts at control and the intrusion of outside influences becomes itself the source of humor. In *Palais royal!* (2005), a Princess Diana send-up never released in the United States, Deneuve is a queen (not unlike Elizabeth II), coping with a revenge-seeking, attention-grabbing, daughter-in-law, a princess played by Valérie Lemercier (who also directed). In François Ozon's *8 Women* (2002), a musical comedy thriller, she was part of an ensemble wondering who among their household might be a murderer.

Ludivine Sagnier, who was the youngest and least famous of the ensemble when *8 Women* was made, recalled Deneuve on the set. "She is shy and has, like, debutante reflexes, like suddenly she's afraid, and 'I don't understand that the microphone was there and then on this take it's here, so I can't concentrate.'"

According to Ozon, "Catherine Deneuve needs to be close to the director. She likes to know what the mise-en-scène will be, because she knows from a long career that directors are important. Catherine always tries to be in the scene. She doesn't keep some distance from the character. Isabelle Huppert is more like a stage actress. She likes to have distance, and she likes to act. It's like Laurence Olivier and Dustin Hoffman. Isabelle is more like Olivier and Catherine is more like Hoffman."

If Deneuve did indeed think Ozon was important, she was right to feel that way. Eight years later, he adapted and reconceived the French play, *Potiche*, as a showcase for Deneuve's comic skill and as a tribute to her place in French cinema. Ozon—who discovered Sagnier, rescued the career of Charlotte Rampling, unlocked the screen sensuality of Valeria Bruni Tedeschi, and brought out new colors in Isabelle Carré—has a talent for seeing what actresses can do and challenging them in new directions. For Deneuve, he recognized elements that were already there in her later work, but he articulated them and brought them forward: her humor, warmth, sense of fun, and down-to-earth genuineness. The opening sequence of *Potiche*, in which she pauses on her morning jog to commune with nature and jot down poetry, is a light moment of well-

played silliness that showed audiences—including many Americans, for the first time—a Deneuve at home with herself, who can laugh at her own legend.

"I want to be the mother of you all," Deneuve says late in the film, as a trophy wife turned politician now addressing her supporters. The moment is, to some degree, a satire of the French politician Ségolène Royal's maternal impulses as a presidential candidate. But it was also an acknowledgment of the space Deneuve occupies in France's affections. "He plays with that," Deneuve said of Ozon. "He plays with everything. He plays with the image I have."

LIKE DENEUVE, Fanny Ardant continues to enjoy a first-rate screen career into her sixties, and, though in a different way, she, too, has come more into focus with the passing of years. By French cinema standards a late bloomer, Ardant was a TV and film actress with no distinguished credits when discovered by François Truffaut and cast opposite Gérard Depardieu in *The Woman Next Door*. She was thirty-two. She went on to star in Truffaut's swan song, the comic thriller *Confidentially Yours* (1983), and has worked ever since. Yet the full distillation of the laughing, insouciant, insinuating, goodtime Fanny Ardant, the one we most remember and always look forward to seeing, didn't fully arrive until the middle of the 1990s . . . or until Ardant was in her mid- to late forties.

Before that, there were shades of it, of course. In *Le paltoquet* (1986), an otherwise awful film, we see some of the languid, endlessly amused Ardant that we recognize with fondness. But she hadn't fully emerged. Cinema history, not least French cinema, is full of alluring women in their forties, and yet I can think of no other established star who suddenly and most definitely became exponentially sexier at, say, forty-five or who experienced such a noticeable jolt in her erotic charge. Watch Ardant, for example, in the opening scene of *Pédale douce* (1996). She sits at a dinner party bantering, juggling friends and enemies, exuding cheer and mischief, confidence and wisdom. She looks like a million bucks and is having the time of her life. In American movies, she might have been over the hill. In France, she was just coming into her queendom.

When Catherine Deneuve smiles, the message is, "Okay, it's safe. We can relax now." When Fanny Ardant smiles, you hear champagne corks popping. It's a smile of mischief, of someone who knows how naughty her companion is and approves completely.

Patrice Leconte, an excellent director of actresses, cast her as the leader of French society in *Ridicule* (1996). In another period role, in the English-language film *Elizabeth* (1998), she appeared in a memorable cameo as Queen Mary of Guise. The audience, told in advance that Mary is the enemy of Elizabeth (Cate Blanchett), prepares to dislike her. Instead, we discover the challenge of international diplomacy embodied in an enemy who is not only seductive but fun to be around.

Since the turn of the millennium, Ardant has appeared as one of the eccentrics in *8 Women*. She was a neglected, suspicious wife in *Nathalie...*, opposite Emmanuelle Béart and Depardieu, and she was Depardieu's wife yet again in *Hello, Goodbye*, a not-bad comedy-drama about a couple that experiences culture shock upon moving to Israel. She was fine, if not optimally used, in the downbeat *Change My Life*, about an out-of-work actress who becomes intimately involved with a transvestite prostitute. In Franco Zeffirelli's *Callas Forever*, she was an ideal Maria Callas—the right height, the right age, the right temperament. Ardant also captured, in lighter moments, Callas's humorlessness, something that could only be adequately portrayed by an actress with a healthy sense of humor.

Claude Lelouch's *Roman de gare* (2007), one of her best recent show-cases, took Ardant up and down the emotional scale, from triumph to disgrace, from confidence to suicidal despair. In this intricate thriller, she played a mystery novelist who is, in fact, a fraud who depends on a ghost writer (Dominique Pinon) to do all her real work. But what a magnificent fraud she is, striding along the dock by her yacht in the world's most exclusive ports, dressed breezily and impeccably; tall and aristocratic and always genial, yet with an underlying note of calculation so that her friendliness is not always reassuring. At one point, in order to placate the writer, who is about to expose their arrangement, she seduces him into bed. The effect is unexpected. Pinon is a peculiar-looking actor,

with the face of a benign gargoyle, and Ardant was fifty-seven when she made the film and looked, more or less, her age. She also looked like nobody told her that she wasn't allowed to be seductive anymore, and so the scene is noteworthy for not being noteworthy, mildly erotic in the usual way of such scenes.

This might simply be my personal reaction to Ardant, and yet I suspect that others share it, that this reaction is to something intrinsic in this actress's essence. For all of Ardant's ability to depict a range of emotion, I most associate her with joy. Not necessarily the depiction of joy, but rather a joy of acting, a joy of being, a *joie de vivre*. Ardant, in her mature performances, conveys the sense of someone bringing to scenes her full being, her whole self and experience. There is an understanding of the value of life in such moments, in the value of the moments themselves. It is not a young person's understanding.

YET OF ALL THE FRENCH ACTRESSES who had already crossed the threshold of fifty at the start of the millennium, none went on to a better decade than Nathalie Baye. In the years from 2000 through 2009, years that took Baye from age fifty-one to sixty-one, she made more films than in the previous decade, working at the height of her powers in popular and prestige films warmly received by the public. That she stayed beautiful was an undeniable advantage. It allowed her to continue to play in love stories, both comic and dramatic, and in films in which romance was a key element. She began the decade with *Selon Matthieu*, as a married woman targeted for seduction by a handsome young man (played by Benoît Magimel). Four years later, she was the woman who comes out of the past—out of Patrick Bruel's past—in *Une vie à t'attendre* (*I've Been Waiting So Long*). Once she does, he can think of nothing else. These roles and films were not over-strenuous assertions of an older star's faded allure. Rather, they worked because Baye remained plausible in a romantic context. Never miscast as a young beauty who comes through the door and everyone drops dead, she played women her own age, and the films often, as if in passing, dealt with the particular concerns of a mature person in love.

In *Cliente* she was a divorced TV executive who has been hurt before—and disappointed many more times than that. With no time for dating, she makes peace with her physical needs by paying for sex. ("The woman in *Cliente*," said Baye, "I can understand perfectly well what she's doing, I don't judge her, I like her very much, but for me, that would just be impossible.") *Cliente* is the old story about the client and the prostitute who fall in love, only this time the professional is a man (Eric Caravaca). When the gigolo decides to go back to his wife, Baye throws herself onto the bed and sobs the second she is alone. She will have to live without love. That is just how it's going to be.

That is just how it's going to be . . . Over the course of this book, I have pointed out that Nathalie Baye has become something of an exemplar of romantic disappointment in French cinema. Yet how strange that that should be the case. Her reasonable screen persona would seem to fit most easily into a happy-marriage scenario, but instead her reasonableness becomes a witness to the unreasonableness or weakness of others.

This has continued into the present day. In Claude Berri's *One Stays, the Other Leaves* (2004), she was the wife of a chronically unfaithful husband (Pierre Arditi). In Noémie Lvovsky's *Les sentiments* (2003), she is shocked when her reliable, stable husband (Jean-Pierre Bacri) has an affair with a younger woman. In Alexandra Leclère's caustic comedy *The Price to Pay*, she found one of her most brutal roles as a financier's wife, who spends her days spending money—until her husband takes away her credit cards in exchange for sex.

One Stays, the Other Leaves was a routine showcase. But *Les sentiments* allowed Baye to play extremes of personal devastation, someone whose foundation is ripped out and whose entire sense of reality is betrayed. *The Price to Pay* called for extremes in another direction. Repulsed by the husband (Christian Clavier)—who seems to us likable and well-groomed—she reacts to his sexual demands with outsized rage. Baye, never one to simply play a result, grounds the wife's disgust in some deep, unexpressed sexual disappointment. Or in some deeper disappointment within herself that she cannot face. ("When you have such an empty life," Baye said

of the character, "you can be stupid and mean.") Baye takes scenes to the edge of hysteria, with bravado and precision, but as always, even in a farce context, she is so truthful that we don't necessarily think of her acting as big or, for that matter, as acting. That she has thought through the character and integrated its extremes within a complete psychological portrait is apparent in the somber sequence in which she picks up a man (her own age) and goes with him to his hotel room.

It's important to note that Baye is not limited to what we might think of as Nathalie Baye roles. In just the last decade, she was up for the screw-ball antics of the chase comedy *Passe-passe* (2008), and her portrait of utter middle-aged confusion in *La Californie* (2006), playing a rich woman with an aimless, pointless existence and an entourage of hangers on, was a far cry from wise contemplation. *Mon fils à moi* (2006), a yet more dramatic departure, found Baye completely outside her familiar mode, as a mother with a destructive, neurotic attachment to her pubescent son. It was a role in which you might expect to find Isabelle Huppert, but instead of showing us the character's perversity—something Huppert would have relished—Baye presents the mother as grounded, rational and frighten-ingly sure of herself. She is sick but without the slightest inkling, and thus she is all the more unsettling.

Still, to consider Nathalie Baye in this or any other decade is inevitably to be drawn toward those films in which a woman's challenges are not internal but external, in which a woman's rationality and fundamental decency are confronted by a world that cannot and never will measure up to her expectations. For this reason, a role that might have seemed at the time like a departure—an alcoholic police commandant in *Le Petit Lieutenant* (2005), originally written for a man—turned out to be her de-fining showcase of the decade.

Baye prepared extensively for the role. "The only thing I didn't try was becoming an alcoholic," she told an interviewer at the time. She met with policewomen who headed squads and investigations, and they turned out to be much more feminine than she expected. Her research is appar-ent in the authority she brings to scenes: Baye bosses young men around

like she has been doing it all her life. At the same time, Baye lets us see, behind the mask of stoicism, the spiritual exhaustion of a life spent facing the dark side of human nature, the futility of pushing back at the never-ending tide of crime.

In her more recent roles, adversity makes Baye's women more curt, businesslike, and less indulgent of weakness than before, but it doesn't make them harder. It makes them, at their core, gentler, more empathic of everyone's place on the same boat heading toward who knows where. It's interesting: Like Deneuve, Baye has played existential confusion in her later career, and yet her confusion is of a different order. Deneuve has always been a pessimist, grappling with practical things. Baye, more buoyant of personality, always seems surprised at life's revelations, not from a practical but philosophical sense. Or to put it another way, Deneuve doesn't worry about what it all means, just what she has to do. Baye always knows exactly what she has to do, yet despairs of what it all means.

In *Le Petit Lieutenant*, Baye becomes especially fond of the title character, a young rookie. This fondness does not manifest itself in any overt sign of favor. She just gives him guidance, good assignments and opportunities to succeed. A casual reference that she makes to a colleague reveals her maternal feelings: He is the same age that her son would have been—the son that died twenty years ago of meningitis, the tragedy from which she has never recovered and can never recover. So when the young lieutenant is stabbed and critically injured, we know what a blow this is. She comes upon the crime scene and stares at the volume of blood with a professional's understanding.

Nathalie Baye should not have to endure this. Nor should she have to get word, days later, that the lieutenant died. Nor should she have to get into a gun battle and kill a bad guy in order to resolve the case. But this is her world and, in a certain sense, everybody's world. Director Xavier Beauvois (*Selon Matthieu*), who knows what this actress can do, hands Baye the ending in one of the unforgettable movie moments. With the lieutenant newly dead and the case ended in violence, she walks alone by the water in Nice, the camera focusing on her face for one long, unbroken take.

Baye had an idea for the film's last moment:

We did two takes in which I look away [in the movie's final seconds], and Xavier Beauvois—we are very close—I told him maybe we can try, it doesn't cost anything, to do one where I'm looking at the camera. He's intelligent, and he's open to anything. I don't know why I suggested that—it was a kind of sensation that it was necessary. I don't know why. Like, look, everybody, yes, now I've lost my new son. What am I doing? If I go and drink again, it's not the solution. I have to find the strength to keep going. So we did the take, and that's the one he kept.

Those of us who aren't actors might naturally assume that Baye, in this moment, is thinking of everything the character has experienced up until that moment. But this was not the case. "I think it was the last shot with that film. We finished in the South, in Nice, and you're not thinking of everything," Baye said. "You have to be completely there, *completely there*, you know what I mean? *Be there*." She tapped the table for emphasis. "Look at the life. Look everywhere. Be absolutely. . . . Don't cheat, don't lie, *be* there, be absolutely *there* in the present, *in* that film, *on* that set. You can think about the beautiful light, or you can feel the story of the character. It was like an end. The end."

And what did turning toward the camera mean for her?

"Maybe a question. Maybe . . . 'Help.'"

When Baye turns and looks almost into the camera, we see the pain of the solitary figure, but also one who is moving forward, a woman no wiser than when she was young but wiser in her knowledge of the limits of earthly wisdom. We see a character in a film, and yet we might also imagine that this is the actress, too, looking back at the young woman she played at the conclusion of *A Week's Vacation*, the one who already had an inkling that life might be lonely and difficult.

It is the face of a woman who thinks and feels and will not go numb, who will stay human in the fullest, despite the anguish. It's the sum of everything that a great actress has meant in almost forty years on screen.

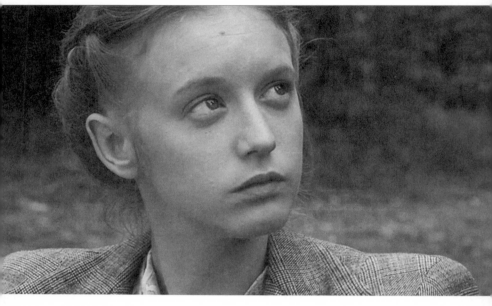

Ludivine Sagnier in the "He's my son" scene from Claude Miller's *A Secret* (UGC), 2007.

15 The New Talent

A FEW YEARS AGO, no one knew Marion Cotillard in America, and then over the course of a few months around the turn of 2008, she impressed everyone twice: First, with her performance in *La vie en Rose*, as the broken-down, prematurely aged Édith Piaf. And second, with her appearances at several gala events looking lovely and fresh and nothing like Édith Piaf. Oscar voters are notorious for honoring chameleonic transformations, and so Cotillard overcame the Academy's usual resistance to foreign-language performances and received the Oscar that launched her American career.

As the first decade of the millennium ended, Cotillard was on the minds of many people in France. She was widely regarded as one of the best and most popular actresses in the country, and there was a good deal of pride at her international success. In the years since, she has mainly worked on this side of the Atlantic, in films of estimable pedigree, for Michael Mann (*Public Enemies*), Rob Marshall (*Nine*), Christopher Nolan (*Inception*), Woody Allen (*Midnight in Paris*), and Steven Soderbergh (*Contagion*). Still, it takes no crystal ball to predict that Cotillard will continue to keep a toehold in French cinema and ultimately do her best work in France, not Hollywood.

Cotillard has distinct advantages in her pursuit of an American career. She is, first of all, a kind of actress Americans recognize—a powerhouse, the heir of such great Hollywood ladies as Bette Davis, Joan Crawford and Barbara Stanwyck, not to mention Olivia de Havilland, to whom she bears a considerable resemblance. Like de Havilland, she has an ideal actress's

face in that she looks like everybody and yet nobody in particular, which means that she can play anything. And she is willing to play anything as well. *La vie en Rose* showed there were no depths she feared exploring.

Her problem is that modern American cinema, unlike the American cinema of two generations ago, has little use for powerhouses. Ashley Judd is a homegrown powerhouse who gets a role worthy of her talents about once every five years. Jennifer Jason Leigh is one of the best screen actresses of her generation, and yet her career has been allowed to drift to the margins. Judd and Leigh have no choice but to endure a less-than-ideal situation and pursue other interests—they're not French. But Cotillard has the escape hatch of French cinema, and at a certain point, when she has made enough money, she will tire of pulling from the pastel end of her spectrum (albeit in prestige projects) and seek a chance to express her full range. She will go home.

In the meantime, it is a pleasure to find her in English-language films, especially ones that give her moments worthy of her force. In *Public Enemies*, as the moll of John Dillinger (Johnny Depp), she had two scenes that Bette Davis could not have done better. In one, tied up and tortured by a fat FBI agent, she still manages to scare "fat boy" (and the audience) with what her "Johnny" might eventually do to him. In another, in prison, days after Dillinger's death, she is told Dillinger's last words and just sits with their impact for a long close-up too complex and eloquent to dissect. On the lighter side, Woody Allen brought out Cotillard's charm and allure in *Midnight in Paris* in a way no American director had previously.

IN RECENT YEARS, AUDREY TAUTOU (born 1976) has stepped out from the doe-eyed Amélie character (and variations thereof) into a mature incarnation that is less mannered, more interesting and more flexible. Her important career began with a supporting turn in *Venus Beauty Institute*, a performance that I, in fact, barely noticed, although the French apparently saw something, because they awarded her a best newcomer César. Given her track record since, whatever they saw was apparently there.

Americans, to the extent they are paying attention, enjoy Tautou as an eccentric and an exotic, as a sort of psychedelic Audrey Hepburn. As such, they see her as an essentially cheerful creature or at least as one of whimsy. In truth, Tautou's basic screen nature is rather wan. Playing average or normal women, she has tended toward melancholy, and in her more cheerful incarnations, she is delusional (as in *He Loves Me . . . He Loves Me Not*) or arch (as in the comedy *Priceless*). Perhaps the first time most Americans ever got a true sense of Tautou was when they saw her as the dour, struggling, determined Coco Chanel in *Coco Before Chanel*. The late scene in which Tautou, as Chanel, supervises models wearing her dresses showed Tautou impressive in her single-mindedness—giving us a Coco who has gained the world by reducing it to precisely *this*.

LUDIVINE SAGNIER (born 1979) is best known in the United States as the malevolent bimbo in François Ozon's *Swimming Pool*, but she is one of the most interesting French actresses of her generation—idiosyncratic and versatile, lacking in vanity, and ambitious in the best way. "Ambition may be dreaming of having a million dollars in your account," she said in 2009. "But that's not the way I conceive of ambition. My ambition is to have the best résumé, to work with the best directors."

Ozon discovered her in a short film, *Acide animé*. "I thought she was amazing," Ozon said. "She was very cute, she has a funny face, and she was insolent. So I did an audition with her for *Water Drops on Burning Rocks*, and I discovered she was childish but at the same time, she has the body of a real woman. I loved this contrast."

Sagnier has intelligence and good taste. For writer-director Pascal Bonitzer, she appeared in *Petites coupures* in what was not even a second but a third lead, behind Emmanuelle Devos and Kristin Scott Thomas. But it was a quality role, as Daniel Auteuil's young mistress, in which she got to be goofy and clueless (and funny) in the opening moments and then play a scene of utter devastation, when she overhears her older lover demeaning her to a friend. Though Sagnier captured American attention as some kind of bombshell in *Swimming Pool*, in France she can slip just

as easily into playing drab, plain women, as she did in *La Californie* (as the daughter of Nathalie Baye) or most memorably as a traditional Jewish wife and mother in Claude Miller's *A Secret*.

In the Miller film, a period piece set during the Nazi occupation of France, she has the moment upon which the entire film pivots. She is a wife who realizes that her husband loves another woman, and so, when she is stopped by soldiers doing a routine check of passports near the border to freedom, she does something of monumental perversity. Instead of handing over her fake passport for inspection, she gives them her real passport, the one stamped "Juive." Then comes the key moment: Her son comes bounding out of the restroom. The soldiers see him, then turn to ask her, "Who is he?"

Her answer: *"C'est mon fils."*

Sagnier remembered her preparation:

It's only one line, only three words, but I was rehearsing it and rehearsing it I don't know how many times. It can't be exterior. It has to come from inside you. And there were so many things in this sentence, because it's like, "I'm in despair, and I want revenge, but I don't want revenge. I want my husband to be happy and free. I want my son to stay with me. I want my love to stay intact forever." There were like a hundred pieces of information to gather in one sentence. I would say the hardest part was not to be watching myself in that moment, because this is so difficult, this is so heartbreaking. The trick was not to cry. The audience has to cry, not the actor. I remember Claude Miller saying, "Don't you cry." My heart became a stone, you know? But at the end of the day, I cried for hours.

Sagnier has a sophisticated sense of how to use herself to bring out a role. If you only saw her, for example, in Claude Chabrol's *La fille coupée en deux* (*The Girl Cut in Two*), as an up-and-coming TV personality exploited by two men, you might think of Sagnier as the girl in the film, as young and buoyant. You might also assume that the radiance she brings to the role is uncontainable. But Sagnier's performance, informed by years of watching people in power, is quite knowing. She is able to show this

girl's wonderful incandescence and then show how it fades; to show this blissful native confidence and then show it turning into doubt; to give us a beautiful child and morph her slowly into a confused adult. In the beginning, there are no clouds on her spirit, no blockage between her and the world, nothing hiding, everything is there on the surface. And by the end, she is as clouded and muddled as anyone else, no longer a candidate for any kind of stardom, just bland real life.

In recent years, Sagnier has appeared memorably as gangster Jacques Mesrine's last girlfriend in the two *Mesrine* films, opposite Vincent Cassel, and had a superb starring role in *Crime d'amour* (the last film of director Alain Corneau), a corporate thriller in which she murders her boss (Kristin Scott Thomas) and frames herself to make it look like a frame-up. Barring bad luck, Sagnier could easily be working until she is Jeanne Moreau's age—she has the ability, the ambition, and a personality that will age well along with her public. She may well turn out to be one of those people that you look at and see a whole generation.

Her American prospects could go either way. Her screen quality— she is pretty, thoughtful and measured in her natural pace—could easily translate into dumb blonde in the idiot shorthand of the American movie business, something she would want no part of and that has nothing to do with her true personality. However, were Sagnier to stumble into a role or a couple of roles in America that showed who she is and what she can do, she could have real success here. If Americans got to know her in all her charming idiosyncrasy, they would like her very much.

In 2009, Sagnier told an interviewer in England, "My breakthrough hasn't come yet. I would like to perform more in English. But there have to be many good things gathered for me to be willing to do a movie. I watch trailers of every new American movie and I'm like, 'OK, I'm not missing anything . . . I think I'm exactly where I should be.'" She is.

THE BELGIAN ACTRESS ÉMILIE DEQUENNE (born 1981) has done strong work for years, starting with the Dardenne Brothers' *Rosetta* (1999) and later as a schoolgirl in Yves Lavandier's *Oui, mais . . .* (2001) and in Claude

Berri's *A Housekeeper* (2002), about a flighty young woman who starts off cleaning house for a newly divorced man (Jean-Pierre Bacri) and then moves in with him. In André Téchiné's *The Girl on the Train* (2009), she suggested something troubled underneath her happy-young-person's aura, the only clue in the movie's first scenes that this woman is emotionally vulnerable—and capable, in the aftermath of grave disappointment, to behave irrationally. Dequenne is someone to watch.

So is Isild Le Besco (born 1982), the younger sister of director Maïwenn Le Besco, a spooky blond actress capable of looking pretty and scary by turns, and sometimes both simultaneously. Benoît Jacquot, with his astute sensitivity to youth, cast Le Besco in *À tout de suite* (2004), as a teenager in the 1970s who finds out that her new boyfriend has killed someone in a bank robbery—so, of course, she runs away with him to North Africa. Jacquot and Le Besco don't give us the romance of youth but the blind impulse of it, which is what the *characters* see as romance, but the audience does not. In one telling scene, not far from the finish, she dances with the boyfriend to one of the hits of the day (Diana Ross's "Theme from *Mahogany*"). She has her eyes closed, and you can feel her psychic strain as she tries to make reality conform to her romantic misperceptions. That this takes such effort indicates the beginning of the very wisdom she is trying to ward off—the realization, which often marks the transition from youth to maturity, that sex can't cure everything.

Le Besco has had her share of hits and misses. But this particular aspect of her work—her capacity to convey the misery, confusion and sheer torment of being young—is interesting, perhaps unique. She was a rebellious teenager in *Wild Camp* (2005), in which there was no joy in rebellion, only wretchedness. Her best role to date was in *Backstage* for director Emmanuelle Bercot, a thoroughly unflattering showcase in which she played a borderline grotesque, an unprepossessing teenager sucked into the vortex of a Madonna-like pop star (Emmanuelle Seigner). Since then, the casting window on teenage roles has closed for her, and Le Besco has begun to pursue a side career as a director. Over the coming years, it will be interesting to see if an actress who found heartache

and anguish in her teenage roles gets to pursue the even darker recesses of the adult experience.

Mélanie Laurent (born 1983), ideally cast in Quentin Tarantino's *Inglourious Basterds*, has a distant self-possession on screen. Behind her composure is not neurotic hostility, but an equable yet merciless search for truth. She looks at the world with calm assessment, as someone who will not be swayed from her perceptions by social niceties or sentiment. This gives her an edge of coldness, because you never have any doubt that she will turn her judgments into action. These actions range from dumping the middle-aged Fabrice Luchini for a man her own age in *Paris* to burning down a movie theater and decapitating the entire Nazi regime in *Inglourious Basterds*. Laurent is not about forgiveness.

Her talent has been known in France at least since 2006, when she made *Je vais bien, ne t'en fais pas* for director Philippe Lioret. She played a college student who has a complete breakdown following the disappearance of her twin brother. Laurent is not a histrionic actress. So she gives us a portrait of an innately private person, with a lot of natural dignity, going through a hell she would prefer no one saw. Following the landmark that was *Inglourious Basterds*, Laurent continued to impress with *The Concert*, in the role of a violin virtuoso. Once again, her cold observation became central to the movement of the story—there was a brilliantly scored dinner scene in which she watches, with a sympathy that slides into disapproval, as her conductor drinks himself into oblivion. But the movie also contains a concert scene in which Laurent gets to turn on the emotional floodgates, and the sight was new and welcome.

THERE ARE YET MORE NOTABLE ACTRESSES present and on the way. Leïla Bekhti (born 1984), from an Algerian background, was memorable as a Muslim girl in *Paris je t'aime* and in 2010 became a box-office star with the comedy *Tout ce qui brille* (1.4 million admissions). She won the newcomer César in early 2011. Louise Bourgoin (born 1981), in her debut film, Anne Fontaine's comic thriller *The Girl from Monaco*, showed a shrewd comic facility, and also (in the hands of a strong director) the

ability to hold something in reserve. Bourgoin, who started as a weather girl and comedienne, is abandoned and unselfconscious, rare in a woman who looks like a fashion model. She seems on her way to some form of significant stardom.

Laura Smet (born 1983), the daughter of Nathalie Baye and French rock star Johnny Hallyday, has demonstrated an arresting presence in films such as *The Bridesmaid* (Chabrol), *Gilles' Wife* (Frédéric Fonteyne) and *La frontière de l'aube* (Philippe Garrel). If she can keep her demons in check—there was a suicide attempt in early 2010—she should emerge as a major actress over the next decade. Speaking of great actresses' daughters, Isabelle Huppert's offspring, Lolita Chammah (born 1983) has made a number of films, including *Copacabana* opposite her mother. She has not shown any signs of inherited genius yet, but she is at least as pretty as the young Huppert and has her mother's deep voice.

Finally, Sara Forestier (born 1986) and Déborah François (born 1987) have practically arrived. As a teenager, Forestier won a newcomer César for *L'esquive* (*Games of Love and Chance*), about kids from a rough neighborhood putting on a Marivaux play. Even this early film found much of Forestier's screen persona already in place—her tightly wired argumentativeness, her single-mindedness, her reflexive defense of the weak, her absolute certainty even when she is dead wrong, and her ability to talk and keep talking without coming up for air. These qualities were put to fine use in *Hell* (2006), in the title role of an aimless rich girl leading a decadent, pointless life. Being Forestier, our heroine pursued decadence and aimlessness aggressively, not passively, with the obnoxiousness befitting a character named "Hell." In *The Names of Love* (2010) she was much the same, yet engaging, as a young leftist who makes it her mission to turn conservatives into liberals by having sex with them. Forestier plays it so wired, so easily distracted and so fixated that she is able to make you believe something that in the script must have seemed merely farcical: She goes out with only her shoes on and has no idea she is naked until she is on the Metro. It's a singular performance, for which she won the Best Actress César in 2011.

Meanwhile, François, who also won a César for Best Newcomer, was touching as a girl who overestimates her strength and her religious faith in the 2008 war drama *Les femme de l'ombre* (*Female Agents*) and ends up committing suicide in a Nazi jail. She was also quite convincing as a troubled teen in her César-winning *The First Day of the Rest of Your Life*; as an assistant with vengeance on her mind in *The Page Turner*; and in *L'enfant* for the Dardenne Brothers. It would not be a surprise if five or ten years from now people are calling Déborah François a great actress.

But now we're about to enter the world of guessing, so let's stop at the brink.

THE DIFFICULT THING about writing about something ongoing is that there cannot be a conclusion, only an ellipsis. Nor can there even be a sure assessment of the current scene, because the present is always in flux. The good side of this is that there is nothing of the obituary about a story that continues, no occasion for nostalgia or loss. On the contrary, these are the good old days, as the philosopher Carly Simon once said.

French cinema abounds with female talent—every year more rise to the surface (Vahina Giocante in *Bellamy*, Florence Loiret Caille in *A Real Life*, Sarah Adler in *Bachelor Days Are Over*, Léa Seydoux in *La belle personne* . . .). Nothing this rich and vibrant has any business holding in place, even if it means that we walk away from the scene with a blurry snapshot.

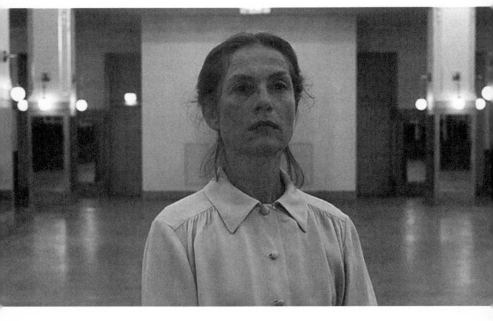

A great actress in her signature role: Isabelle Huppert at the climax of *The Piano Teacher* (MK2), 2001.

16 France and America

THE FRENCH SEE THEIR STARS DIFFERENTLY from the way we see them. If we hear, for example, that such and such an actor is "the French George Clooney," we immediately assume that this particular actor means to the French what Clooney means to Americans. Most of us don't quite grasp that the real Clooney is just as famous there as here and that, even in France, he is probably a bigger star than his French counterpart. It's sometimes as if Europeans see their own stars as local or regional celebrities, rather than the real thing—the equivalent of a local newscaster in comparison to Diane Sawyer or Tom Brokaw. Thus, Europeans in general would be more excited to encounter Brad Pitt than any of their national stars, not because Pitt is American but because, being American, he is therefore international.

The recognition minus hysteria that attends French film stardom might make it less exalted and mythic, but in the end it may allow French actors and actresses to have the best of both worlds: public careers, private lives. Isabelle Carré, typically modest, insists that no one recognizes her and that she's not famous at all. Sandrine Kiberlain says that getting around unmolested is more difficult for male celebrities, but that French people have respect for women and leave them alone. Even Catherine Deneuve, the most exalted of French stars, says that she can walk around her neighborhood without being bothered. In my own experience, I have not seen a single actress pestered or even acknowledged in a public place. Géraldine Pailhas walked down the boulevard du Montparnasse without entourage, chauffeur or accompaniment. Valeria Bruni Tedeschi carried

her baby while the nanny pushed the empty stroller, on a busy Paris street. Nathalie Baye sat in a café for almost two hours and no one seemed to look her way. Of course people knew who they were. Tedeschi had a new movie out that week, playing a few blocks away. And after Baye left, the café owner said to me, *"C'est une grande dame."* But all were left alone and none showed any consciousness of this being unusual.

An attitude underlies this hands-off policy. In the United States, celebrity is deeply craved, so if you have it, you are expected to share it. In exchange for achieving what so many dream of—and humbly seek with their blogs, websites, and Facebook and Twitter pages—celebrities belong to the public, and the love they get comes mixed with resentment. A film star is a fame bomb, a fame entity, an imposition on the consciousness of others. They are not thought of as artists primarily, and some stars aren't really regarded, in the public mind, as artists at all. Needless to say, some of this attitude is present in France as well. Success is resented in France— "Success is a disease," as director Patrice Leconte puts it—in ways that may even be more overt in France than in America. Yet, all the same, cinema is thought of as an art form, and actors and actresses are thought of, not merely as famous people, but as artists. As artists they have the same rights as everyone to something at least approximating a normal existence.

Indeed the stars themselves see themselves as artists, which makes it easy to talk to them about their work. In the United States, it's not as easy. Take a film star's work seriously and an unsavory undertone enters the conversation. He or she will look at you like you're one of the idiots who got fooled, a child in a world of adults. You will be gazed at half-quizzically, as if being asked, "Why are you bringing in irrelevant values in assessing what is essentially a commercial transaction?" There are exceptions to this, certainly, and I'm sure some American stars who avoid such questions do so because they understand the antagonism and fear generated by the mere word "artist," with everything it implies about free thinking, free living and independent values. (In the United States, it would be unthinkable to place an artist of any kind on currency, though this is common in Europe.) All the same, many, many American stars are

really all about the stardom and that's all. They are not about building a legacy, nor are they in a particular position to care about cinematic legacies, not being familiar with previous cinematic legacies. Lots of screen actors in America really don't know American movies. In France, they do, and their willingness to speak about their work is aided by their understanding that they are in the business of making art.

Perhaps one thing that helps ground them is that most of them are not super-rich. A few years ago, Audrey Tautou was France's highest paid star, and she made a million euros per picture. Not bad. But compare that to the payoffs of top American stars, the $20 million up-front and the points on the back end—Tautou's humble million per picture pales next to the $27 million that Jennifer Aniston makes. Thus, French stars don't live in palaces. They live in very nice houses and apartments of a kind, say, that a successful cardiologist might own in the United States. They take walks, go to the store and even invite foreign film critics into their home, and they don't worry about becoming such objects of obsession that they end up like John Lennon. They are not divorced from daily existence or from normal human beings. They are practically normal human beings themselves, and this has to have a positive influence on their work.

Of course, the grass always seems greener elsewhere, while experience usually finds the grass brown everywhere, but for different reasons. French stars, for example, often overestimate the opportunities for American actresses in independent cinema and cite the careers of people such as Meryl Streep, Kate Winslet and Cate Blanchett as though they were not out of the ordinary. They envy things that we barely notice or sometimes deride. "I think when you watch a great American movie, you cannot compare it with a good French movie," Marie Gillain told me in 2009. "Sometimes in French cinema I regret the lack of creativity. Even if the plot is interesting and the psychological relationships are good, sometimes in a French movie what you *see* is less important." Just as we in America take for granted our films' visual capacity—and even complain about excessive special effects—the French take for granted their films' concentration on authentic human emotion.

Vincent Lindon, in 2010, had a theory about French cinema's concentration on interpersonal relationships. "Sometimes critics and journalists find reasons for things that are not the real reasons, because the real reasons are very difficult to believe. We don't have enough money to do big entertainment movies, so unconsciously we try to find stories that don't cost too much money. We can't do *Benjamin Button*—it's 75 million, it's in French—who's going to buy that movie? We have to film *Benjamin Button* in French so it's *seven* million dollars, and if you make it for seven million dollars, you have to forget that he's old and he becomes younger—it's too expensive. You just keep the love story, and you make the movie between a man and a woman. So we are obliged to shoot inside the house between two persons."

Lindon's assessment has the ring of truth. It doesn't preclude a cultural tendency—other cinemas aren't wealthy, either, but they don't focus on love stories to the extent that the French do. Yet it does explain to some degree an economic underpinning for the enduring and growing prominence of women in French cinema, one existing in harmony with the cultural predilection: In a culture of small-sized movies, women are going to be at an advantage. Movies about women tend to be about emotional life, inner life. Even when they take place in the world of commerce, the movies still tend to concentrate on inner workings and feelings, and all these lend themselves to small-scale treatment, to movies that stay close to and concentrate on the human face. For an actor such as Lindon, who with absolute accuracy sees himself as the French equivalent of Russell Crowe, it's frustrating never to get the chance to make a movie on the scale of *Gladiator*. But does anybody even remember the woman in *Gladiator*? Concentrate for a minute and some vague memory of Connie Nielsen might float to consciousness, but it's buried under recollections of Crowe and of Joaquin Phoenix as the Roman emperor.

If you were an actress (not a businesswoman, not someone thinking about residuals, but an actress thinking about art) what role would you rather have, Connie Nielsen's in *Gladiator* or Sandrine Kiberlain's in *Mademoiselle Chambon*?

AS WE'VE SEEN over the course of this book, romance in French cinema is not just about the nuances of love. Love becomes the ultimate educator and the moral definer, the cauldron in which identity is forged and character revealed, not merely a prism in which old verities are discovered to be right, after all. Love stories are personal, specific to the individuals. And the attitudes, thoughts and faith behind such films come out of French tradition. "From Marivaux and Molière to nineteenth-century novels like *Madame Bovary*, this notion [of love] is anchored in our collective imagination," said Stéphane Brizé, the director and cowriter of *Mademoiselle Chambon.* "And it really nourishes us without our being really aware of it."

"We're shy about many things," said Yvan Attal. "Maybe we're shy to speak about our president. Maybe we're shy to speak about our wars. We're not shy to talk about love—it's all we have. It's an obsession in France. Everybody wants to be in love. That's what we love to do. We're not motivated by career. The thing we target is love."

When Julie Gayet made *Clara et moi*, about a woman who is rejected by her lover when he finds out she is HIV positive, she was thinking of a parallel experience in the life of a friend—a woman in her late twenties, diagnosed with a brain tumor, whose boyfriend couldn't take it and left her after eight years together. For both the man and the woman, the crisis became the ultimate definer and revealer—of his limitations and, in the case of the woman, of her own generosity. She let him go without bitterness and, in what turned out to be the last two years of her life, forged friendships and connections that were a lot more meaningful than watching a dutiful boyfriend go through the motions. It's this kind of story that French cinema looks for, things about love that are bigger than love—or rather as big as love really is, not love as depicted in silly movies, in which people can't have sex without knocking over furniture.

The French do not eschew sex in their romances, but it's not all about oo-la-la. In recent years Sandrine Bonnaire has made three major love stories in which she doesn't even kiss the guy. In Patrice Leconte's very satisfying 2004 film *Confidences trop intimes* (*Intimate Strangers*), she intends to go to an analyst but opens the wrong door and starts pouring out her

story to a shy, withdrawn tax accountant (the usually voluble Fabrice Luchini). Even when she discovers her mistake she continues to see him, and despite intimations of intrigue and echoes of Hitchcock, the film is really about how two people end up helping each other. Specifically, it's about how she quite consciously helps him emerge from his shell and out of the office where he has worked for many long, stultifying years. Fine romance, no kissing.

Two other Bonnaire films have dealt with love at the edge of death. In an earlier chapter, I talked about Bonnaire's astonishing work in *C'est la vie* (2001), in which she played a hospice volunteer who falls in love with one of the patients (Jacques Dutronc). In *Queen to Play* (2009), Bonnaire is a house cleaner (and a wife and mother) who discovers an innate gift for chess. She bonds with a wealthy widower (Kevin Kline), who is terminally ill, and he teaches her the game. She spends so much time in his company that her husband starts following her and peering through windows to catch them in the act—but all he sees are chess matches, this film's substitute for lovemaking. Through this connection, the widower finds definition and peace, and the woman finds confidence and liberation. He launches her on a new life.

The French cinema's lack of judgment allows morality to be discovered in art. It's not pre-cooked or predecided. Look, for example, at first-time director Anne Le Ny's *Those Who Remain* (2007), about a man (Vincent Lindon) and a woman (the remarkable Emmanuelle Devos) who meet innocently in a hospital while their respective partners are fighting for their lives. The romance that develops slowly between them is true, desperate and utterly understandable, even though we might, if presented only with the raw facts, be appalled to hear of it in real life. But the movie, free from having to conform to some predetermined pattern, finds its way to a moral resolution that takes into account the depth of the lovers' emotion, the extent of their confusion and the reality of their responsibility. Thus, near the finish, when Lindon is breaking it off and Devos says, "It's not love?" and he answers, "It's not love," we know, of course, that it is, one of the many kinds, and worthy of respect.

AS IN FILMMAKING, one of the challenges in writing a book like this is in having to decide, moment by moment, when to move in for a close-up and when to pull back for a wide shot; when to slow down and observe one thing and when to stand back and take in the panorama. In the case of French actresses, we may value the forest for the magnificence of its trees, but how does one give a sense of the forest as whole—of its breadth and richness?

To do so completely is impossible. But to get something of this feeling, perhaps it might help to imagine, say, that you've moved to Paris on New Year's Day with the intention of spending one year enjoying the women of French cinema. Since we must choose a year, let's make it 2001, for no reason but that it marks the official start of the millennium. Otherwise, it's not a special year, not particularly better or worse than the several years preceding it or the years since.

What movies would you see? How busy would you be?

Well, the first thing you'd do, on January 1, is buy a newspaper—or better yet, *Pariscope*—to find out what movies are already playing in theaters. Ludivine Sagnier is starring in *Bon Plan*, about a group of students on a Eurail adventure. Marie Gillain is appearing in the first film from the young director, Emmanuel Mouret, *Laissons Lucie faire*. And two extraordinary actresses are appearing in *Ca ira mieux demain*, the latest from director Jeanne Labrune (*Beware of My Love*): Nathalie Baye and Isabelle Carré.

On January 10 two more movies open that you will definitely want to see: *Lisa* stars seventy-two-year-old Jeanne Moreau and twenty-five-year-old Marion Cotillard as the same woman in two different time periods. And *Selon Matthieu* stars Nathalie Baye, as an industrialist's wife seduced by a young man (Benoît Magimel). Magimel was twenty-five at the time of filming, and Baye was fifty-one.

Then three weeks go by without much happening. On January 31, if you're in the mood for an adventure, you might see *Brotherhood of the Wolf*, starring Monica Bellucci and the young Belgian actress Émilie Dequenne. On February 7, you certainly will want to see Charlotte Rampling in *Under the Sand*, the first of her films for François Ozon.

The Ozon entry is the most important actress showcase of the month. But you might also want to see Élodie Bouchez in *La faute à Voltaire* and Elsa Zylberstein in *Les Fântomes de louba* (both Feb. 14); Isild Le Besco in *Adieu Babylone*, about a young woman on a journey of self-discovery (Feb. 21); Nathalie Baye and Marie Gillain as the wife and lover, respectively, of Fabrice Luchini in the comedy *Barney et ses petites contrariétés* (Feb. 21); *La Moitié du ciel*, with Caroline Sihol, about a woman's effort to adopt an orphan in China; and Claude Miller's *Le chambre des magiciennes*, about a young woman (Anne Brochet) who has a breakdown (Feb. 28). She is placed in the same ward as Mathilde Seigner. The film, in fact, aired on television in 2000, but this marks its theatrical release.

The latest from director Catherine Breillat, *À Ma Soeur!* (*Fat Girl*) opens March 7. So does *Félix et Lola*, the latest Patrice Leconte film, starring Charlotte Gainsbourg.

(Then on March 14, you may be confused. For the first time in this calendar year, there is not a single major release built around an actress. So you call friends in the United States to see what has been happening there. What you find out confirms you're in the right place: In the entire month of March 2001, *there will not be a single actress vehicle released into theaters.* What's more, February only had one film that might fit that definition: *Sweet November*, with Charlize Theron. And what did January bring to American audiences? Just two films: *The Wedding Planner*, an indifferent romantic comedy starring Jennifer Lopez, and *Chocolat*, an English-language film starring a French actress, Juliette Binoche.)

The first highlight of the spring arrives right on time on March 21: *Mademoiselle*, with Sandrine Bonnaire. *Rue du Retrait* (Mar. 28) closes the month, with the story of a friendship between a ninety-year-old woman (Dominique Marcas) and a businesswoman in her forties (Marion Held).

April begins with Sophie Marceau in her action mode, with *Belphégor— Le fantôme du Louvre* (Apr. 4). Virginie Ledoyen turns up the following week (Apr. 11) in *De L'amour.* So does Emmanuelle Béart in *Voyance et manigance*, in a film about crooked seers. Émilie Dequenne is superb the following week in *Oui, Mais . . .* (Apr. 18), about a teenager who seeks counseling

from a sympathetic therapist. That same day, *Le roman de Lulu* arrives, about a romance between a young actress (Claire Keim) and a cartoonist (Thierry Lhermitte) in his early fifties. Then on April 25, you can be the first to see a film destined to become an international sensation: *Le fabuleux destin d'Amélie Poulain ("Amélie"),* with Audrey Tautou. The women's road movie, *Du cotes des filles,* opens on the same day.

May, June and July see something of a lull. Perhaps the French studios are holding back their best product in anticipation of the rush of American blockbusters. On May 14, *Roberto Stucco* is released. It's hardly a woman's film, dealing as it does with a psychopathic criminal on a tear, but it costars Isild Le Besco as a sixteen-year-old moll, and her performance results in a nomination for the best newcomer César the following year. If you want to go to Cannes on May 15, you can see Emmanuelle Bercot in *Clément,* a film that she also wrote and directed, about a woman who falls in love with a teenage boy. Then on May 22, you can see *Les Âmes fortes,* with Laetitia Casta.

In June, there's nothing going on but an Elsa Zylberstein action drama, *Une Ange* (June 20), followed the next month by an interesting French-Canadian entry, *Maelstrom* (July 4), starring Marie-Josée Croze. That same day comes *What Women Were Doing When Men Walked on the Moon,* a lesbian comedy set in 1969. Then on July 22 comes Claire Denis's *Trouble Every Day,* an English-language feature about cannibals starring Vincent Gallo and Beatrice Dalle.

Things begin to pick up at the end of August, with the new Catherine Corsini film, *La répétition* (Aug. 22), about the lifelong obsession of one woman (Pascale Bussieres) for another (Emmanuelle Béart). The following week comes *Absolument Fabuleux* (Aug. 29), the French version of the British comedy hit *AbFab,* with Nathalie Baye and Josiane Balasko as Patsy and Edina, respectively, and Marie Gillain as Edina's disapproving daughter.

The fall movie season kicks off on September 5 with the release of two films representing signature work by their respective actresses. The first is *The Girl from Paris,* Mathilde Seigner's breakthrough role. The second is *The Piano Teacher,* from director Michael Haneke, starring Isabelle

Huppert. That same day, as a footnote to these future classics, comes the comedy *Virilité*, with Estelle Skornik as a successful businesswoman giving a passive fellow instructions in manly behavior.

Later in the month comes *The Milk of Human Kindness* (Sept. 19), a black comedy with Marilyne Canto not adjusting well to motherhood and with Dominique Blanc, Mathilde Seigner and Valeria Bruni Tedeschi making appearances. Also that day comes the new Anne Fontaine film, *How I Killed My Father*, starring Charles Berling but featuring Amira Casar, Karole Rocher and Natacha Reigner. The following week (Sept. 26) finds Audrey Tautou in *Dieu est grand, je suis toute petite*, a comedy in which she plays a neurotic religious seeker.

October begins with Catherine Frot in one of her best films, *Chaos* (Oct. 3), playing an upper-middle-class woman who befriends a young North African prostitute. The following week (Oct. 10) brings two new movies: Natacha Reigner in *La fille de mon père*, and Jeanne Balibar in the new Jacques Rivette comedy, *Va Savoir*.

If you have the time, you might pause to consider that you're seeing, within a matter of days, some of the best actresses in the world do the best work of their lives. But no, you're practically a Parisian now, and so you take for granted terrific films by Huppert, Seigner, Frot, Balibar . . . and then Emmanuelle Devos in *Read My Lips* (Oct. 17), the brilliant Jacques Audiard thriller, with Devos as a partially deaf woman whose lip-reading skills become an intricate part of a heist.

At this point, after savoring this deluge of cinematic riches, another more uneasy feeling may begin to set in. You may start thinking you have an obligation to tell people about this, and with that you may start to feel a vague sense of panic. Sure, you can open your mouth and start buttonholing people when you go home to the U.S., but how do you capture the vastness of the riches here? How do you do justice to the scale of it, while also conveying the magnificence of the individual achievements? And how do you make Americans care about what they don't know about, and feel a desire for that which they've learned to live without? Likewise, how do you presume to tell the French—the French, of all

people—about what they have and aren't completely appreciating? You may begin to feel very alone.

And in the midst of these thoughts, perhaps you'll amble into a theater on September 24 to get blown away by the new Kiberlain—Claude Miller's *Alias Betty*. While you're at the cineplex that day, you might also check out the new Karin Viard release, *Reines d'un jour*.

In November, you will start the month with the comedy *J'ai faim* (Nov. 7), from director Florence Quentin. The following week comes yet another defining film for an indelible actress, *My Wife Is an Actress*, starring Charlotte Gainsbourg. That same day (Nov. 14) finds Marion Cotillard in *Pretty Things*, about a woman who assumes her twin sister's identity when the latter commits suicide.

If you're already reeling from this deluge of brilliance, prepare to be knocked out the following week by Sandrine Bonnaire in *C'est la vie*. After you've seen that two or three times, you may also want to get around to seeing *Tanguy*, with a funny and frantic Sabine Azema doing everything she can (along with husband Andre Dussollier) to make her grown son leave the nest. Then at the end of the month comes Fanny Ardant in *Change My Life* and Jeanne Balibar in *Avec tout mon amour* (both Nov. 28).

December is weak by the previous month's standards, but it does contain *La Plage Noir* (Dec. 12), starring Dominique Blanc, and the charming Julie Gayet in *Vertiges de l'amour* (Dec. 19). In the meantime, you've probably seen coming attractions for *Se souvenir des belles choses* (Jan. 9, 2002), starring Isabelle Carré, so you know that the trend will continue into the next year, that 2001 was no anomaly, that you really are witnessing a golden age.

THE OPPORTUNITIES FOR WOMEN provided by French cinema don't need to be exaggerated. The number of films either starring or dealing primarily with women characters may be impressive, but it represents no unmanageable deluge. If you lived in France, you could keep abreast of everything by going to the movies once or twice a week. That may leave room for French cinema to grow, although it's worth pointing out that the

French release only about two hundred features a year. And so the movies I've mentioned constitute a sizable proportion of one year's total output. Moreover, I have not mentioned a number of sex farces made in 2001, such as *People in Swimsuits Are Not (Necessarily) Superficial*, despite an actress in the lead role, nor did I list *Un jeu d'enfants*, a regulation horror film that just happened to have Karin Viard and Ludivine Sagnier in the cast. I haven't mentioned routine thrillers, such as *Te Quiero* with Maruschka Detmers, or the successful gimmick picture, *Thomas Amoureux*, about a man whose romances take place entirely online. Finally, I haven't mentioned any number of films revolving around men but with women in them, from *Time Out* (also with Viard) to *Le Pornographe*, starring Jean-Pierre Léaud as a porn director (lots of women in that one). By the standards of American cinema, any of these omitted films might be considered to have good roles for women. Indeed, an actress playing a porn star in some American version of *Le Pornographe* would be guaranteed interviews in major media outlets, in which she'd get to describe her character "as a strong, assertive woman in control of her own destiny." That's how every monster, harpy and exploited, degraded female character in American cinema has been described in the press for the last twenty years.

To best appreciate the French output one need only compare it to the American output during the same period. In 2001, for example, there were about four hundred new American films, and yet fewer than twenty could be said to be actress showcases, and some of those could be a stretch, such as *The Shipping News* (with Julianne Moore, though it was mainly a vehicle for Kevin Spacey); or Tim Blake Nelson's *O* (a youth-oriented re-telling of "*Othello*," with Julia Stiles as Desdemona, but with much of the action taking place between Iago and Othello). Likewise, *Novocaine*, about a dentist (Steve Martin) in the clutches of a femme fatale (Helena Bonham Carter), was, like most noirs, essentially the man's story; and *Town & Country* was a romantic comedy from a man's standpoint.

Take those away and then subtract other films never meant to be taken seriously, such as the juvenile film *Crazy/Beautiful* with Kirsten Dunst, or *Glitter* with Mariah Carey. What does that leave? It leaves barely enough

to fill a best actress category, which that year consisted of Judi Dench for *Iris,* Nicole Kidman for *Moulin Rouge,* Sissy Spacek for *In the Bedroom,* Renee Zellweger for *Bridget Jones's Diary,* and Halle Berry, who won for *Monster's Ball.* The only other conceivable nominees in 2001 were Naomi Watts for *Mulholland Drive* and perhaps Stockard Channing for *The Business of Strangers.*

Compare that to the César nominations for the same year: Devos (*Read My Lips*), Frot (*Chaos*), Huppert (*The Piano Teacher*), Rampling (*Under the Sand*) and Tautou (*Amélie*). Four amazing performances, plus Tautou's, whose nomination was an understandable concession to (and consequence of) her film's off-the-charts popularity. And in contrast to the Oscars, these were far from the only possible choices. Any of the following would have made wholly plausible nominations: Ardant (*Change My Life*), Balibar (*Va Savoir*), Béart (*The Repetition*), Bonnaire (*Mademoiselle* or *C'est le vie*), Cotillard (*Pretty Things*), Gainsbourg (*My Wife Is an Actress*), Kiberlain (*Alias Betty*) and Mathilde Seigner (*The Girl from Paris*).

And it's the same every year. We release four hundred films, and when the year is over, we find at most twenty that might be considered actress vehicles, of which, at most, ten aren't ridiculous romantic comedies, lightweight youth romances or car crashes on the order of *Glitter.* The French release two hundred films, of which at least fifty are worthy of attention. Meanwhile the number of French imports to America keeps going down. Even in movie cities like New York and San Francisco, if I tell people I just saw a terrific Isabelle Carré movie, they look at me with the stricken discomfort of people who think they're seconds away from failing a quiz.

This is not a good state of affairs. To make things better, the first step is to recognize what's going on; specifically, what's going on there and what's not going on here. Once we overcome our ignorance of the riches currently being generated in France and get past the delusion that the situation for women in American film is steadily getting better, all kinds of things become possible. Filmmakers can see another way of doing business. American actresses can start expecting more and generating their own product. American film consumers, familiar with another way,

can start demanding more from American films—and supporting more French imports, now that they know that these movies contain many of the values and attitudes that they have been vainly seeking on their own shores. Even in the best of times, a foreign cinema can only gain a minimum of currency in America. In the 1960s, only a fraction of the population was going to see Antonioni, Fellini or Truffaut. But it was big enough to have an influence, possibly because it was also the *right* fraction of the population—filmmakers, tastemakers and more refined consumers of motion pictures.

In the meantime, the best thing an individual movie lover can do is have fun. No great movement can happen in popular art without pure pleasure being the motive. Letter writing campaigns are fruitless, and boring. An attitude of outrage is pointless and even, in a way, misdirected. There should be nothing dutiful about exploring these actresses, and no one needs to consider himself or herself virtuous for knowing their films. All they offer is the exhilaration of experiencing a grand movement and the satisfaction that great art grants to those who pay attention.

If we enjoy their work and love their work and spend our money accordingly, all will turn out right in the end.

Appendixes and Reference Matter

Appendix One:
How to Sell French Films
in the United States

Foreign films fared well domestically in the fifties and sixties, but they had two advantages they don't have now: (1) there was no thriving independent scene tapping into the same audience; and (2) for a long time, they were the only films dealing with adult subjects in adult ways. It is not always easy to persuade people to have a fulfilling cultural experience. It is sometimes not easy to persuade people to have a purely titillating experience. But the promise of a cultural experience that is also titillating—something that's good for you and stimulating as well—will always bring in audiences.

In the absence of those advantages, today's distributors need to make adjustments. Unfortunately, Europeans often have no idea what specifically about their work would appeal to the American mentality. And American distributors often don't fully understand what they're selling or how to sell it. These problems are surmountable in the case of French product, however, for the simple reason that the films are good and in specific ways that American films are not. They would appeal to millions of American viewers. The challenge, then, is to reach people and get them interested in something they most certainly *would* be interested in, but they don't know it.

The most common sales strategy for unknown product is the weakest and must be avoided. This is the losing strategy that attempts to transcend a cultural divide and preempt xenophobia by saying, in effect, "This movie is just like your movies!" I have found, with movies, as well as with books, that people are not seduced by strategies that say, "This is like something else that you're already interested in; therefore you should buy this." No, the thing itself must be made seductive on its own terms.

This argument should be made: "This is something you don't have. But you want it very much." Only then does the prospect of venturing out of the familiar by watching a film in a foreign language, for example, become worth the small extra effort.

Now in the case of French cinema, I would be at a loss to figure out how to sell the kinds of films that we, in America, already have a surfeit

of—crime dramas, thrillers, horror movies. But as the preceding pages have (I hope) made clear, the French cinema has the women's films we lack, as well as many more great actresses actually headlining films. This is where France's opportunity lies.

So, first, French cinema needs to be branded in the American public mind as the land of women's cinema. This would not be difficult, because, quite conveniently, it happens to be true. This notion could be advanced in the press kits and releases accompanying new films. It could also be supported through the French film festivals held in major U.S. cities, which are, in part, financed by Unifrance, whose mission is to promote French film abroad.

The goal would be to sell French film as a concept, so that each French film no longer must be sold as a discrete proposition. As it stands now, all French films—indeed, all foreign films—are sold in the United States in the same way: "This is a good one! Check it out!" Thus, their audiences must be built from the ground up with each campaign. No surprise, then, that most campaigns fail. That's just not how to create a reliable fan base.

As we reinforce the branding of French cinema as the epicenter of women's pictures, each individual film must be sold on the basis of its principal actress. After all, today's French actresses embody moral archetypes, and this feature alone will appeal to the American way of looking at, watching and thinking about movies. It's a huge untapped advantage that the French would do well to make use of: Americans are very actor-centric (much more than French audiences). Advertisers should be aware of this, and stateside advertising should exploit this opportunity.

Mademoiselle Chambon, for example, did fairly well in the United States. If you sell it to someone as a one-off sensitive love story, congratulations, you have sold one ticket. But if you sell it as a Sandrine Kiberlain film, then you may very well have sold tickets to the next five Sandrine Kiberlain movies—not to mention at least one Sandrine Bonnaire movie, because Americans are bound to get their Sandrines confused.

Advertising is, of course, expensive. But it would cost nothing to make an American print ad that says "Sandrine Kiberlain in *Mademoiselle Chambon*" instead of just *Mademoiselle Chambon*. Moreover—and this is the part that the general reader cannot possibly realize—the advertising doesn't start with what appears in the paper. It starts in the press releases that go to the journalists who write the reviews and advance stories about a given film. If every press release for every French women's film emphasized the explosion of female talent in France, you would start seeing that concept reflected in the press. Likewise, press releases that emphasize the value and meaning of each star, and how those values and meanings are reflected in

the work, will find their way into the copy of the respective journalists and into the consciousness of readers.

American journalists are not pushovers. They are not parrots or ventriloquist dummies. But if, upon examination, they find that everything being advertised is true, they will say so. Certainly, once they know it's true, the American press will be welcoming of the concept of France as the land of women's cinema, because the vast majority of film writers and critics are in ideological and cultural sympathy with the mere fact of such a cinema's existing. (Many of these writers are, in fact, middle-aged and older women, who are acutely aware of their marginal presence on Hollywood screens.) Make this world accessible to film writers and critics, give them a hook, and they will in turn hook their readers. Similarly readers (and audiences) would welcome being told about French films in terms of their stars, because it is a valid way of looking at these films. Thus fans of French cinema and of individual stars will be created, both within the critical community and in the general community of educated filmgoers.

To accomplish this, some things must be overcome. French filmmakers and distributors must, first of all, rise above any squeamishness or misplaced snobbishness they might feel about speaking to the American audience on its own terms. I imagine, also, that a coordinated effort along these lines might provoke some hostility in male stars who, after all, have more box-office clout in France than women and therefore the power to make their disapproval known. Finally, organizing disparate distributors around a central theme would require coordination by a central organization, such as Unifrance, that would set policy and encourage (with no power to enforce) cooperation. This would not be easy, though money does have a way of talking, and not only in the United States. If this strategy were tried long enough to produce an increase in revenue, that might be persuasion enough.

Finally, lest my enthusiasm be mistaken for self-delusion, the obvious must be said: Valeria Bruni Tedeschi is never going to become Tom Cruise in this country. Or Angelina Jolie. But with intelligent, targeted, strategic promotion, there is no reason why the market for French cinema, or certain kinds of French cinema, can't double or triple. That in itself would be an accomplishment—and something to build on.

Appendix Two:
How to See French Films
in the United States

If you want to see French films in America, the first thing to do is to see what is available on American DVD and VHS. Just that much might satisfy your interest, but if you want more—you should want more—there are other things you can do.

The first and least expensive thing is to get the French station TV5 Monde USA as part of your cable or satellite package. A few years ago, it was barely available, but now it is pretty much everywhere as a pay channel. Depending on where you are, it's about ten dollars per month. Every day two or three movies are shown. Ninety percent of them have English subtitles. Many of the films I write about on these pages—major films I might not have seen otherwise, such as *C'est la vie* (Bonnaire) and *Un week-end sur deux* (Baye)—I saw for the first time on TV5 Monde USA. Also on cable, take a look at the schedule for Turner Classic Movies, which has, in recent years, increased its programming of French films.

If that's not enough—of course it's not enough—you must buy a Region Free DVD player and start buying DVDs from overseas. DVDs outside of North America don't play on most American DVD players, but a Region Free player costs only about $50 or $60 as of this writing. Also many Blu-ray disc players and newer DVD recorders feature Region Free as an option. A half-hour's research on the Internet will tell you all you need to know.

Once you have a Region Free player, your options increase exponentially. If you're fluent in French, *virtually every film mentioned in this book* is available to you. If you require subtitles, the selection is more limited. And if you are somewhere in between, like I am, you can buy French DVDs that have no English subtitles but that have French subtitles for the hearing (or the understanding French) impaired.

Once you have a title that you want to purchase, if it's not available as a Region 1 (North American) DVD, go to amazon.co.uk (the British Amazon site). The postage from Britain is reasonable, delivery is fast, and, if it's available in a UK edition, that means it has English subtitles. If it's not

there, you still may be able to find a subtitled edition on amazon.fr (France's Amazon site). With postage, amazon.fr is more expensive than the UK site. Occasionally something will also turn up on the Australian site Family Box office. As a last resort, try amazon.ca (Canada). They are the least reliable, often advertise items as having subtitles when they do not, and the postage is more expensive than from England. Canada's DVDs, however, do have the advantage of being Region 1, so you can play a Canadian DVD on a regular domestic DVD player.

If you live in a city that happens to have a good video store, check its selection—especially for old VHS versions of titles that are out of print and perhaps never made it to DVD.

Finally, the most expensive way to see French films is to get on a plane to see them, which means traveling to New York in March for the Rendez-Vous with French Cinema festival; then on to Richmond for Virginia Commonwealth University's annual French Film Festival that same month; then to Los Angeles' City of Lights, City of Angels (ColCoa) film festival in April; then on to the San Francisco Film Society's French Cinema Now festival in November. Also, if you are near a major or regional film festival, check the catalog, because you never know what will show up.

What follows is a list of films that I've mentioned in this book that have been shown on television or *are available in subtitled editions*. As such, it's neither an exhaustive list nor a filmography. Many films, including some indispensable ones, are not included. In preparation for this book—and in preparing for it before I knew I was preparing for it, when I thought I was just enjoying myself—I saw many more films than those listed here. For example, because of film festivals, I have seen subtitled French films that were subsequently released without subtitles.

Finally, in the hope that this list might inspire further viewing and serve as a grounding in contemporary French women's cinema, I am also including some films I did not mention in the text for reasons of space but that are available and worth seeing:

Actrices is available in a German DVD that contains English subtitles.
L'adversaire is available on French DVD.
Ah! Si j'étais riche has been shown on TV5 Monde USA
Un air de famille is available on American DVD.
Alice et Martin is available on British DVD.
Amélie is available on American DVD.
Les ambitieux has been shown on TV5 Monde USA and is well worth seeing.
L'amour braque is available on American DVD.

Anatomy of Hell is available on American DVD.

. . . And They Lived Happily Ever After is available on American DVD.

Anna M. is available on British DVD.

Anthony Zimmer, a very entertaining thriller starring Sophie Marceau and Yvan Attal, can be found on Australian DVD.

Après lui is available on American DVD.

Avenue Montaigne is available on American DVD.

Backstage is available on American DVD.

Le bal des actrices has been shown, with French subtitles, on TV5 Monde USA.

La balance is available on American DVD.

La balia is available on American DVD.

Belphégor—Le fantôme du Louvre is available on American DVD.

La Baule-les-Pins, known in the United States as *C'est la vie* (not to be confused with the Sandrine Bonnaire film of the same title), can be found used on American DVD.

La Belle Noiseuse is available on American DVD.

Betty Fisher et autres histoires, known in the United States as *Alias Betty,* is available on American DVD.

Beware of My Love is available on American DVD.

La Boum and *La Boum 2* aren't easy to find on home video, in any format, though there are out-of-print VHS and DVD copies floating around in the United States and Britain. Also, both films have played on TV5 Monde USA.

Brotherhood of the Wolf is available on American DVD.

Le bureau de dieu, or *God's Offices,* has been shown on TV5 Monde USA.

Camille Claudel is available on American DVD.

Le Californie is available on French DVD.

La captive du desert is available on French DVD, without subtitles. It's listed here because the film has so little dialogue that subtitles aren't necessary.

Les cent et une nuits de Simon Cinéma is available on American DVD.

La Cérémonie is available on American DVD.

Certified Copy is available on British DVD.

C'est la vie has been shown on TV5 Monde USA.

C'est le bouquet! has been shown on TV5 Monde USA.

Ceux qui restent is available on Canadian DVD.

Change My Life is available on American DVD.

Les chansons d'amour is available on American DVD.

Children of the Century is available on American DVD.

A Christmas Tale is available on American DVD.

Clara et moi has been in and out of print in the United States and Canada. But it can be found. Keep looking.

Cliente is available on French and British DVD.

Coco Before Chanel is available on American DVD.

Coco Chanel & Igor Stravinsky is available on American DVD and Blu-ray.

Un couer en hiver is available on American DVD.

Un Coeur du Mensonge, known in the United States as *The Color of Lies*, is available on American DVD.

Colonel Chabert was available on American DVD. It can be found used.

Comme une image is available on American DVD.

Confidentially Yours is available on American DVD.

Coup de foudre, known in the United States as *Entre Nous*, is available on American DVD.

Coup de torchon is available on American DVD.

Le coût de la vie has shown on TV5 Monde USA.

Je crois que je l'aime is available on Canadian DVD.

Danse avec lui has shown on TV5 Monde USA.

The Daughter of D'Artagnan is available on American DVD.

Day for Night is available on American DVD.

De l'amour is available on British DVD.

La dentellière, or *The Lacemaker*, isn't easy to find, though an English-language VHS was released many years ago.

Didine has been shown on TV5 Monde USA.

East/West is available on American DVD.

L'effrontée is available on American DVD.

8 Women is available on American DVD.

Embrassez qui vous voudrez is available on Canadian DVD.

Les émotifs anonymes is available on French DVD with French subtitles.

L'enfant is available on American DVD.

L'enfer (1994) is available on American DVD.

L'enfer (2005) is available on British DVD.

Entre ses mains is available on British and French DVD.

L'équipier is available on British DVD.

L'été meurtrier is available on American DVD.

Espions, a good thriller starring Géraldine Pailhas, is available from France with no English subtitles, but half of it's in English, and the rest is fairly easy to follow.

L'étudiante can be found in a French edition with French subtitles, but it has also shown on TV5 Monde with English subtitles.

Family Hero is available on Australian DVD.

Fat Girl is available on American DVD.

Felix et Lola was available in Britain. Look for it used.

Une femme française is available on British and French DVD.

Les femmes de l'ombres or *Female Agents* is available in an English import.

La fidélité, a likable if overlong art film starring Sophie Marceau, can be found on DVD in various countries. Check for English subtitles.

La fille coupée en deux is available on American DVD.

Filles perdue, cheveux gras is a slight but engaging film, starring Amira Casar and Marina Foïs, that has shown on TV5 Monde USA.

The First Day of the Rest of Your Life is available on American DVD.

5x2 is available on American DVD.

À la folie . . . pas du tout is available on American DVD.

Fort Saganne is available on American DVD.

Frankie, with Diane Kruger as a fashion model, is available on British DVD.

Friday Night is available on American DVD.

Gabrielle is available on American DVD.

Games of Love and Chance is available on American DVD.

Gilles' Wife is available on American DVD.

The Girl from Monaco is available on American DVD.

The Girl from Paris is available on American DVD.

The Girl on the Train is available on American DVD.

God Is Great . . . I Am Not is available on American DVD.

Going Places is available on American DVD.

The Green Room can be found on American VHS.

La Gueule Ouverte is available on British DVD.

Hello Goodbye is available on American DVD.

Her Name Is Sabine is available on American DVD.

Holy Lola is available on French DVD.

Honeymoon was available on American VHS and is now out of print.

The Horseman on the Roof is available on American DVD.

The Housekeeper is available on American DVD.

Indochine is available on American DVD.

Intimate Strangers is available on American DVD.

Les invités de mon père is available on French DVD with French subtitles.

I Married a Dead Man can be found used on American VHS and is well worth seeking out.

It's Easier for a Camel . . . is available on American DVD.

I've Loved You So Long is available on American DVD.

Je l'aimais was shown on TV5 Monde USA with French subtitles.

Je vais bien, ne t'en fais pas is available on British DVD.

Je pense à vous has been shown on TV5 Monde USA.

Jeanne and the Perfect Guy is available on American DVD.

Un jeu d'enfants is available on British and French DVD.

Joan the Maid is available on American DVD.

Joueuse, under the English-language title *Queen to Play*, is available on American DVD.

Lady Chatterley's Lover is available on American DVD.

The Last Mistress is available on American DVD.

Late August, Early September is available on American DVD.

Leaving, or *Partir*, is available on American DVD.

Une liaison pornographique is available on American DVD.

Love After Love is available on American DVD.

Loulou is available on American DVD.

The Lovers on the Bridge is available on American DVD.

Madame Bovary is available on American DVD.

Mademoiselle is available on American DVD.

Mademoiselle Chambon is available on American DVD and Blu-ray.

Maelstrom is available on American DVD.

Maman est folle has shown on TV5 Monde USA.

The Man of My Life is available on American DVD.

Manon des sources is available on American DVD.

Mariages! is available as an American import in Britain.

Marquise can be found on amazon.co.uk in a Hong Kong import.

La mémoire courte has been shown on TV5 Monde USA.

Merci pour le chocolat is available on American DVD.

La mere is available on American DVD.

Mesrine is available on French DVD.

Modern Love, with Alexandra Lamy, Clotilde Courau and Berenice Bejo, is available on Canadian DVD.

Le Mome, known in the United States as *La vie en Rose*, is available on American DVD.

Mon homme can be found used on American VHS.

Monsieur Hire is available on American DVD.

Mortelle randonnée is available on American DVD.

La Moustache is available on American DVD.

My Nights Are More Beautiful Than Your Days is available on American DVD.

My Wife Is an Actress is available on American DVD.

Nathalie . . . is available on American DVD.

Le neige et le feu is available on French DVD.

Nelly & Monsieur Arnaud is available on American DVD.

Nenette and Boni is available on American DVD.

Normal People Are Nothing Exceptional is available on British DVD.

À nos amours is available in a beautiful DVD set from the Criterion Collection.

La nouvelle Ève is available used on American VHS.

On connaît la chanson is available on British and French DVD.

Oui, mais . . . is available on American DVD.

The Page Turner is available on American DVD.

Palais royal! is available on French DVD.

Le paltoquet is available on French DVD.

Paris is available on American DVD.

Paris je t'aime is available on American DVD.

Parlez-moi de la pluie can be found on DVD in the United States and Britain.

La parola amore esiste is available on American DVD.

Passe-passe has been shown on TV5 Monde USA.

Les patriotes is available on an American DVD.

Pédale Douce has been shown on TV5 Monde USA.

Mon père, ce héros is available on British DVD.

La peste is available on American DVD.

Un petit jeu sans consequence has been shown on TV5 Monde USA.

Le Petit Lieutenant is available on American DVD.

Petites coupures can be found on a British DVD.

Peut-être has been shown on TV5 Monde USA.

The Piano Teacher is available on American DVD.

Place Vendôme is available on American DVD.

Au plus pres du paradis has been shown on TV5 Monde USA.

Police was available on American VHS. It's now out of print but can be found used.

Le pornographe is available on American DVD.

Possession is available on American DVD.

Post coïtum, animal triste was available on American DVD and sometimes can be found used. Find it.

Premiers désirs is available on British DVD.

Priceless is available on American DVD.

Private Fears in Public Spaces is available on American DVD.

Le prix à payer is available on Canadian DVD.

Quatre étoiles has been shown on TV5 Monde USA.

Queen Margot is available on American DVD.

Read My Lips is available on American DVD.

Le Refuge is available on British DVD.

Rendez-vous is available on American DVD.

La répétition is available on American DVD.

The Return of Martin Guerre is available on American DVD.

Les revenants is available on American DVD.

Ridicule is available on American DVD.

Rien à faire was available on VHS. It is now out of print but can sometimes be found used. Keep looking.

Le rôle de sa vie can be found on French DVD.

Roman de gare is available on American DVD.

Rosetta can be found used on American VHS.

Rue de retrait is available on French DVD.

Select Hotel is available on British and French DVD.

Une semaine de vacances is difficult to find. I saw it on an ancient VHS found at a video store. It's worth looking for.

Sauve qui peut (la vie) is available on British DVD.

La seconda volta can be found used on American VHS.

Un Secret is available on American DVD.

Les sentiments is available on French DVD with French subtitles.

Séraphine is available on American DVD.

Sex Is Comedy is available on American DVD.

Shall We Kiss is available on American DVD.

A Single Girl is available on American DVD.

Skirt Day is available on American DVD.

Sky Fighters is available on American DVD.

Les soeurs Brontë has been shown on TV5 Monde USA.

Les soeurs fachée is available on Australian DVD under the title *Me and My Sister.*

The Story of Adele H. is available on American DVD.

The Story of Women is available on American DVD.

Suite 16 was available on British DVD.

Summer Hours is available on American DVD and Blu-ray.

Swimming Pool is available on American DVD.

The Taste of Others is available on American DVD.

La tête de maman is available on Canadian DVD.

Thomas amoreux is available on American DVD.

Three Colors: Blue is available on American DVD.

Tickets, with Valeria Bruni Tedeschi, is available on British DVD.

Time Out is available on American DVD.

Toi et moi is available on American DVD.

À tout de suite is available on American DVD.

Tout plaisir est pour moi is available on French DVD.

Tout va bien, on s'en va is available in a French edition with English
 subtitles.

L'un reste, l'autre part is available on Australian DVD.

Under the Sand can be found on American DVD.

Under the Sun of Satan can be found used on American VHS.

Vagabond is available in a gorgeous edition from the Criterion Collection.

Va Savoir is available on American DVD.

À vendre was available on American DVD and can be found used.

Venus Beauty Institute is available on American DVD.

La vérité ou presque is available in a Canadian DVD.

La vie promise is available on American DVD.

Une vie à t'attendre is available on French DVD.

Violette Nozière is available on American DVD.

Water Drops on Burning Rocks is available on American DVD.

Water Lilies is available on American DVD.

Un week-end sur deux can be found used on American VHS.

Wild Camp is available on American DVD.

The Witnesses is available on American DVD.

The Woman Next Door is available on American DVD.

Acknowledgments

The first people who must be thanked are the actresses who agreed to speak to me. Although from the beginning I knew that I did not want this to be a book of interviews, I also knew that writing about the work of living people requires more fact and less speculation than writing about the dead. Readers will tolerate guesswork as to thoughts and motivations when nothing but guesswork is possible. But when the subject concerned is alive, the reader has a right to think, "But why didn't you just ask her?"

Of course, getting the opportunity to ask isn't always easy, but I had the indispensable help of Magali Montet, who really made this book possible. Magali acted as my conduit in Paris, setting up interviews with the various actresses. In addition, she offered advice and friendship and made what might have been difficult into an unalloyed pleasure. It's a wonderful thing to be on the train to Reims when a message pops up saying Nathalie Baye will meet you tomorrow at three. Martin Marquet was also indispensable, for his advice in the early going, for his insistence that I not try to set up the Paris interviews myself and for introducing me to Magali.

The great Leba Hertz, the arts and entertainment editor at the *San Francisco Chronicle*, helped with her willingness to run interviews with many of these actresses in our Datebook section. Of course, without the Bay Area's sophisticated readership in all things cinematic, such articles would be impossible.

For various other reasons, thank you to Florence Charmasson of Unifrance, Frederic Dart of the Alliance Francaise in Sydney, Nathalie Schreier of the Alliance in San Francisco, Christiane Gautier, Sophie Gluck, Karen Larsen, Aimee Morris, Christophe Musitelli, Susan Norget, David Wiegand, Leo Wong, Peter Cowie, Michel Ciment and the late and much missed Graham Leggat.

Thanks to my agent, Alan Nevins, for jumping on this potential bestseller and representing it like I was his most important client. I'm not. Many thanks also to Emily-Jane Cohen, my editor, whose knowledge of France

(and French) have been ongoing sources of insight and support. Beyond that, Emily-Jane was willing to fight for this book to reach you in its current form. This makes her a stud among editors, not a houseboy. I am indebted to Pierre-Francois Mourier, as well, the former consul-general of France in San Francisco, for introducing us.

I knew this book was in good hands after the first communication from Judith Hibbard, Stanford University Press's Senior Production Editor. Her warmth and respect for this project is appreciated enormously. I extend my grateful appreciation also to Jeffrey Wyneken, who eschewed the rusty meat cleaver of tradition and copy edited this book with a pair of golden tweezers, and to Rob Ehle, who did a lovely job on the cover.

My cat Sandrine sat on my desk and kept me company through the long writing process and only once asked me if she was named after Kiberlain or Bonnaire or both. I told her to read the book and figure it out herself. (All right, but don't tell the cat or else she'll never read anything: Bonnaire.)

Finally, I have to thank my wife Amy, who has not seen an American movie in three years and is finally beginning to climb the walls.

Sources

America's heretofore lack of familiarity with these women, as well as the French tendency to look at cinema almost entirely as the art of the director, has kept the number of useful books on this subject to the barest minimum. Thus, aside from a couple of books, a handful of newspaper articles, a couple of YouTube videos and random DVD commentaries, just about all the quotes in this volume were derived from firsthand interviews, conducted either exclusively for this book or for publication in the *San Francisco Chronicle*. Information on *Le Figaro*'s list of the most popular and the highest-paid French stars came from a number of web sources. Likewise, many other websites, newspaper articles and videos were consulted for purposes of background.

Sources

Bonnaire, Sandrine, Tiffy Morgue, and Jean-Yves Gaillac. *Le soleil me trace la route*. Paris: Stock, 2010.

"Emmanuelle Béart Interview 1987." YouTube. 2009. http://www.youtube.com/watch?v=550z8lO9eXM

"Emmanuelle Béart interview, Emanuel Ungaro, Fall/Winter 2009–2010." YouTube. 2009. http://www.youtube.com/watch?v=t80YOZarZFk

"Isabelle La Dentelliere." May 1977 interview. Isabelle Huppert: La Vie Pour Jouer. Missouri State University. Website: mjf.missouristate.edu/faculty/wang/ih

Le Temps. Interview with Isabelle Huppert and Claude Chabrol. July 31, 1998.

Morin, Edgar. *The Stars.* Minneapolis: University of Minnesota Press, 2005.

Strauss, Frederic, and Serge Toubiana. "Guerrieres: Entretien avec Solveig Anspach et Karin Viard." *Cahiers du Cinéma* 540 (1999), 88–93.

Interviews

Interviews were conducted in person, except where noted.

Attal, Yvan. March 16, 2010.
Baye, Nathalie. September 15, 2010.
Bonnaire, Sandrine. March 2, 2008.
Brizé, Stéphane. Telephone interview. March 21, 2010.
Carré, Isabelle. September 17, 2009.
Deneueve, Catherine. March 3, 2011.
Gainsbourg, Charlotte. Telephone interview. October 13, 2009.
Gayet, Julie. March 17, 2010.
Gillain, Marie. September 8, 2009.
Huppert, Isabelle. November 8, 2010.
Jaoui, Agnès. September 17, 2010.
Kiberlain, Sandrine. September 17, 2009.
Leconte, Patrice. Telephone and e-mail interview. April 1, 2010.
Lindon, Vincent. March 16, 2010.
Marceau, Sophie. April 1997.
Mastroianni, Chiara. March 18, 2010.
Ozon, François. Telephone interview. March 22, 2010.
Pailhas, Géraldine. September 14, 2009.
Sagnier, Ludivine. May 6, 2008.
Tedeschi, Valeria Bruni. September 18–19, 2009.
Thomas, Kristin Scott. Telephone interview. October 13, 2010.
Viard, Karin. September 15, 2009.
Zylberstein, Elsa. March 3, 2008.

Index